Realistic Architectural Visualization with 3ds Max and mental ray®

Roger Cusson

Caught the AutoCAD bug in 1985. After learning and applying the software to his profession, he became a consultant to architectural firms implementing AutoCAD into their work process. Roger has been an active educator for years in the professional and academic communities. He has worked as a full time professor at Vanier College, and a training manager at Autodesk. He was lead author for two Autodesk VIZ books and was a significant contributor to the 3ds Max 8 and 3ds Max 9 Essentials books.

Jamie Cardoso

Is a 3D artist who has been producing 3D graphics for professional organizations and companies since 1994. He has been involved in numerous multimillion-dollar projects ranging from graphic design work to 3D visualizations. Jamie has worked for 4 years as a senior 3D artist/special effects designer for a multinational company called Carillion plc and is currently working for GMJ Design Ltd.

Realistic Architectural Visualization with 3ds Max and mental ray®

Roger Cusson and Jamie Cardoso

ELSEVIER

AMSTERDAM • BOSTON • HEIDELBERG • LONDON • NEW YORK • OXFORD
PARIS • SAN DIEGO • SAN FRANCISCO • SINGAPORE • SYDNEY • TOKYO

Focal Press is an imprint of Elsevier

Focal Press

Acquisitions Editor: Paul Temme
Publishing Services Manager: George Morrison
Project Manager: Kathryn Liston
Associate Editor: Dennis McGonagle
Marketing Manager: Rebecca Pease

Focal Press is an imprint of Elsevier
30 Corporate Drive, Suite 400, Burlington, MA 01803, USA
Linacre House, Jordan Hill, Oxford OX2 8DP, UK

∞ Recognizing the importance of preserving what has been written, Elsevier prints its books on acid-free
paper whenever possible.

Library of Congress Cataloging-in-Publication Data
Application submitted

British Library Cataloguing-in-Publication Data
A catalogue record for this book is available from the British Library.

ISBN: 978-0-240-80912-0

For information on all Focal Press publications
visit our website at www.books.elsevier.com

07 08 09 10 11 10 9 8 7 6 5 4 3 2 1

Printed in Canada

Contents

Acknowledgments

I would like to acknowledge and thank two individuals. I would like to thank Pia Maffei for her constant support. She may not have seen any of this book yet, but she has provided moral support throughout this project. I would also like to thank Amer Yassine for his help as a friend, reviewer and general "man these images are nice" support.

Roger Cusson

I would like to acknowledge and thank a number of people. The "old" Object Technology team: Nadeem Bhatti for being very supportive throughout this project, Steve Jolley, Phil Mutter, Geoffrey Chilvers, Paul King, Robin Anjan, Brian Napper and Adrian Hughes. From the mental ray team: Alf and Mr. "Zap" Andersson, you were really fantastic. Also for the constant feedback from John Cheong, Andreas Alexiou, my brother Martins Cardoso, Nina Suwala, Shawn Khan, Sharron Pomells, Olivier Ladeuix and Richard Bobb.

Finally, I would like to dedicate this book to my father.

Jamie Cardoso

Preface

3ds Max has existed for many years with alternate plugin renders to the default scanline renderer. These plugin renderers like Brazil, Vray and mental ray have been used by the 3ds Max community to some degree. How these renders integrate with 3ds Max, and the availability of training material has though limited the rate of adoption of these plugin renders.

In 1997 a connection from 3ds Max to mental ray was introduced. This was soon followed by an agreement where a license of mental ray was included whenever a set of 3ds Max was purchased. Despite the fact that mental ray came at no cost to the customer, there were still many 3ds Max users who stuck with the traditional scanline render or went to other plugin renders.

In 3ds Max 9 Autodesk has made a concerted effort to make the use of mental ray more approachable by simplifying the interface of the lighting and creating a new material type which is flexible enough to create most materials.

What we tried to do in this book was to put you into real-life situations where you would be required to produce renderings of real-life projects. The approach was to go over tasks which an architectural illustration artist would typically find themselves in. The discussions and tutorials are limited to materials and lighting, essentially what makes up mental ray. We have assumed that you already know how to create architectural models and leave it up to you to determine what software you feel the most comfortable to create those models. At the end of this book you will find an appendix on transferring CAD files from AutoCAD and Revit to 3ds Max. In addition, you will find other appendices on caustics, camera effects, HDRI, rendering large and complex scenes and others.

Project Files: Exercise Disk

Attached to this book is a data DVD disk. This disk will contain files which are required by the tutorials in each of the chapters. Copy these files to a location on the computer you intend to do these exercises on. Each series of project files is organized by a folder bearing the name of the chapter.

The Living Room: Introduction

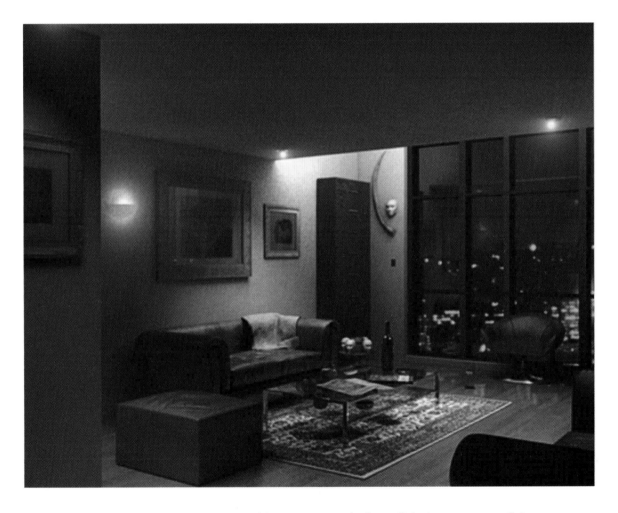

In this section you will create two renderings of the same scene. The first will depict an apartment living room space during the day, the second at night. The section is composed of three chapters: in the first you work on the materials in the scene, the second lighting during the day and the third lighting the scene at night.

Chapter 1

Preparing Materials for an Interior Space

1.1 Introduction

In this chapter you will see how to prepare materials for an interior scene. This chapter is composed entirely of material creation in a light-free environment. Working both lighting and materials simultaneously increases rendering time and therefore reduces efficiency. While either lighting or materials could be worked on first, the choice was made to work on materials first as it is easy to disable the materials when working on the lighting.

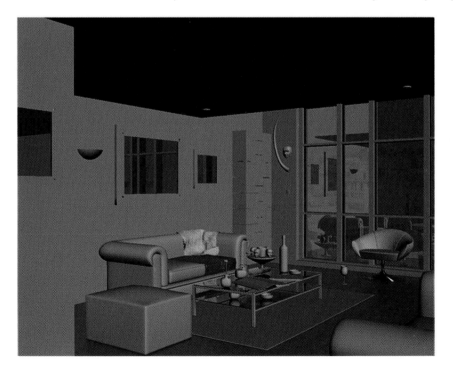

1.2 Starting the Scene

Before beginning on a new 3ds Max scene it is imperative that you ensure that the units are properly set up in your scene. Otherwise you will later encounter a number of undesirable results:

1. Start or Reset 3ds Max.
2. From the Customize pull down menu select Units Setup …

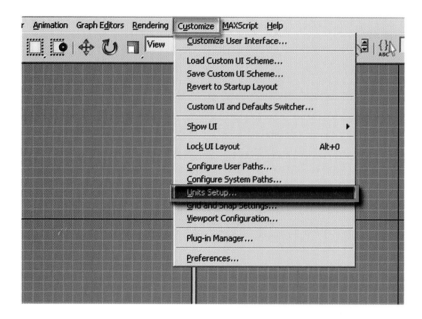

3. In the Units Setup dialog, in the Display Unit Scale, set the scale to Metric Millimetres.

4. In the Units Setup dialog click on the System Unit Setup button.

5. In the System Unit Setup dialog set the System Unit Scale to millimetres.
6. Click OK to exit both dialog boxes.

Note: It is important that the units setup and system unit setup are the same to prevent undesirable results when rendering.

To get started we are going to open the version of the living room scene where only grayscale materials have been applied:

7. Open the file **LR materials start.max** from the files folder.

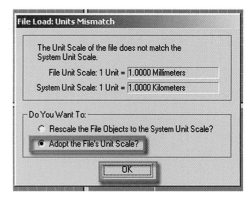

The units of 3ds Max have been carefully set in advance to match the units of the incoming file; both are in metric millimetres. It is often the case that a file being opened does not match the system units of 3ds Max. In this case, the File Load: Units Mismatch dialog box will alert you to the discrepancy. You should always adopt the file's unit scale in order to avoid problems with units later in the development of the scene:

8. Once the scene is loaded, open the Render Scene dialog by clicking on the Render Scene Dialog button on the Main Toolbar.
9. In the Render Scene Dialog, click on the Common tab.
10. Set the Output Size Width to 450 and the Height to 352.

Note: These values worked well for this scene, but you could enter different image sizes if desired:

11. Click on the Lock button next to the Image Aspect value to enable it.
12. Click on the Lock button next to the Viewport list at the bottom of the dialog. This will lock the Camera01 view to be rendered until it is unlocked.

Now load the mental ray renderer:

13. In the Render Scene dialog, click the Common tab and scroll down until you reach the Assign Renderer rollout.
14. Click on the button to the right of the Production renderer.
15. In the Choose Renderer dialog select mental ray® Renderer and click OK.
16. Render the file by clicking the Quick Render button on the Main Toolbar. The scene is rendered with its default grayscale materials.

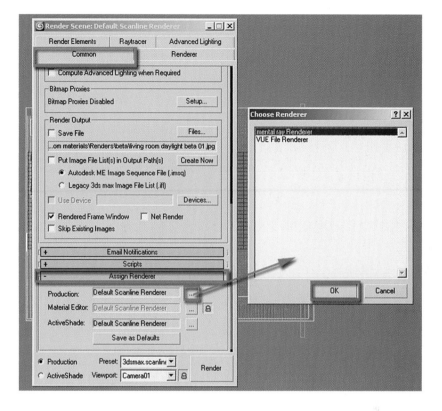

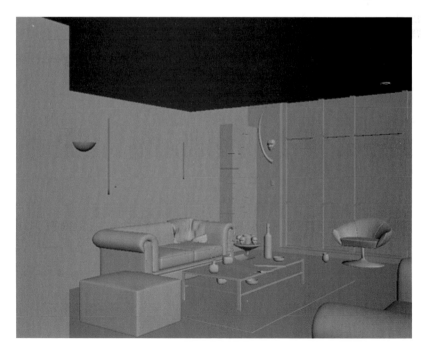

1.3 The Arch & Design Material

3ds Max 9 provides a new material type which works with the mental ray renderer. This material will become the default material in the Material editor if you choose to change the default setup of 3ds Max.

The Arch & Design material has a different look and feel to that of the Standard and Architectural materials. You will find some familiar parameters, but often they will be in a different location.

Fortunately, one of the items which have been created in the Arch & Design parameters is the inclusion of a list of material templates.

Selecting one of the templates changes the parameters in the Arch & Design rollouts. Once the initial template is selected you can then make modifications to make the material suitable to your specific needs.

The first area of the main rollout is the most recognizable, Diffuse parameters. The diffuse color specified with a color swatch and a Diffuse Map can be accessed by clicking on the button adjacent to the color swatch.

Diffuse Level: It controls the intensity of either the diffuse color or the diffuse map values range between 0 (no diffuse) and 1 (full intensity).

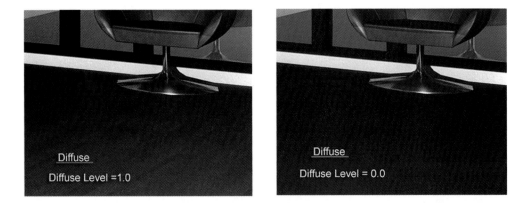

Diffuse Roughness: It is a parameter which bears some explanation. If you select the Templates list, and choose a Matte Finish you should note, the roughness changes to 0.2. Go to a Glossy Finish and the Roughness is back to 0.0.

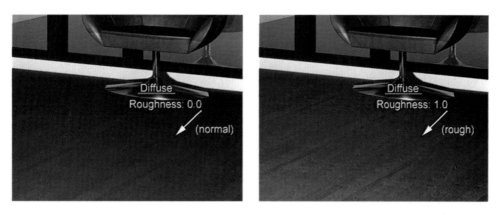

The next section of the Main material parameters to discuss is the Reflection area. There are several parameters which control the reflection on a material's surface.

Reflectivity: It is the amount of reflectivity or reflection when higher values produce more reflection.

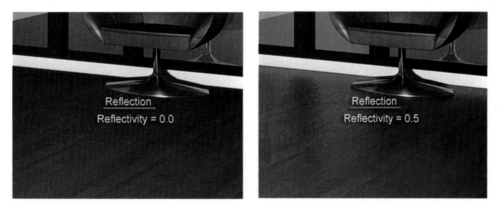

Reflection Glossiness: This is blurriness or sharpness of reflections. Low values will produce a blurry reflection, whereas a high value will produce a mirror like appearance.

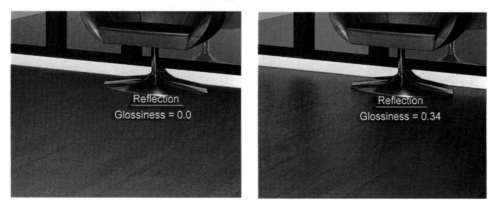

Reflection Color: The color of the reflection is generally kept as white.

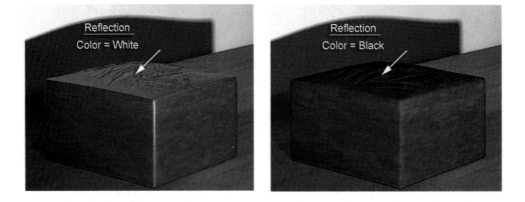

Glossy Samples: It defines the maximum number of samples (rays) which mental ray will shoot to create glossy reflections. Higher values produce a smoother result. Glossy samples value is available only when Glossiness is less than 1.

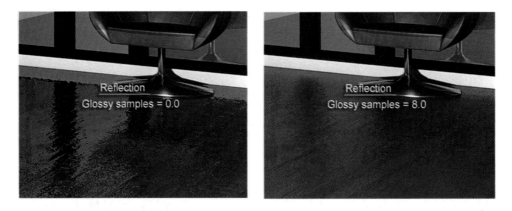

Highlights + FG Only:

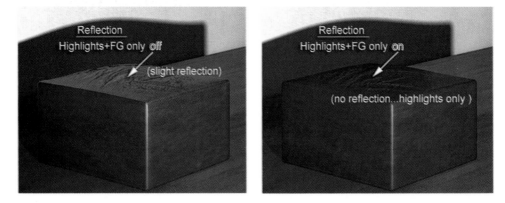

Metal Material: A metal object reflection's color is affected by the color of the metal object. Enabling this check-box turns on this feature. On a dark metal surface the reflections will remain dark.

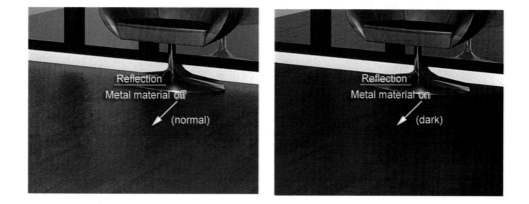

The next section of the Main material parameters to discuss is the Refraction area. There are several parameters which control the refraction of light through a surface.

Transparency: This defines the level of refraction; if a surface is completely transparent (=1.0) you can see right through it.

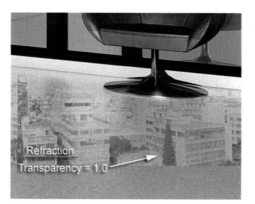

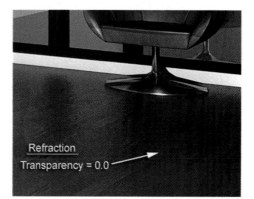

Refraction Glossiness: It defines the sharpness of the refraction. High values produce clear transparency, low values produce blurry or diffuse transparency.

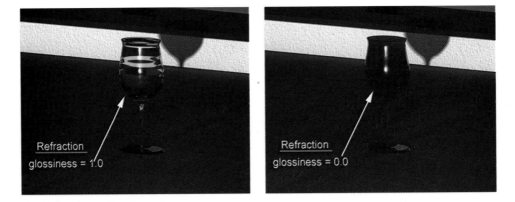

Refraction Color: It defines the color of the refraction. Refraction provides a quick way to create colored glass.

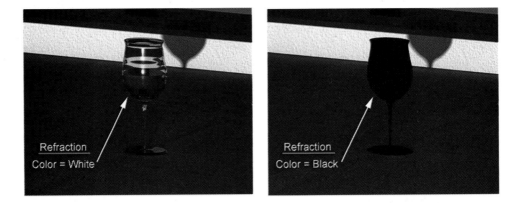

Refraction IOR: The Index of Refraction (IOR) is a measurement of how much light will bend when it enters or exits a material.

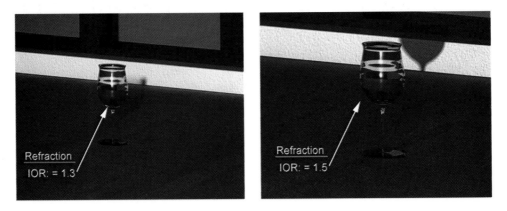

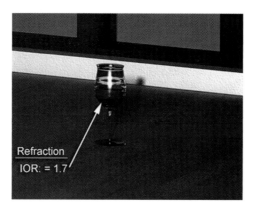

1.3.1 BRDF

The BRDF rollout controls a material's reflectivity based on the angle from which the surface is viewed. When using the Custom Reflectivity Function the value in the 0 degree reflectivity defines the intensity of reflections when the camera is looking directly at the reflective surface. If the value is 0 there will be no reflection. The 90 degree reflectivity value defines the reflection of surfaces which are at a 90 degree angle to the direction of the camera. The graph curve represents the transition from one reflectivity value to another.

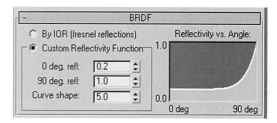

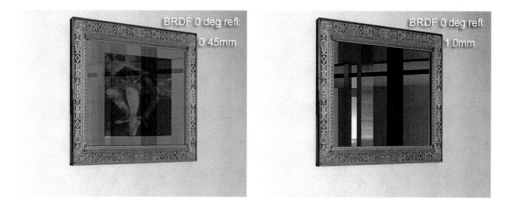

1.3.2 Advanced Rendering Options

A final series of parameters which will be discussed are found in the Advanced Rendering Options rollout. Although there are numerous parameters in this rollout there will only be a few which will be looked at.

Advanced Rendering Options

Reflections
- Max Distance — 0.0m
 - Fade to end color
- Max Trace Depth: 4
- Cutoff Threshold: 0.01

Refraction
- Max Distance — 0.0m
 - Color at Max Distance
- Max Trace Depth: 6
- Cutoff Threshold: 0.01

Advanced Reflectivity Options
- ☑ Visible area lights cause no Highlights
- ☑ Skip reflections on inside (except total internal reflection)

Advanced Transparency Options
Glass / Translucency treat objects as...
- ● Solid (requires two sides on every object)
- ○ Thin-walled (can use single faces)

When Caustics are enabled, transparent objects:
- ○ Refract light and generate Caustic effects
- ● Use Transparent Shadows
- ☐ Back Face Culling
- ☐ Transparency propagates Alpha channel

Indirect Illumination Options
- FG/GI multiplier: 1.0
- FG Quality: 1.0

Refraction Color at Max Distance: This group of parameters allows you to control the color of transparent glass according to distance.

The Max Distance checkbox must be enabled so that the Color at Max Distance feature is available. Once selected, you can choose a color for the transparent material.

Refraction
- ☑ Max Distance — 0.0m
 - ☑ Color at Max Distance
- Max Trace Depth: 6
- Cutoff Threshold: 0.01

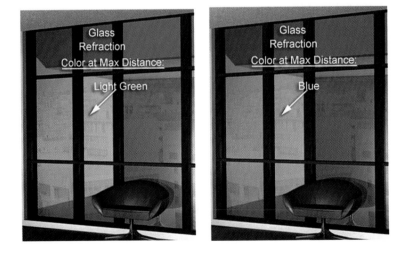

Indirect Illumination FG/GI Multiplier: This value allows you to control how strongly a material responds to indirect illumination.

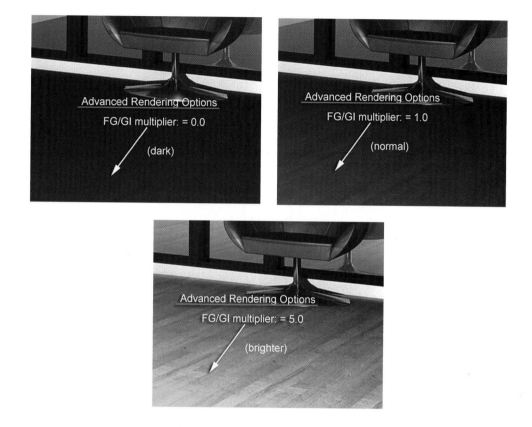

Indirect Illumination FG Quality: This is a multiplier to enhance Final Gather at the material level, thereby enhancing the rendering of certain objects.

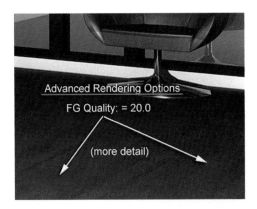

1.4 Working on the First Material

Whenever you create a material it is always a good idea to have a reference from which to observe when you recreate the material in the scene. In the next few steps you will recreate a cloth material for the living room scene and apply it to the cloth model draped over the sofa:

1. In the File Menu, select View Image File and open the image **Cloth_small.jpg** from the files directory.

Note in the photo the folds in the cloth and how they create an undulating shadow pattern. The material itself is rough, the cloth surface has a pattern of woven fibers producing this appearance:

2. Dismiss the View Image window.

3. Open the Material Editor and select an unassigned material slot.

4. Click on the Material/Map Browser button.

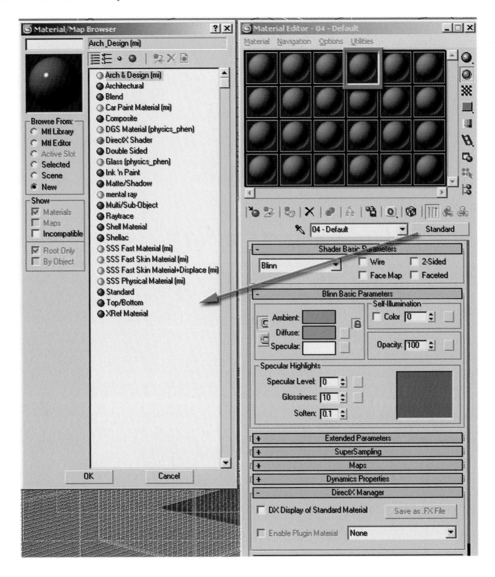

5. In the Material/Map Browser button select the Arch & Design shader and click OK.

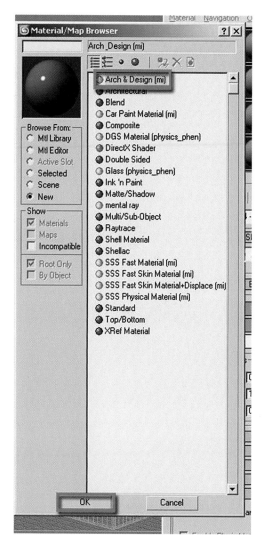

6. In the Templates rollout choose Matte Finish from the pull down list.

Note: A description of the properties of the material template appears to the left of the pull down list as you scroll down the list of templates. This will give you an idea of the settings and best use of an individual template:

7. Name the material, Cloth (Matte Finish) by typing it in the edit box to the left of the Material/Map browser button.

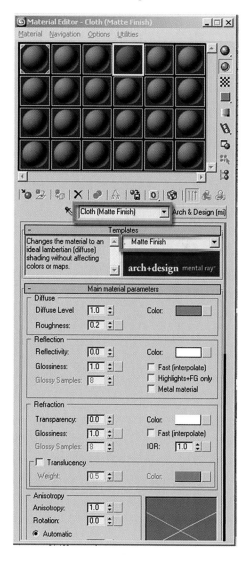

Note: It is always a good idea to name the material after the template which has been used to create it. In this case you used the Matte Finish template and also included it in its name. If you work on this file some time in the future you will know that the base settings were derived from the selected template. Once you continue working on the material the Matte Finish template is no longer displayed at the top of the list:

8. Click on the button next to the Color swatch in the Diffuse section of the Main material parameters.

9. In the Material/Map Browser dialog choose Bitmap and click OK to exit the dialog.

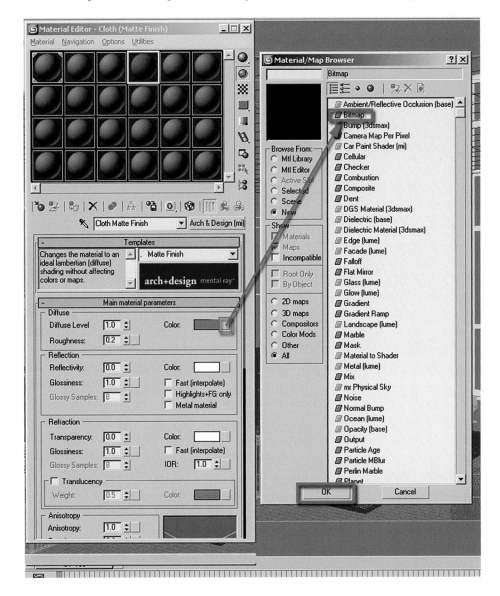

10. Choose *cloth.jpg* from the files folder and click Open to close the Select Bitmap Image File dialog box.

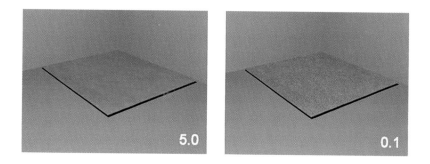

11. In the Material Editor, under the coordinates rollout, set the Blur value to 0.1.

Note: Lowering the Blur value sharpens the bitmap display in the material. In this case the number of pixels the material uses in the image is quite small, so sharpening of the bitmap is necessary in order to see the material clearly. The effect of a change in the Blur value can be seen more clearly at render time and is sometimes difficult to see in the sample spheres:

12. Click on the Go to Parent button.

13. At the root of the Arch & Design parameters scroll to the Special Purpose Maps rollout and open the rollout.
14. Click on the button labeled None on the right side of the Bump map.
15. Select Bitmap from the Materials/Map Browser.
16. Select the *cloth bump.jpg* from the files folder.

17. Note the difference adding a bump map to the material has on the sample sphere.

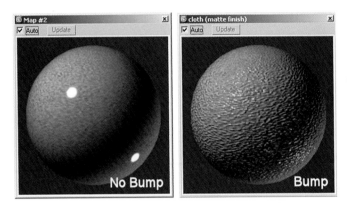

18. At the bitmap level of the material adjust the Blur value in the Coordinates rollout to 0.2.

19. Click the Go to Parent button to get back to the root parameters of the material.
20. Select the Cloth Main object in the scene.
21. Assign the Cloth (Matte Finish) material to it.

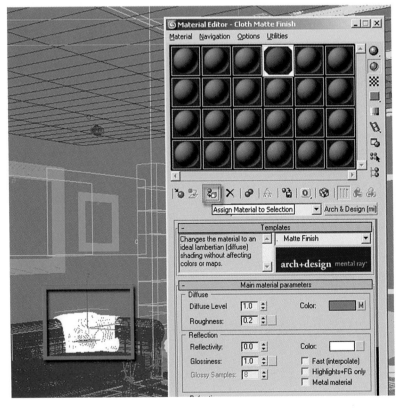

To see how this material will appear in some detail you will render a blowup of that area of the image where the cloth main is located:

22. Select Blowup from the pull down list adjacent to the left of the Quick Render button.

23. Click on Quick Render.
24. In the Camera01 viewport resize the dashed rectangle to include the sofa.
25. Click on the OK button which has appeared at the lower right of the Camera viewport.

3ds Max will render an enlarged view of this area of the viewport, so you can see some of the detail in the cloth material.

The cloth material looks good, but it could look better by increasing the bump map value:

26. In the Material Editor, go back to the Cloth Matte Finish material's main parameters and find the Special Purpose Maps rollout.
27. In the Value field in the bump map increase the value to 2.0.
28. Click the Quick Render button.
29. Click on the OK button at the lower right of the Camera01 viewport.

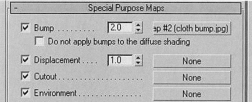

The cloth material now looks fluffier and softer.

1.5 Working on the Sofa Material

The next material to work on is the sofa. Here you will simulate leather for this object in the scene:

1. Continue working on the 3ds Max scene from the previous section or if you prefer open the file **LR materials cloth done.max**.
2. In the File Menu, select View Image File and open the image **leather sofa 01.jpg** from the files directory.

Note in the photo how the leather in the sofa is slightly creased and in addition creates dispersed specular highlights:

3. Dismiss the View Image window.
4. In the File Menu, select View Image File and open the image **leather sofa 02.jpg** from the files directory.

This image shows a leather couch with a different leather treatment. The leather itself appears more shiny and the leather surface is more creased and crinkled:

5. Dismiss the View Image window.
6. Open the Material Editor and choose an unassigned material slot.
7. Click on the Material/Map Browser button to change the Standard Material type to the Arch & Design material type.

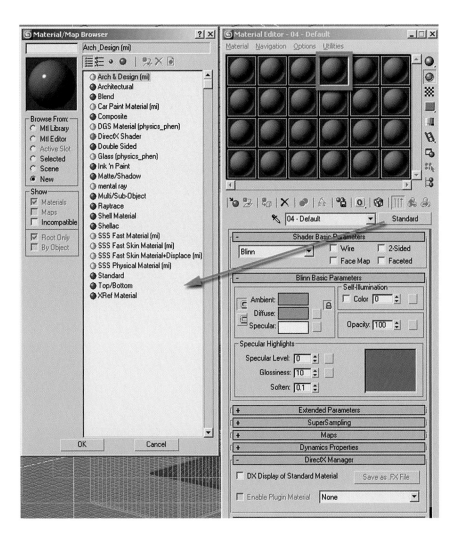

8. Click OK to exit the Material/Map Browser.

9. Choose the Pearl Finish template by selecting it from the Templates pull down list.
10. Name the material, sofa (Pearl Finish) by typing it in the edit field to the left of the Material/Map Browser button.

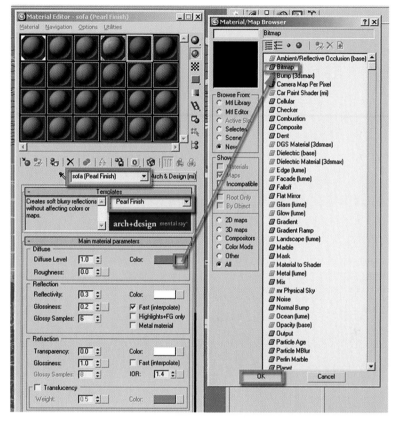

11. Click on the button next to the Color swatch in the Diffuse section of the Main material parameters.
12. In the Material/Map Browser dialog choose Bitmap and click OK to exit the dialog.
13. Choose the *leather material Ranch.jpg* and click Open to dismiss the Select Bitmap Image File dialog.
14. In the bitmap parameters, Coordinates rollout, change the Blur value to 0.2.

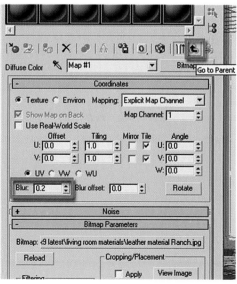

15. Click on the Go to Parent button.
16. Go to the Special Purpose Maps rollout at the root of the sofa (Pearl Finish) material.
17. Click on the button labeled None in the Bump map area.
18. Select Bitmap in the Material/Map Browser.
19. Select the file *7.jpg* from the file directory.
20. In the bitmap parameters, Coordinates rollout, change the Blur value to 0.2.
21. Click on the Go to Parent button.
22. In the camera viewport select the mesh, Back Sofa seat L.

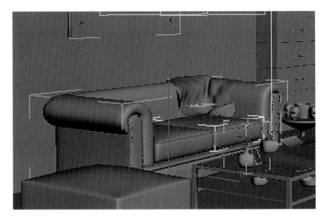

23. Assign the sofa (Pearl Finish) material to this object.
24. Render a blowup of the same area of the camera viewport as you did before.

Note how much longer it took to render with the materials applied to these two objects:

25. Increase the Bump value in the Special Purpose Maps rollout to 1.3.

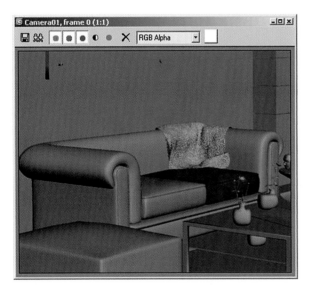

Next, you will change some of the Pearl Finish template settings to get a better leather look for the sofa:

26. In the Main material parameters rollout in the Reflection section uncheck the Fast (interpolate) option. This will provide you with more accurate glossiness calculations and appearance.
27. Change the Glossiness value to 0.3 to make the material slightly more glossy.

Note: If you wish to have lower glossiness check the highlights + FG only option:

28. Decrease the Reflectivity value to 0.2.

29. Open the Fast Glossy Interpolation rollout.
30. Change the Interpolation grid density to be 1 (same as rendering) by selecting it from the pull down list.

This is done to ensure that all bitmaps are accurately rendered:

31. Go to the BRDF parameters rollout.
32. In the Custom Reflectivity Function change the 0 deg. refl: value to 1.0.

Changing this value creates wider highlights and the material sample looks much more like the image of the sofa at the beginning of this section:

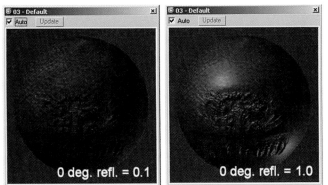

29

33. Render a blowup of the back sofa as you did before.

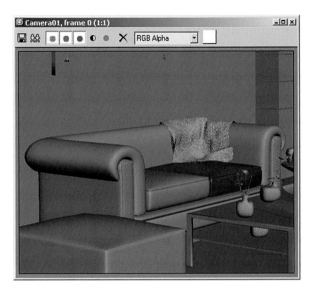

The sofa seat is starting to look leather like, but you can hardly see the bump and glossiness due to the fact that there are no lights in the scene yet. Once all the materials have been applied you will work with the materials and lights together. This will be the time to further tweak the bump and glossiness values. Even though you have to wait to see the quality of the final materials it is the fastest way of getting good results and minimizing test render times.

1.6 Working on the Floor Material

The next material to work on is the floor. Here you are trying to simulate a semi-polished wood for this object in the scene:

1. Continue working on the 3ds Max scene from the previous section or if you prefer open the file *LR materials sofa done.max*.
2. In the File Menu, select View Image File and open the image *Floor Image.jpg* from the files directory. Open the image *Floor Image 01.jpg* as well.

Note in the photos how the pattern and grain of the wood is only one of the distinctive elements of the material. The wood pictured here is fairly dull and does not have an enhanced reflective quality. You can only see a clear reflection in the image where the camera is near the floor. In this photo you can also see that the reflection of the sofa in the floor fades as the distance from the sofa and floor becomes greater. Lastly, note the specular highlights created by the light coming in through the windows. They create patches of reflective light which are mostly fuzzy around the edges. The specular reflection only enhances the appearance of the material:

3. Dismiss the View Image window.
4. Open the Material Editor and choose an unassigned material slot.
5. Change the Standard Material type to the Arch & Design material type.
6. Choose the Glossy Varnished Wood template by selecting it from the Templates pull down list.
7. Name the Material, floor (Glossy Varnished Wood) by typing it in the edit field to the left of the Material/Map Browser button.

8. In the Main material parameters rollout uncheck the Fast (interpolate) checkbox.

9. Set the Glossiness value to 0.34. This will blur the circular highlights in the material.

10. Set the Glossy Samples value to 8. This will make reflections in the material blurrier.

11. Click on the button to the right of the Diffuse Color swatch. The Bitmap parameters of an already assigned bitmap will pop up.

12. Change the tiling values to U: 30 and V: 7.

13. Adjust the Blur value to 0.1.

14. Go to the main parameters by selecting the Go to Parent button.

15. Go to the Special Purpose Maps rollout.

Note that there is already a bitmap in the bump map slot:

16. Click on the map slot to access the parameters of the map.

The map which is used in the Arch & Design glossy varnished wood is a mix map combining a noise and the same bitmap as the diffuse map:

17. Click on the map slot next to Color #2.

You will now be brought down another level in this material. Note here that the bitmap's tiling coordinates are the same as the adjusted coordinates you changed in the diffuse map. This is due to the fact that the maps were instanced when the template was created. This is standard behavior in the Arch & Design templates:

18. Go up one level by selecting the Go to Parent button.

You are going to make a major adjustment to the bump map in this material which will require replacing the entire mix map with a bitmap:

19. Click on the Material/Map Browser button which is currently labeled, Mix.

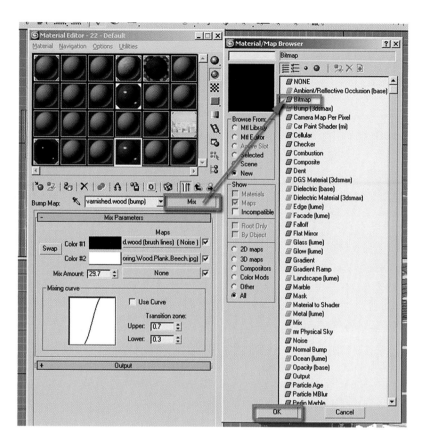

20. Select Bitmap from the Material/Map Browser.
21. Open the file *large oakglasgow life2 bump.bmp*.
22. Change the tiling values to U: 30 and V: 7.

23. Click on Go to Parent.
24. In the Special Purpose Maps rollout change the Bump value to 0.2.
25. In the BRDF rollout change the 0 deg. refl: value to 0.68.
26. Go to the Fast Glossy Interpolation rollout and verify that the Interpolation grid density is set to 1 (same as rendering).

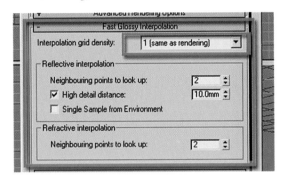

Note: In the Arch & Design material you can hover the cursor over a parameter and a tool tip like box will appear. The tool tip will display additional information on the parameter where appropriate.

Sometimes this tool tip will display when you point to different areas of the control:

27. Select the Main Floor object in the scene, and apply the floor (glossy varnished wood) material to it.
28. Render a blowup of your camera view, but expand the rectangular area to be rendered slightly to see more of the floor area in the rendering.

Once again, the final quality of this material will not be apparent until we bring the scene into a lit environment.

1.7 Working on the Glass Material

The next material to work on is the glass material for the picture frames. Here you are trying to simulate transparent glass for this object in the scene:

1. Continue working on the 3ds Max scene from the previous section or if you prefer open the file **LR materials floor done.max**.
2. In the File Menu, select View Image File and open the image **glass Image.jpg** from the files directory.

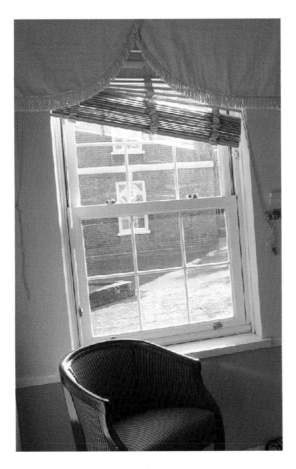

Glass is an interesting material and one which may require some tweaking depending on your lighting conditions. In the photo reference you are looking from inside to outside, where there is a considerable difference in the intensity of light outside. Under these conditions the glass is very transparent and little or no reflection of the interior exists. Under night-time conditions the light conditions are reversed, the interior is generally illuminated and there is little or no light outside. Under these conditions the glass will reflect the interior environment and make it very difficult to see outdoors:

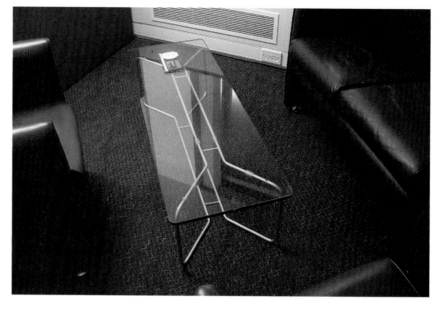

3. Dismiss the View Image window.
4. In the File Menu, select View Image File and open the image *glass Image 01.jpg* from the files directory.

In this photo reference several attributes of the glass produce an enhanced reflection. The darker background of the carpet and the sharper angle of the camera to the surface of the glass contribute to the increased reflective quality:

5. Dismiss the View Image window.
6. Open the Material Editor and choose an unassigned material slot.
7. Change the Standard Material type to the Arch & Design material type.
8. Choose the glass (physical) template by selecting it from the Templates pull down list.
9. Name the glass (physical) by typing it in the edit field to the left of the Material/Map Browser button.
10. Go to the BRDF rollout and verify that the By IOR (fresnel reflections) is currently enabled.

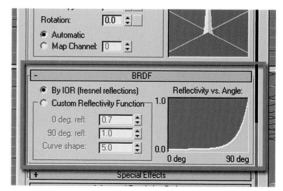

11. Select the glass mesh object in the scene which is part of the rectangle picture frame group.
12. Assign the glass (physical) material to it.
13. Render a blowup of the area including the picture frame above the rear sofa.

Although there is some change to the appearance of the glass there is some improvement to be made here. The IOR fresnel reflection is a good option and often works for most scenes. In this case due to the current camera

angle, the reflections are not very apparent. This might be accurate, but if you desire better control of the reflections you need to change the BRDF settings to a Custom Reflectivity Function:

14. Select the Custom Reflectivity Function option.
15. Change the 0 deg. refl: value to 0.45.
16. Render a blowup of the same area to see the difference.

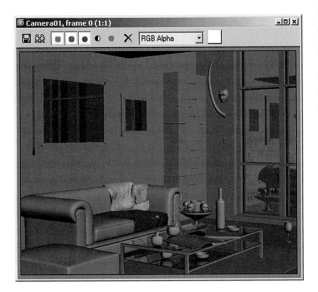

You can see the reflections of the curtain wall frame in the picture frame glass more clearly now. You can experiment with different values of the 0 degree reflection and see the results you get.

Another attribute of the glass material you should note is the slightly bluish color. This is due to the Color at Max Distance setting.

17. In the Advanced Rendering Options rollout, click on the Color swatch next to the Color at Max Distance.
18. Change the Color to a very pale green, use the RBG values of R: 0.88, G: 0.9, B: 0.89 if you like.

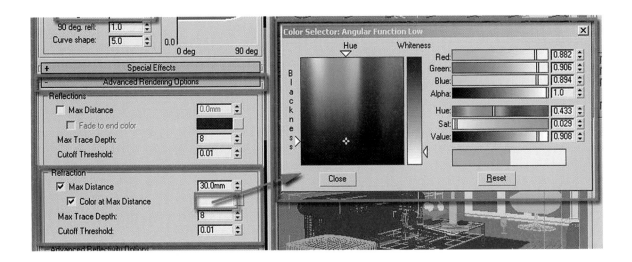

19. In the Advanced Transparency Options area of the Advanced Rendering Options rollout, click on the Use Transparent Shadows option.

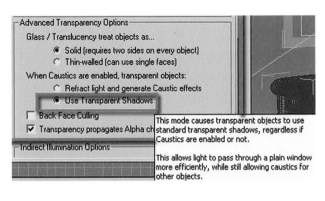

As noted in the tool tip this option is to allow light to pass through a plain window and use standard transparent shadows. Caustics can cause a large amount of calculations to occur, slowing down rendering time. This option allows you to control if these calculations will occur for each transparent material you create:

20. In the Fast Glossy Interpolation rollout change the Interpolation grid density to 1 (same as rendering).

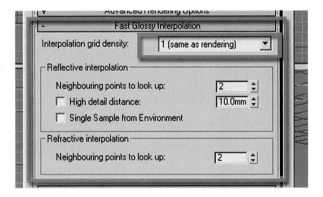

21. Apply this glass material to the following objects, some of which are contained in the groups indicated in brackets []:

- Window glass
- Table glass [table glass]
- Table glass01 [table glass]
- Glass [picture frame R]
- Glass [picture frame L]

22. Render the blowup of the scene.

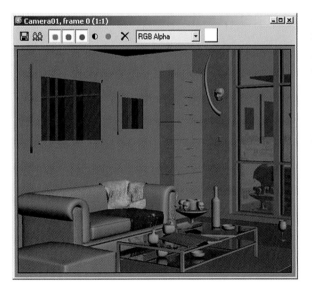

Note the amount of reflections which are occurring in the scene. The slight bluish tint of the window glass is due to the background which is beginning to show through. It may not be necessary to use the custom reflectivity function in all occurrences of glass in this scene. You could experiment with some of the glass objects using the Custom Reflectivity functions in the BRDF rollout.

1.8 Working on the Metal Material

The next material to work on is the metal mate-
rial for the base of the chair near the window.
Here you are trying to simulate a brushed metal
for this object in the scene:

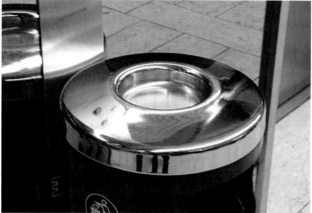

1. Continue working on the 3ds Max
 scene from the previous section or if you
 prefer open the file **LR materials glass
 done.max**.
2. In the File Menu, select View Image File
 and open the image **Metal Image.jpg** from
 the files directory.

Note in the photo reference the highly reflective
nature of the metal surface. The surface reflects the
surrounding environment and has a highly polished
surface which creates sharp and intense specular
highlights:

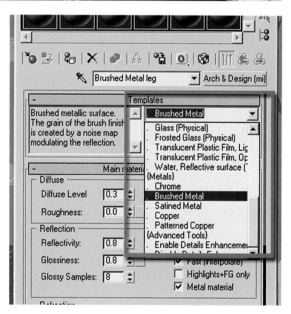

3. Dismiss the View Image window.
4. Open the Material Editor and choose an unas-
 signed material slot.
5. Change the Standard Material type to the Arch
 & Design material type.
6. Choose the Brushed Metal template by selecting
 it from the Templates pull down list.
7. Name the Material, chair leg (brushed metal).
8. In the Main material parameters, uncheck the
 Fast (interpolate) option.

9. In the Fast Glossy Interpolation rollout change the Interpolation grid density to 1 (same as rendering).

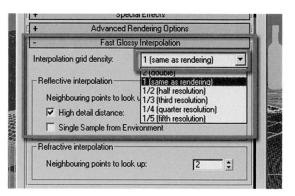

The next thing you are going to do with this material is look at its Ambient Occlusion values. This template has Ambient Occlusion turned off. Ambient Occlusion (sometimes simply referred to as AO) is the effect of shadows appearing in crevices of objects. Note in the following illustration the darker shadows in the crevices of the sofa and diffuse shadow which appears at the corner of the wall.

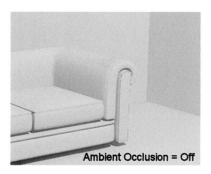

Ambient Occlusion = Off

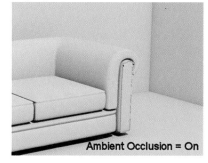

Ambient Occlusion = On

There are two ways to enable Ambient Occlusion:

10. The simplest way of enabling Ambient Occlusion is through the Templates pull down list.
11. Select Enable Details Enhancements at the bottom of the Templates list.

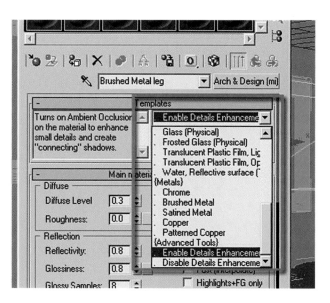

Note that there is a Disable Details Enhancements option in the list as well. Enabling Details Enhancements turns on Ambient Occlusion with some preset values:

12. Open the Special Effects rollout.
13. If Ambient Occlusion is not enabled, click in the box to turn it on.
14. Change the samples to 8. The higher the number of samples, the better results you will get with the Ambient Occlusion shadows.
15. Adjust the Max Distance to approximately 100. This distance refers to the maximum distance which should be used in looking for objects which will create occluded shadows. A smaller number will reduce the effect on large areas. Large numbers can adversely affect render times.

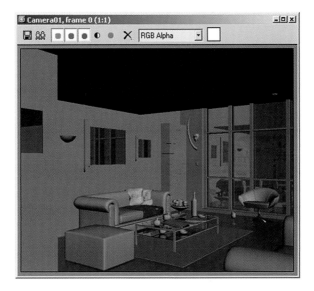

16. Assign this material to the Leg object in the Contemporary Chair group.
17. Render the entire camera view to see your progress so far.

1.9 Conclusion

In this chapter you saw how to begin the creation of a mental ray rendered image by beginning with material application. You studied extensively parameters in the Arch & Design material which is designed to be used with the mental ray renderer. Several important parameters were demonstrated and illustrated. Finally, you applied this theory in several examples for materials like wood, metal, leather, cloth and glass.

Chapter 2

Day Lighting for an Interior Space

2.1 Introduction

In this chapter you will learn about lighting an interior scene while you work on the lighting for the living room interior. Specifically you will learn:

- An efficient workflow for working on a scene's illumination once materials have been applied to the entire scene.
- The use of Final Gather to generate indirect illumination.
- The use of Global Illumination (GI) to further enhance the indirect illumination.
- To use color bleeding to enhance an image's quality.
- Placing and modifying mental ray lights for sunlight and skylight.
- To adjust exposure controls to enhance the output of your final image.
- To set controls for the final render and avoid time-consuming test renders.

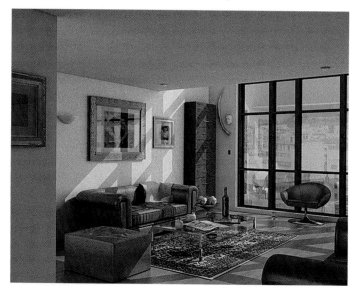

2.2 Interior Lighting Concepts with mental ray

When a scene is rendered without indirect illumination, it is only light rays which strike the surfaces directly which affect its illumination. In scanline rendering you could use fill lights to simulate indirect lights or go to an advanced lighting solution like radiosity to obtain more realistic results. In mental ray you will use indirect lighting controls to provide your images with realistic illumination.

Whenever you work on an interior scene there will be a number of potential adjustments you can make to the way mental ray calculates light distribution in a 3D scene which will make the scene look more realistic. Initially, without lights and the controls provided by mental ray, an image will look flat and lifeless. Using these controls will provide you with a more realistic image, but it will take longer for 3ds Max and mental ray to generate a final image.

The controls you will use in mental ray will fall under two areas of indirect lighting: Final Gather and Global Illumination. As you work with values in indirect GI you will clearly see the trade-off between rendering speed and quality. One of the skills which will be demonstrated in this chapter is how to make your work as efficient as possible, creating and adjusting your lighting with a minimum amount of time expended. You will start with the interior living room scene with all of the materials applied and work on the lights. It should be noted, that even though the implied workflow is to work first on materials then lights, as is suggested by the chapter order in this book, it is entirely possible and efficient to work on lights first and then on the materials. In fact, it is hard to imagine a project where you would not have to go back and forth working on lights and materials.

As a reference the living room scene has been rendered with a sample light behind the camera and with no indirect illumination.

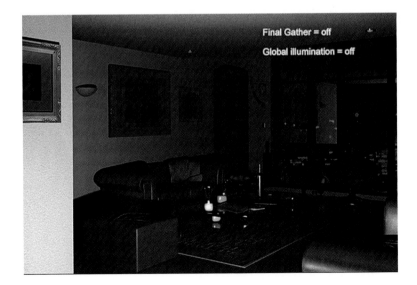

Final Gather is usually the first step in using indirect illumination in mental ray. When you turn on Final Gather you will begin to see indirect illumination in areas previously only in dark shadows.

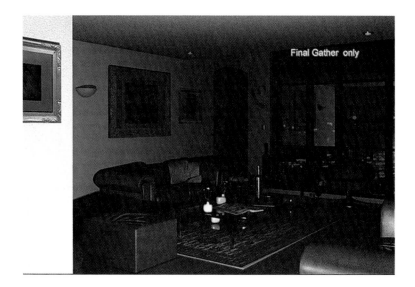

GI is used in mental ray to contribute to the overall bounce of light. GI will provide more color appeal to an image as light will pickup colors from reflected surfaces. It is not necessary to use GI, but it adds the extra quality that will turn a nice image into a very nice one.

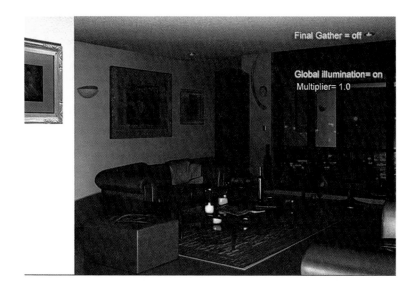

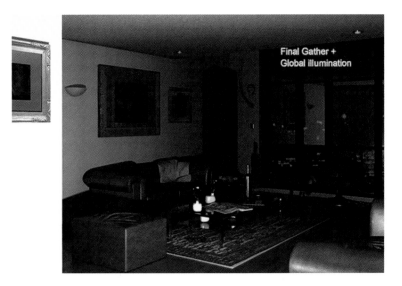

2.3 Parameters in Final Gather

There are numerous parameters in Final Gather and GI which control the quality of the indirect illumination in a scene.

Preset: This list sets the accuracy of which mental ray will interpret the basic parameters values of Final Gather. It will ultimately determine the rendering time (draft = fast; high = slow). It is a good quick tool for novices and experienced users to set Final Gather parameters at preset levels.

2.3.1 Basic Group

Enable Final Gather: This checkbox must be turned on to enable all the basic parameters values.

Multiplier: Sets the amount of brightness in the scene by multiplying the indirect light and its color stored on the final gathering solution. Default value is 1.0.

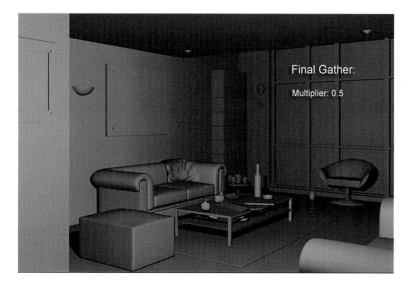

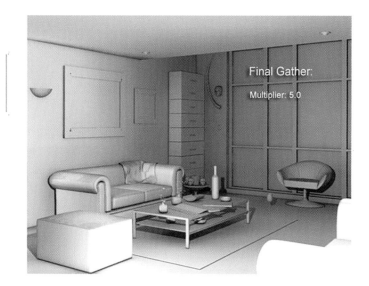

Initial FG point density: This value reduces the amount of noise (grain) generated by the Final Gather points. High values will dramatically increase the rendering time. Default value is 1.0.

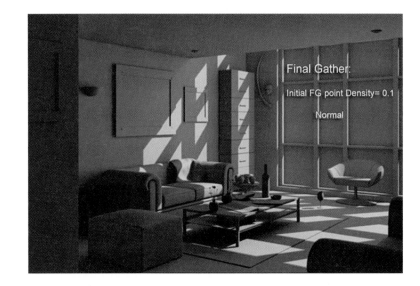

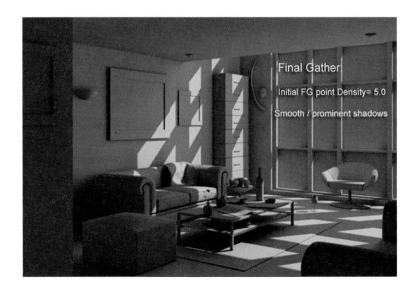

Rays per FG point: Sets the number of rays used to compute indirect illumination. High values will increase the rendering time. Default value is 250.

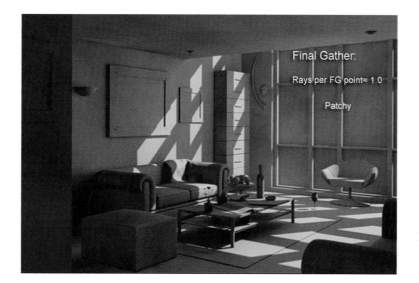

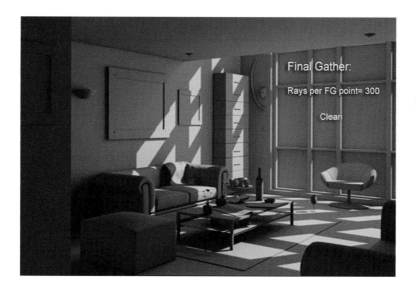

Interpolate over number of FG points: This adds (by interpolating) more FG points over the rays per FG point (this interpolation will result in a smooth transition between dark and light areas such as corners, etc.). Note that high values will increase the rendering time. Default value is 27.

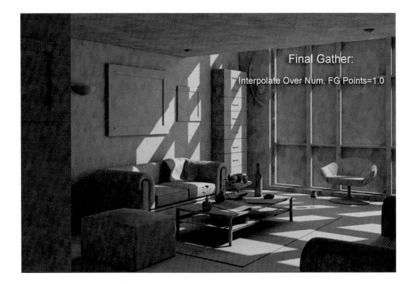

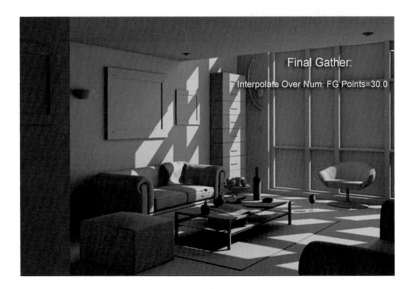

Diffuse bounces: Sets the amount of diffuse color reflected from one surface to other nearby surfaces. Default value is 0.

Weight: It invigorates the "diffuse bounces" visibility. Default value is 1.0.

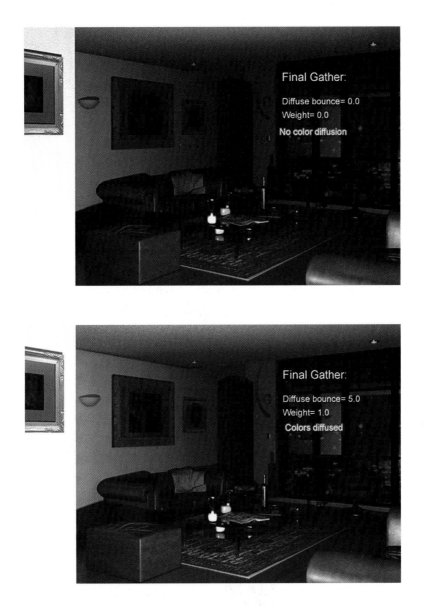

2.3.2 Final Gather Map Group

Read/write file: When on, it reads or writes the file specified on the browse slot underneath it.

Every time a change occurs in the scene (lights/objects moved or replaced), the saved Final Gather Map file will be rewritten automatically. When running out of memory while computing the Final Gather process of a high-resolution image (300 dots per inch, etc.), the best way to overcome that is to save the Final Gather Map into a small resolution image such as 320 × 240 pixels and reuse it on your final high-resolution image.

Note that the Final Gather Map file is designed to be used only for static images/animations (i.e. no changes in the scene apart from the camera moving).

(…) *Browse*: This slot allows you to click and choose a location to save your Final Gather Map file.

Read only (FG freeze): This option is grayed out by default, it only becomes available once a Final Gather Map file is saved in the browse slot. When on, it enables the user to freeze the already saved Final Gather Map file (prevents resaving the FG map file again).

2.4 Parameters in Global Illumination

The following are the main parameters of Global Illumination:

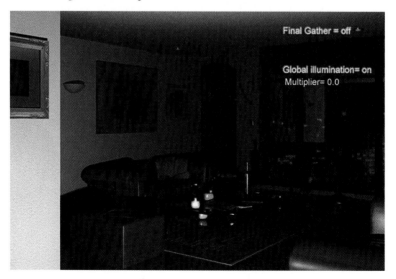

Enable: When on, it calculates Global Illumination. Default = off.

Multiplier: This value sets the brightness of the photons. Default = 1.0.

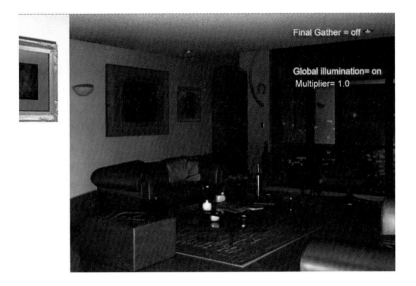

Maximum number of photons per sample: Sets the number of photons to be used when processing the intensity of the Global Illumination. Increasing its values reduces the noise; however, it blurs the image. Higher values will increase the rendering time. Default = 100.

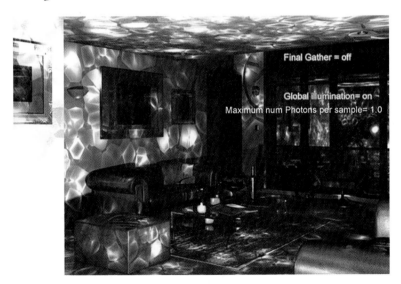

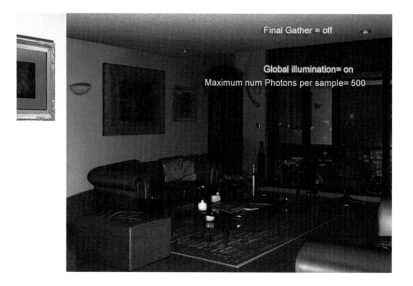

Maximum sampling radius: When the checkbox is on, it sets the size of photons. Default: checkbox = off; value = 1.0.

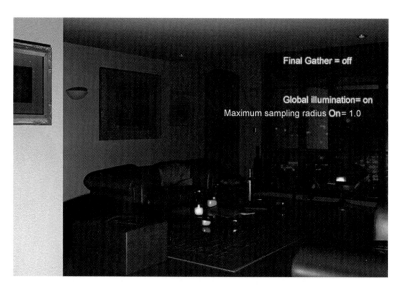

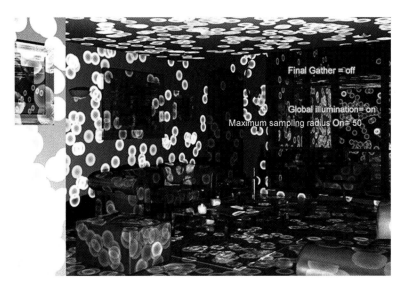

Merge nearby photons (saves memory): When checked, it prevents the mental ray render from releasing more photons by merging the nearby ones (no need to use high "maximum number of photons per sample" values), subsequently saving the memory usage.

Optimize for Final Gather (slower GI): When this checkbox is on, it works in conjunction with the Final Gather settings by optimizing its samples; however, it may increase the GI calculation.

2.5 Starting the Scene

Before beginning on a new 3ds Max scene its imperative that you ensure that the units are properly setup in your scene. Otherwise you will later encounter a number of undesirable results.

1. Start or Reset 3ds Max.
2. From the Customize pull down menu select Units Setup …

3. In the Units Setup dialog, in the Display Unit Scale, set the scale to Metric Millimetres.

4. In the Unit Setup dialog click on the System Unit Setup button.

5. In the System Unit Setup dialog set the System Unit Scale to Millimetres.
6. Click OK to exit both dialog boxes.

Note: It is important that the units setup and system unit setup are the same.

To get started you are going to open a version of the living room scene where all of the materials have been applied but where only default lighting is being used.

7. Open the file ***LR Light start.max*** from the files folder.

The units of 3ds Max have been carefully set in advance to match the units of the incoming file, both are in Metric Millimetres. It is often the case that a file being opened does not match the system units if it is in 3ds Max. In this case, the File Load: units mismatch dialog box will alert you to the discrepancy. You should always adopt the file units in order to avoid problems with units later in the development of the scene.

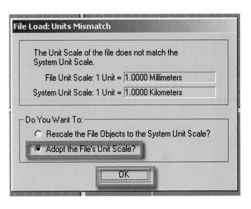

8. Once the scene is loaded, open the Render Scene dialog by clicking on the Render Scene Dialog button on the Main Toolbar.
9. In the Render Scene Dialog, click on the Common Tab.

Note: the image size values, worked well for this scene but you could enter different image sizes if desired.

10. Make sure the Camera01 view is selected, click on the Lock button next to the Viewport list at the bottom of the dialog. This will lock the Camera01 view to be rendered until it is unlocked.

2.6 Establishing Basic Lighting Parameters

Before creating lights in the scene you will establish some parameters for how mental ray works with these lights.

1. If it is not already displayed, open the Render Scene dialog by clicking the icon on the Main toolbar.
2. Select the Indirect Illumination tab.

Note that the parameters for Final Gather are grayed out. This is simply due to the fact that it has not been enabled yet.

3. Click on the Enable Final Gather checkbox.
4. Make sure in the advanced group that Draft Mode (No Precalculations) is not selected.
5. Click on the Quick Render button on the Main toolbar.

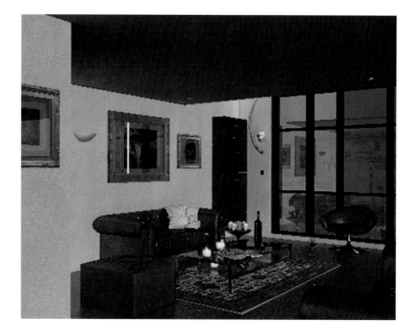

Although the render is reasonably quick, it took 2 minutes and 17 seconds to render on a selected system. The rendering time can be further reduced so that you can continue to do test renders efficiently.

6. In the Final Gather rollout, select Draft from the Preset pull down list. Note the changes in the Basic parameters.

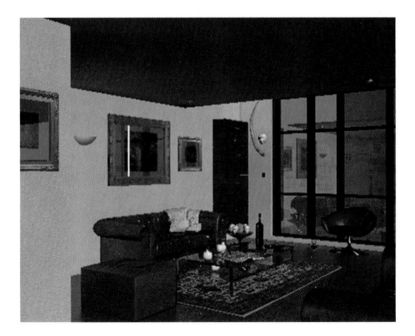

7. Click on the Quick Render button again to render the Camera01 view.

When Final Gather is set to Draft the render time is reduced to 35 seconds. Even though there has been a dramatic change in the rendering time, a considerable amount of time is being used in creating and generating the materials in the image. To make the process of illuminating the scene most efficient you will replace the scene materials at render time with a neutral gray material.

8. In the Render Scene dialog, Processing tab, check the Enable checkbox in the Material Override area in the Translator Options rollout.
9. Open the Material Editor and choose the material called ambient occlusion in the first column and third row.
10. Drag and drop the material into the material override slot. Select Instance in the Instance (copy) material dialog.

11. Render the Camera view.

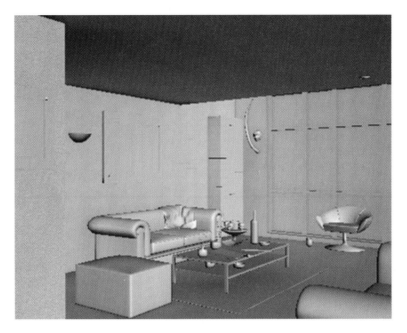

The material override feature has reduced the render time to 22 seconds. You have used a fairly simple material with ambient occlusion, which generates connecting shadows whenever one surface meets another. This material will allow you to focus on the lighting and render quickly and efficiently, you are temporarily removing any time-consuming calculations generated by the materials. When you wish to see the materials in the scene you simply remove the override.

2.7 Adding Lights

The next step in this scene is to add lights to create some depth in the image. In this scene you will emulate sunlight shining through the glass in the living room.

The photo of light coming in through a window is a good photo reference for this exercise. Note how the natural light coming through the window is affecting the surfaces around the space. For instance, notice the bright areas created by the contrast of direct light and the darker areas of the scene are catching hues of blue created by the sky's atmosphere. Objects with neutral colors are catching colors generated by other surfaces with more predominant colors.

First you will mimic the sunlight coming in through the window using an mr Area Spot light.

1. Open the file **LR Direct Start.max** or continue working on the file in the previous section.
2. Click on the Maximize Viewport toggle to switch to a 4-viewport configuration.
3. From the Create Tab in the Command Panel, select the Lights button and click on the mr Area Spot button.
4. Click and drag the light in the top viewport as shown, starting from the upper right to a point roughly to the left of the center of the living room geometry.

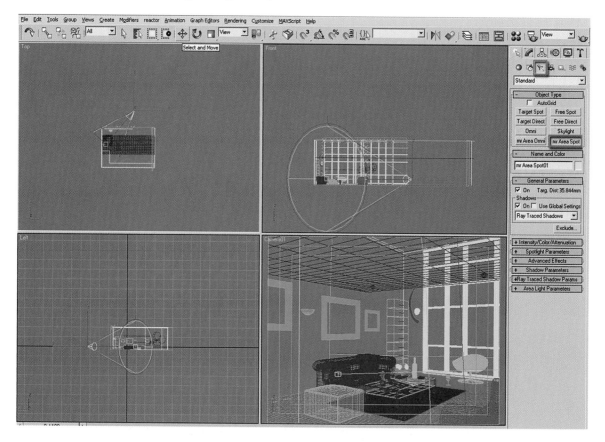

5. In the left view select the light object and move it vertically to the approximate position indicated. Alternatively you can use the move Transform Type-in dialog and position the light to approximately X: 13000 Y:19000 Z:15000 in absolute world coordinates.

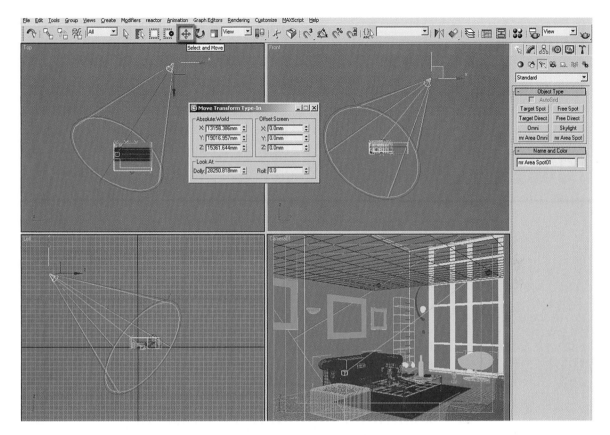

6. Render the scene by clicking on the icon in the Main toolbar.

7. The scene is entirely black. This is due to the fact that the light is not being allowed to enter through the window geometry.

8. In the Select Objects dialog box, select the object called window glass. Then click on the Select button.

9. Right click on the window glass object in the camera viewport and select Object Properties from the menu which appears.

10. In the Object Properties dialog in the General tab, remove the checkbox for the Cast Shadows parameter in the Rendering Control area.

11. Click OK to exit the dialog.
12. Render the camera view again.

The light coming through the windows is evident, but the image is still quite dark. To improve the image you will turn on Global Illumination.

13. In the Indirect Illumination tab of the Render dialog check the Enable checkbox in the GI area of the Caustics and GI rollout.

14. Render the camera view.

The scene is still quite dark; in order to generate a noticeable change in the scene you will create an omni light to emulate the scattered rays from the sun.

2.8 Adding an Omni Light to Simulate Scattered Light

On a normal day the sun emits an enormous number of rays of light. As they pass through the atmosphere they are then split into two types: direct rays and scattered rays. The direct rays give you direct shadows and highlights. These rays are stronger and provide more distinct shadows since these rays managed to pass through thinner layers of clouds or no clouds at all.

Scattered rays provide you with feathered shadows and no highlights. This is due to the fact that the sunrays which pass through thicker layers of clouds are scattered by them, so by the time the rays reach the earth they are in the form of a feathered shadow. In addition, because they are scattered by the clouds they will carry fragments of the cloud's color which is typically blue/gray. This is why there are no direct shadows/highlights in a cloudy day only feathered shadows.

3ds Max emulates the phenomenon of a sunny day with scattered light with the daylight system object which consists of the sunlight (for direct shadows/highlights) and the skylight (feathered shadows/no highlights). In addition a separate light system used to emulate a cloudy day only (feathered shadows/no highlights) is in the Skylight object.

If you were to use the daylight system in this exercise the back area of the sitting room would have been completely dark (which is probably accurate), however at times one has to use one's artistic license to achieve what is appealing to the eye without detracting from the realism of the image.

1. Open the file *LR Omni Start.max* or continue working on your current scene.
2. In the Command Panel, create tab, select the Lights icon and select the mr Area Omni button.

3. Drag and drop the light in the Top viewport near to the window.

4. Move the light close to the window by using the Select and Move tool. If necessary right click on the Select and Move button and enter values for the world coordinates roughly equal to X:1000 Y:2000 Z:600.

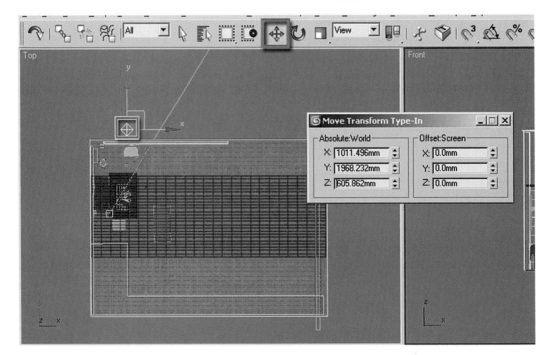

Positioning the light closer to the window will provide for better Global Illumination.

5. Render the Camera01 view.

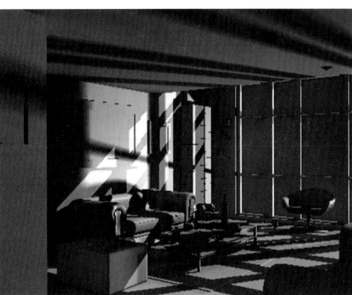

The scene is much brighter now; however, the light is not reaching areas far from the window. That is probably accurate, but somehow it feels that the scene should be much brighter. In addition, the light emanating from the Omni is generating very strong shadows. This light should be simulating scattered light which comes from many directions and therefore would produce feathered shadows. In the next few steps you will brighten the scattered light and feather the shadows.

6. Make sure the light mr Area Omni01 is still selected.
7. Go to the Modify Tab.
8. In the General Parameters rollout make sure the shadows are enabled and are set to Ray Traced shadows.
9. In the Intensity/Color/Attenuation rollout change the Multiplier to 3.0.
10. Click on the Color swatch next to the Multiplier and change the color to a light blue. This is to emulate the color of the scattered light.

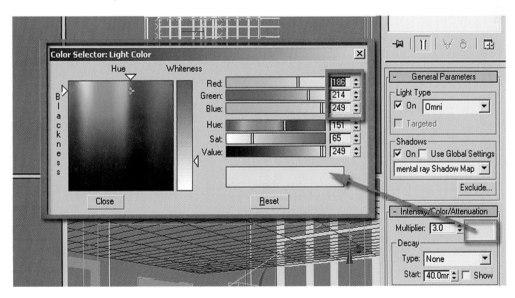

11. In the Area Light Parameters rollout change the Radius value to 1400.

 Changing the Radius value has the effect of enlarging the sphere from where light emanates, this will produce feathery shadows.

12. In the mental ray Indirect Illumination rollout, remove the check in Automatically Calculate Energy and Photons.

13. Enable Manual Settings.

14. Render the Camera01 view for a quick test.

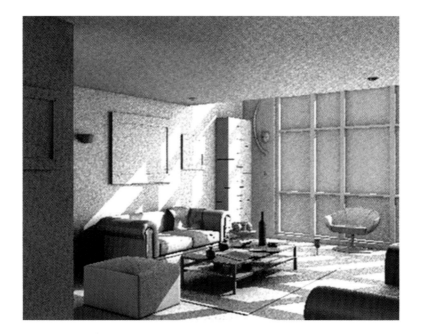

The image is looking much better now. To quickly check how the lighting is working with the materials you will turn off the materials override.

15. In the Render Dialog box, Processing tab remove the check in the Enable checkbox in the Material Override area of the Translator Options rollout.

16. Render the Camera01 view again.

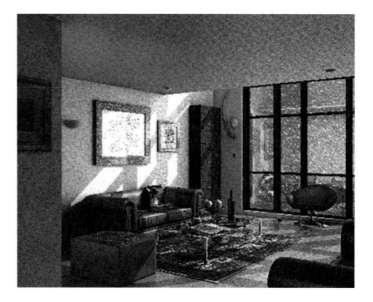

The image is looking good; however, the highlighted artifacts around the window glass are quite noticeable. That is due to the Omni's specular highlights affecting the window glass directly. In order to rectify this you will remove this light's effect on specular highlights.

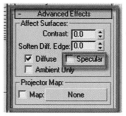

17. Select the mr Area Omni01 light and go to the Modify tab of the Command Panel.
18. In the Advanced Effects rollout, uncheck the Specular checkbox.
19. Render to see the changes.

As a last step you will copy the color of the light's multiplier to the light's energy.

20. In the Intensity/Color/Attenuation rollout right click on the color swatch next to the Multiplier value.
21. Select Copy.

22. Scroll down to the mental ray Indirect Illumination rollout.
23. Right click on the color swatch above the Energy value.
24. Select Paste.

2.9 Modifying the Spot Light

Next you will change the settings of the mr Area Spot light which represents sunlight.

1. Select the mr Area Spot01 light and go to the Modify tab of the Command Panel.
2. In the Intensity/Color/Attenuation rollout click on the color swatch next to the Multiplier value.
3. Select a pale yellow color or enter RGB values as depicted in the image.

4. Copy the Multiplier color by right clicking on the color swatch and selecting copy from the menu which appears.

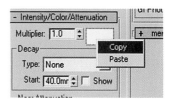

5. In the mental ray Indirect Illumination rollout change the settings to Manual.
6. Paste the pale yellow color into the energy color swatch by right clicking on the swatch and selecting paste.

7. Render the Camera01 view.

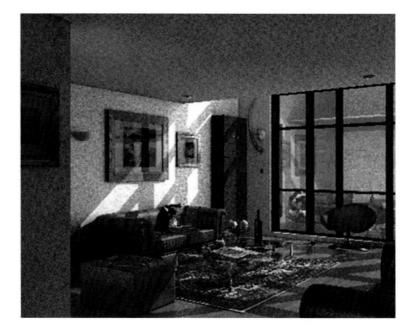

2.10 Making Changes to Materials Due to Light Effects

There are some bitmap/shader problems which are only visible when interacting with lights. For example, in the living room image which you are working on, you will note some small black patches in the cloth. This is due to the complexity of the surface.

In the next few steps you will change a parameter to make the cloth render without the black patches. In order to work on smaller areas of the scene without blowing up the area to a full-sized render, you can use the crop tool in the Render type pull down list.

1. Open the file **LR Light Done.max** or continue working on your file from the previous lesson.
2. Maximize the Camera01 viewport by selecting the Maximize Viewport Toggle.

3. Select Crop from the Render Type pull down list.

4. Click on the Quick Render button. A dashed rectangle appears with handles in the viewport, along with an OK button at the lower right of the viewport.

5. Resize the rectangle so that it is somewhat larger than the size of the cloth.
6. Click on the OK button at the lower left of the viewport.

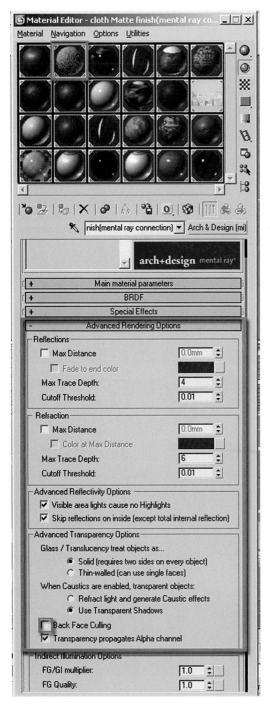

Rendering the image in this fashion took approximately 1/3rd of the time to render the entire image. When working on individual areas of the image this is a good time saver.

The next step is to fix the cloth material.

7. Open the Material Editor and select the Material along the first row, second column. This material is named cloth Matte finish (mental ray connection).
8. In the Advanced Rendering Options rollout, Advanced Transparency Options area, uncheck the Back Face Culling option.
9. Render the cropped area again to see the improvement.

2.11 Exposure Control

When you render your scene in 3ds Max you can improve the image using Exposure Control tools. The following are the principal exposure control tools found in the Environment tab of the Environment and Effects dialog. You can access this dialog by selecting Environment from the Render Menu.

In the Environment Tab of the dialog there are two roll-outs which deal with exposure control.

In most cases the type of exposure control selected will be the default value of Logarithmic Exposure Control. For information on the other exposure control types available in the pull down list in the Exposure Control rollout refer to the 3ds Max User Reference.

Once the Exposure Control type is set, the second rollout will change to display the parameters which are appropriate to the exposure control selected. In this case a Logarithmic Exposure Control Parameters rollout appears with the following controls:

Brightness: Sets the brightness of converted colors. Default = 65.

Contrast: Sets the contrast of converted colors. Default = 50.

Mid-tones: Sets the mid-tone values of converted colors. Default = 1.0.

Physical scale: Sets the physical scale of the exposure control when using lights that are not physically correct. This will result in a render that resembles an eye's perception of the scene. Default = 1500.0.

Color Correction checkbox and color swatch: When on, color correction changes all colors, so the color displayed appears as white. This method is used to remove the color projected from a light source. Default = off. Clicking the color swatch displays a Color Selector, so you can choose the color to use.

Desaturate low levels: When on, it renders colors that are dimly lit in tones of gray, as in real life, the eye does not perceive colors in dim lighting. Default = off.

Affect Indirect Only: When on, the logarithmic Exposure control is used solely for areas where indirect lighting occurs. Default = off.

Exterior daylight: When on, it converts the colors of an exterior scene. Default = off.

This checkbox is commonly used for adjusting the lighting in exterior scenes as it compensates for the extreme intensity of an IES sunlight object.

2.12 Adjusting the Exposure of the Living Room Scene

In the next few steps you will adjust the lighting in the living room to produce a better-lit scene.

1. Open the file **LR Exposure Control.max** or continue working on your current file.
2. Render the Camera01 view in its entirety.

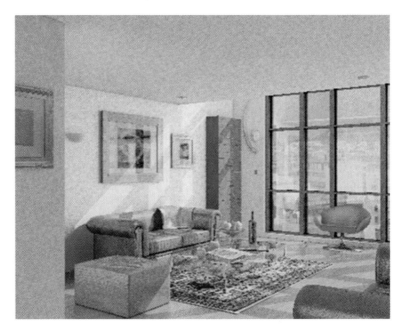

The rendering is looking pretty good but you can improve it using exposure controls.

3. Select Environment from the Render pull down menu.
4. Change the Brightness to 50.0 in the Logarithmic Exposure Control Parameters rollout.
5. Render again to see the difference in the image.

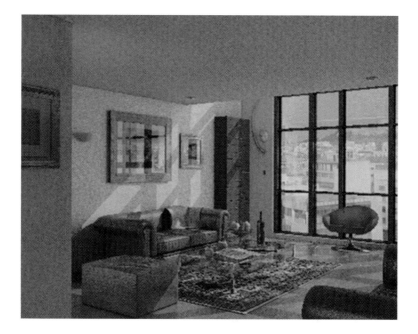

6. Increase the contrast to 70.0.
7. Render the Camera01 view to see the increased depth provided by increasing the contrast.

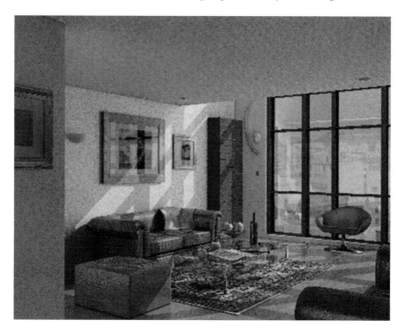

8. Check the Desaturate Low Levels checkbox.

9. Render to see the differences in the image.

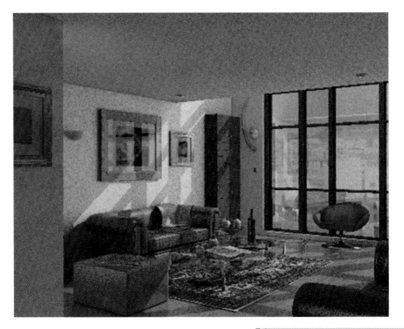

These settings worked well for this scene and they most probably work for most scenes, however, you may decide to adjust these settings depending on circumstances and as a matter of personal preference.

2.13 mental ray Parameters for the Final Render

As your lighting and materials become sufficiently refined, you will want to produce higher-quality images than those you have done to date. You will adjust parameters found in the Renderer Tab of the Render dialog, as well as set your indirect illumination settings to produce higher-quality images. The following section starts with a brief introduction to the parameters you can adjust in the Renderer Tab of the Render Scene dialog.

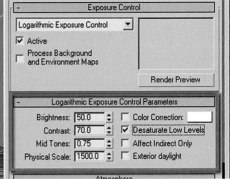

2.13.1 Samples per Pixel Group

Sets the minimum and maximum sample rate.

Minimum: Sets the minimum sample rate and represents the number of samples per pixel. Values higher or equal to 1 mean that one or more samples are calculated per pixel.

Fractional values mean that one sample is calculated for every N pixels (e.g. 1/16 calculates a minimum of one sample for every 4 pixels). For draft renders use values between 1/64 and 1/4 (fractional values); for high-quality renders use values between 1 and 64. Default = 1/4.

Maximum: Sets the maximum sample rate. For draft renders use values between 1 and 4; for high-quality renders use values between 16 and 1024. Default = 4.

2.13.2 Filter Group

Box filter: This is the quickest and blurriest to render. Fine details in the scene are lost. It is commonly used for draft renders.

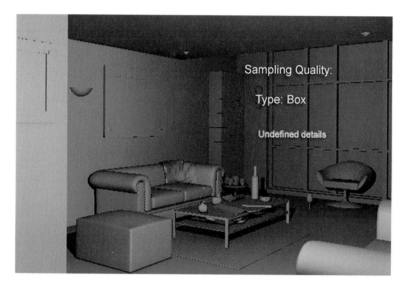

Gauss filter: The image quality is soft like, the rendering speed is average.

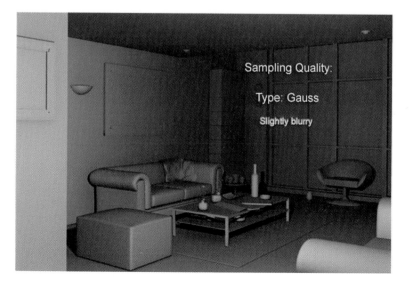

Triangle filter. The quality is better than the box filter type but not as fast to render. Objects further from the center of the scene are not as affected by the filter.

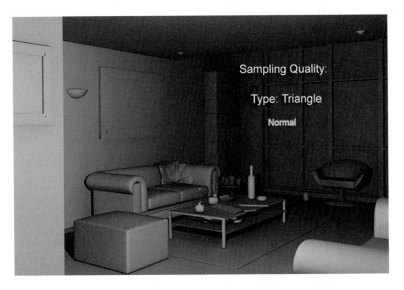

Mitchell filter. This is the most accurate filter to render with; however, it is also the slowest.

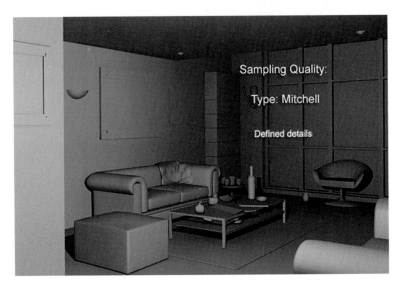

Lanczos filter: Produces the slowest render times, however it makes the images very sharp.

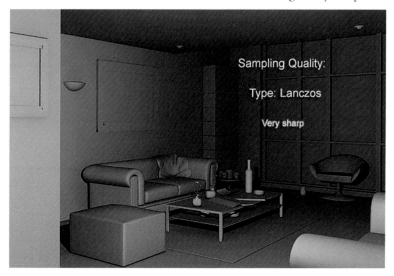

Width and height: Sets the size of the filtered areas. By increasing its values one can soften dramatically the rendered images; however, it will slow the rendering time. The following are the default values used by the various filter types.

Box filter	Width = 1.0, Height = 1.0
Gauss filter	Width = 3.0, Height = 3.0
Triangle filter	Width = 2.0, Height = 2.0
Mitchell filter	Width = 4.0, Height = 4.0
Lanczos filter	Width = 4.0, Height = 4.0

Jitter: Reduces aliasing when on. Default = off.

2.14 Finalizing the Living Room Render

In this final section you will change some of your rendering parameters in both the Indirect Illumination tab and the Renderer tab to produce a final polished image.

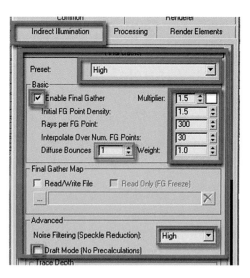

1. Open the file **LR_Final Start.max** or continue working on your previous file.
2. Open the Render Scene dialog box and go to the Indirect Illumination Tab.
3. In the Final Gather Rollout change the Preset to high, by selecting it in the pull down list.
4. Change the Multiplier to 1.5.
5. Reduce the number of Rays per FG Point to 300. Higher values will produce longer render times.
6. Change the number of Diffuse Bounces to 1. Higher values will lead to excessive color bleeding.
7. In the Advanced area set the Noise Filtering to High.

8. Scroll down to the Caustics and GI rollout.

9. Set the maximum number of photons per sample values to 10,000. This value works well in most common scenes without compromising the rendering time.

10. Click on the Renderer tab in the Render Scene Dialog.

11. In the Sampling Quality rollout, Filter group, change the type to Mitchell.

This filter is particularly useful on images of a small resolution, as it sharpens them.

12. Change the Width and Height values to 5.0.

Increasing the Width and Height values will improve the image especially images of smaller resolution.

13. In the Samples per Pixel group change the minimum value to 1 and the maximum to 16.

14. Render the Camera01 viewport.

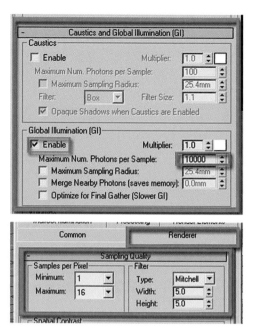

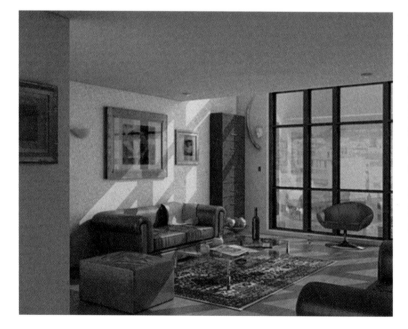

You can see the dramatic increase of render time once all the final parameters have been set.

Often when rendering fairly small image sizes and using lights whose Radius values are too high, one may find that the rendered images are slightly grainy; to correct that one should do the following:

Select the light/s that has/have **high Radius values** in scene; on the **modifier** command panel, go

to the **Area Light Parameters** section and increase the **U & V Samples** values. Note that this may slow down the render slightly. Normally when rendering large images there's no need to increase the samples.

15. Save your image from the Render Window.

2.15 Conclusion

In this lesson you learned a lot about lighting and how the mental ray's Indirect Illumination parameters can affect the GI and Final Gather calculations. In addition, you saw how changes in the renderer's Sampling Quality parameters can affect the overall quality of the image. Finally, in the overall workflow of the lesson you saw how a complex scene was worked on in an efficient manner reserving the long render time for the end, once all the lighting settings have been set and tested.

Chapter 3

Artificial Lighting for the Interior Space

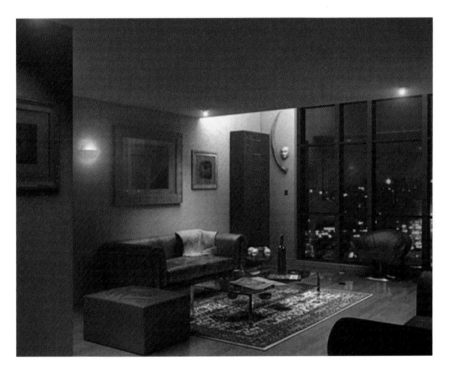

3.1 Introduction

In this chapter you will learn about lighting an interior scene using artificial lighting. Specifically you will learn how to:

- Create an interior night scene lit by artificial lighting.
- Establish basic lighting parameters in the scene.
- Render lighting tests efficiently.
- Add artificial lights and adjust their parameters.
- Add the lume shader to lights to give a more realistic appearance.
- Make a few final adjustments so that a very good rendering becomes a great one.

3.2 Starting the Scene

Before beginning on a new 3ds Max scene it is imperative that you ensure that the units are properly setup in your scene. Otherwise you will later encounter a number of undesirable results.

1. Start or Reset 3ds Max.
2. From the Customize pull down menu select Units Setup …

3. In the Units Setup dialog, in the Display Unit Scale, set the scale to Metric Millimetres.

4. In the Unit Setup dialog click on the System Unit Setup button.

5. In the System Unit Setup dialog set the System Unit Scale to Millimetres.
6. Click OK to exit both dialog boxes.

Note: It is important that the Units Setup and System Unit Setup are the same.

To get started you are going to open a version of the living room scene where all the materials have been applied, but where only default lighting is being used:

7. Open the file **LR Night start.max** from the files folder.

The units of 3ds Max have been carefully set in advance to match the units of the incoming file; both are in metric millimetres. It is often the case that a file being opened does not match the system units of 3ds Max. In this case, the File Load: Units Mismatch dialog box will alert you to the discrepancy. You should always adopt the File Units Scale in order to avoid problems with units later in the development of the scene:

8. Once the scene is loaded, open the Render Scene dialog by clicking on the Render Scene dialog button on the Main Toolbar.

9. In the Render Scene dialog, click on the Common tab.

Note: The output size values worked well for this scene, but you could enter different image sizes if desired.

10. Make sure the Camera01 view is selected, click on the Lock button next to the Viewport list at the bottom of the dialog. This will lock the Camera01 view to be rendered until it is unlocked.

3.3 Establishing Basic Lighting Parameters

Before creating lights in the scene you will establish some parameters for how mental ray works with these lights:

1. If it is not already displayed, open the Render Scene Dialog by clicking the icon on the Main Toolbar.
2. Select the Indirect Illumination tab.

Note: The parameters for Final Gather are grayed out. This is simply due to the fact that it has not been enabled yet.

3. Click on the Enable Final Gather checkbox.
4. Make sure in the advanced group that Draft Mode (No Precalculations) is not selected.

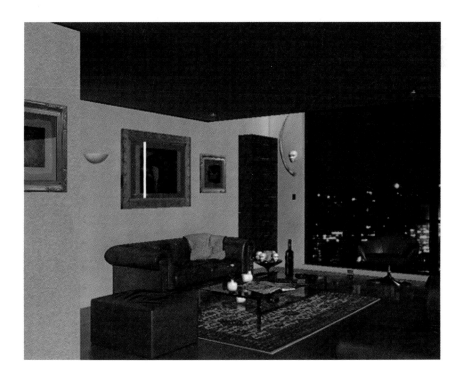

5. Click on the Quick Render button on the Main Toolbar.

Although the render is reasonably quick, it took 2 minutes and 41 seconds to render on a selected system. The rendering time can be further reduced so that you can continue to do test renders efficiently:

6. In the Final Gather rollout, select Draft from the Preset pull down list. Note the changes in the Basic parameters.

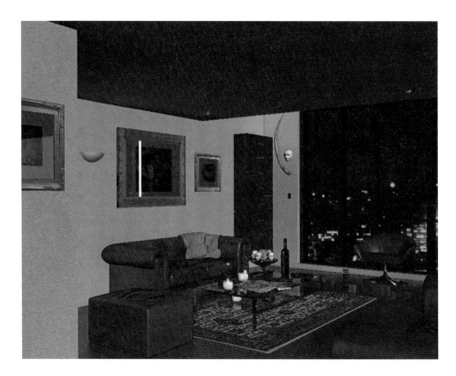

7. Click on the Quick Render button again to render the Camera01 view.

When Final Gather is set to Draft the render time is reduced to 1 minute and 02 seconds. Even though there has been a dramatic change in the rendering time, a considerable amount of time is being used in creating and generating the

materials in the image. To make the process of illuminating the scene most efficient you will replace the scene materials at render time with a neutral gray material:

8. In the Render Scene dialog, Processing tab, check the Enable checkbox in the Material Override area in the Translator Options rollout.

9. Open the Material Editor and choose the material called ambient occlusion in the first column and third row.

10. Drag and drop the material into the Material slot. Select Instance in the Instance (copy) Material dialog.

11. Render the Camera view. If you get the Missing/Map Coordinates dialog simply click Continue.

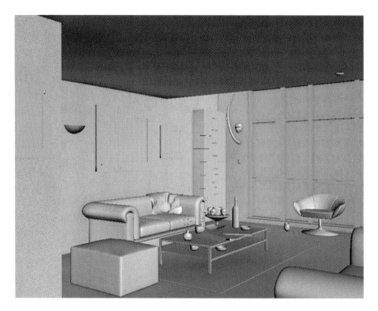

The material override feature has reduced the render time to 26 seconds. You have used a fairly simple material with ambient occlusion, which generates connecting shadows whenever one surface meets another. This material will allow you to focus on the lighting and render quickly and efficiently. You are temporarily removing any time-consuming calculations generated by the materials. When you wish to see the materials in the scene you simply remove the override.

3.4 Adding the Artificial Lights

The next step in this scene is to add lights to create some depth in the image. In this scene you will emulate a night version of the scene with artificial lights shining down from the ceiling. The photos below show how light behaves in the real world and provides you with an excellent reference for the image you want to create.

Note the pattern and distribution of light emanating from the down lights as well as the illumination of the lights themselves.

First you will mimic the down lights from the ceiling as the references above:

1. Open the file **LR Night Light Start.max** or continue working on the file in the previous section.
2. Click on the Front viewport.
3. Click on the Maximize Viewport toggle to switch to an enlarged view of the Front viewport.
4. Zoom the view so that you can clearly see the ceiling and the floor.
5. In the Command Panel, Create tab, click Lights and under the Lights Object type, choose mr Area Spot.
6. Click and drag the light in the Front viewport so that the light is just about touching the light fixture on the ceiling and its target is directly underneath touching the floor.

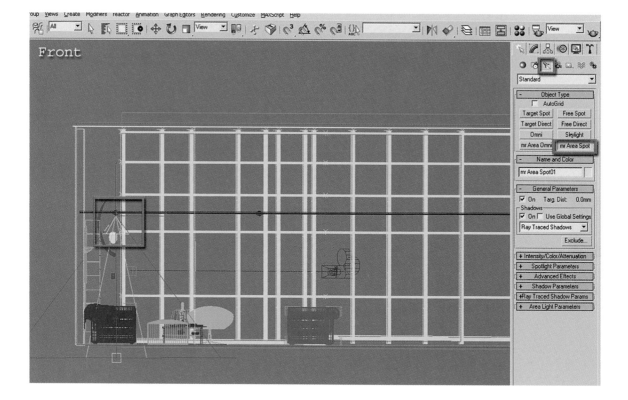

7. Click Render for a quick test. If you get the Missing/Map Coordinates dialog simply click Continue.

The render looks good: however, the cone-shaped highlighted area on the wall is not feathered enough and the shadows on the floor are a bit too sharp.

Since you are going to be doing a lot of work with the lights in the scene, it is a good time to use the selection filter next to the Select button on the Main Toolbar. This will limit your ability to select objects in the scene and in this case allows you to select only lights without worrying about selecting other objects:

8. Click on the list and select Lights from the items which appear.
9. Make sure the light you inserted is still selected and go to the Modify tab on the Command Panel.
10. In the General Parameters rollout in the Light Type area uncheck the targeted option. This will allow you to easily move the light around later on without having to worry about moving the light's target as well.
11. In the Shadows area of the General Parameters rollout, keep the shadows as Ray Traced Shadows.
12. In the Intensity/Color/Attenuation rollout change the color of the multiplier to a pale yellow color. Recess lights are often this color.

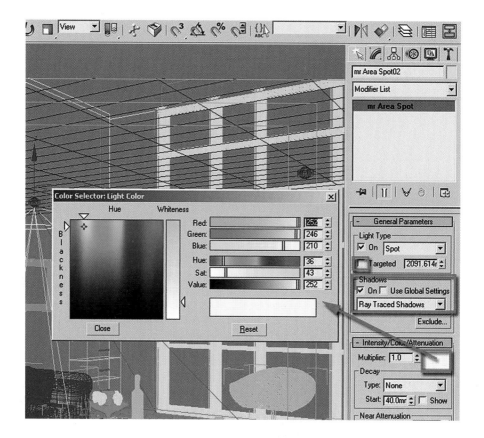

13. Render the scene to see the differences. If you get the Missing/Map Coordinates dialog simply click Continue.

Next you will feather the sharp highlighted area on the wall:

14. Further down the Command Panel under the Spotlight Parameters rollout, change the Hotspot/Beam value to 25.0. A lower value will decrease the highlighted areas.

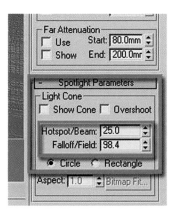

15. Change the Falloff/Field values to 98.4. A higher value will produce a more feathered rim of the highlighted areas.

16. Render the view. If you get the Missing/Map Coordinates dialog simply click Continue.

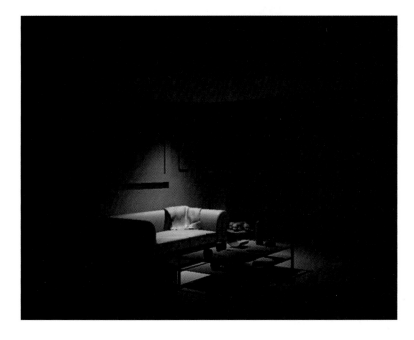

Next you will feather the shadows on the floor:

17. Go to the Area Light Parameters rollout.
18. Under the Type list, currently set to Rectangle, increase the Height and Width values to 500.0 mm.

19. To manually control the indirect illumination, uncheck Automatically Calculate Energy and Photons under the mental ray Indirect Illumination rollout.
20. Next set the Manual Settings option to On.
21. Change its color swatch to the same tone of yellow as the multiplier in the Intensity/Color/Attenuation rollout. You can copy and paste colors by right clicking on the color swatch.
22. Render to see the changes in the scene. If you get the Missing/Map Coordinates dialog simply click Continue.

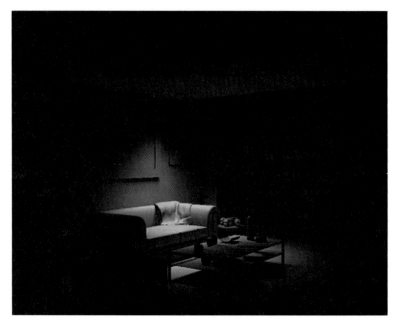

The light now has a nice feathered look to it. Overall the scene is still quite dark, you will work on improving the image in the next section.

3.5 Adding More Lights to the Scene

In this particular scene, the image appears quite dark as you might expect in reality if only one ceiling light were illuminated in an entire living room. You will add more brightness to the scene by adding more lights:

1. Open the file *LR Night Light 01.max* or continue working on your current file.
2. In the Front viewport select the Light and click on the Select and Move tool.
3. Hold the Shift key down and move the light to the right of its current location.
4. Release the mouse button and the Clone Options dialog will appear.
5. Select Instance in the dialog and click OK.

Note: When lights are instanced, their parameters are dependant allowing you to control multiple lights together.

6. Type the letter "T", or in the Viewport menu select Views>Top, to switch to the Top view.
7. Zoom out so you can see the entire living room area.
8. Use the same technique as above to create a total of five lights and place them in the Top view as described and shown below:
 - Place two of the lights under the light fixtures, flush against it.
 - One near the stool.
 - One by the picture frame close to the camera.
 - One behind the sofa on the right.

9. Click Render. If you get the Missing/Map Coordinates dialog simply click Continue.

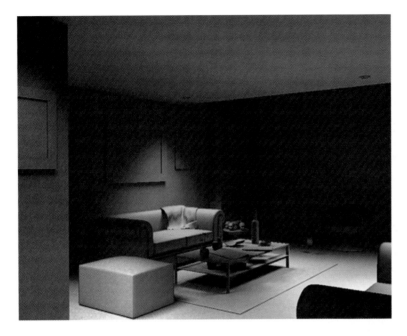

The scene is much brighter now; however, it could benefit with more lights. The next step is to place an mr Area Omni light on the wall to emulate the wall fixture:

10. Type "F" to switch to a Front viewport or choose Views>Front from the viewport menu.
11. Zoom into the wall-mounted fixture on the left wall of the living room.
12. In the Command Panel, Create tab, click Lights and choose mr Area Omni.
13. Click to place the light in the fixture enclosure in the Front View.

14. Minimize the Front viewport and move the new mr Area Omni so that it is inside the fixture enclosure in all views.

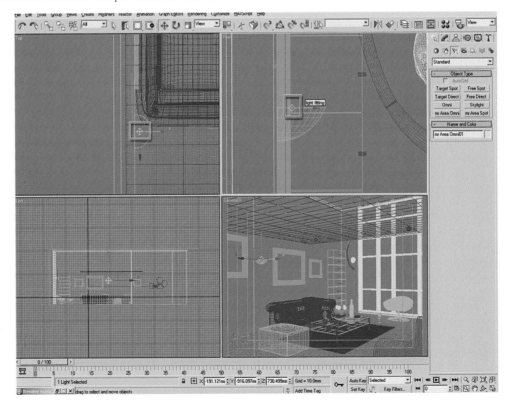

15. Click Render. If you get the Missing/Map Coordinates dialog simply click Continue.

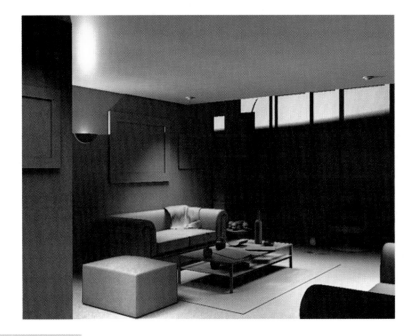

The scene looks overly lit as the light from the wall fixture is propagating across the scene without restriction. Also the shadows are very sharp:

16. With the mr Area Omni light selected go to the Modify tab in the Command Panel by clicking on its icon.

17. In the Intensity/Color/Attenuation rollout verify if the color of the wall light is the same tone of yellow as the other lights in the scene. If it is not the same color of yellow change it to that color.

18. Set the Multiplier's values to 2.0.

19. To control the propagation of the light across the scene, in the Intensity/Color/Attenuation rollout, change the Decay type to inverse square and check the Show option.

You should now see a spherical controller wrapped around the light. It indicates where the light's illumination begins to decay:

20. Increase its size to about the same dimension as the wall light by setting the Start value to about 78.0.

103

21. Render again. If you get the Missing/Map Coordinates dialog simply click Continue.

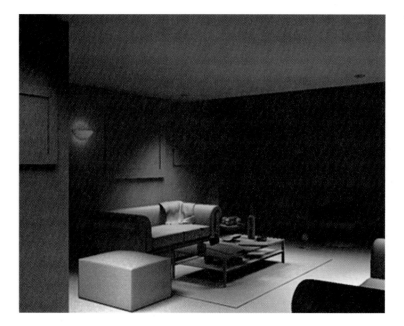

22. To feather the shadows casting on the floor from the Area Omni light go to the Area Light Parameters rollout, change the radius value of the Sphere type shadow to 500.0 mm.

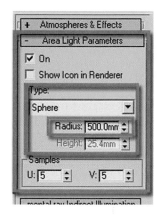

23. Verify that the Manual Settings option under the mental ray Indirect Illumination rollout has been enabled.
24. Verify that the color swatch in the Manual Setting area is the same tone of yellow as the multiplier.
25. Click Render again. If you get the Missing/Map Coordinates dialog simply click Continue.

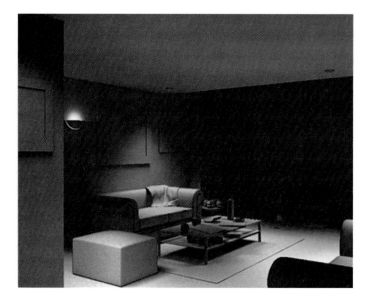

The scene is gradually improving; however, there is little or no light coming from the floor above. (There is a 2nd floor loft space.) Consequently the glass curtain wall is very dark:

26. Create another mr Area Omni light by copying the light in the wall fixture. Make sure you do not instance the light as you are going to be changing values of the new light that you do not want to propagate to the existing light.

27. Move the light so that it is in the middle of the floor above.

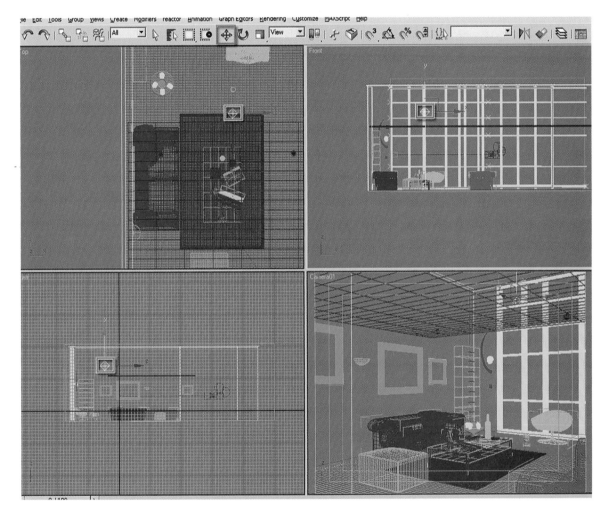

28. Select the new light and go to the Modify tab of the Command Panel.

29. Change the Decay Start values to 913.77 mm.
30. Also change the Multiplier value to 0.7, this will provide for more contrast.

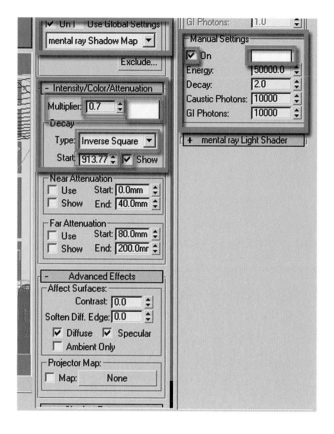

31. Click Render for a quick test. If you get the Missing/Map Coordinates dialog simply click Continue.

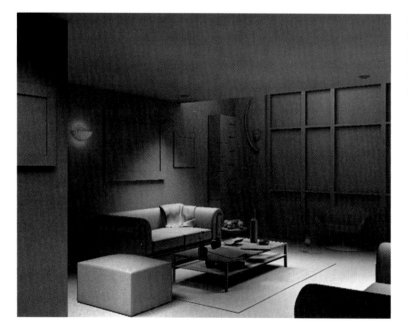

3.6 Adding a Lume Shader to the Lights

In this section you will add a glow to the lights by applying the Beam (lume) shader to them:

1. Open the file **LR_Lume.max** or continue working on your file from the previous section.
2. Open the Render Scene dialog box.
3. In the Renderer tab find and open the Camera Effects rollout.
4. In the Camera Shaders area, click on the button next to the Volume checkbox to open the Material/Map Browser dialog box.

5. In the Material/Map Browser dialog select Beam (lume) on the Volume shaders list.
6. Click OK to close the dialog box.

7. To view the parameters of the Beam (lume) shader, drag and drop the map from the volume slot under the Camera Shaders options into an empty material slot in the Material Editor.

8. The Instance (Copy) Map dialog box will display. Choose Instance as a method and click OK to close the dialog.

The Beam (lume) Parameters should now be visible in the Material Editor dialog box:

9. Under the Beam (lume) Parameters rollout change the color to the same yellow as the other lights.
10. To assign the Beam (lume) to a light, first check the Lights option.

Note that if the Lights option is not checked the Beam (lume) will be automatically applied to the whole scene.

11. Click the Add button.
12. Click the Select by Name icon from the Main Toolbar. The Pick Object dialog box will display.
13. Choose all the lights from the list except the last light which you placed on the floor above.

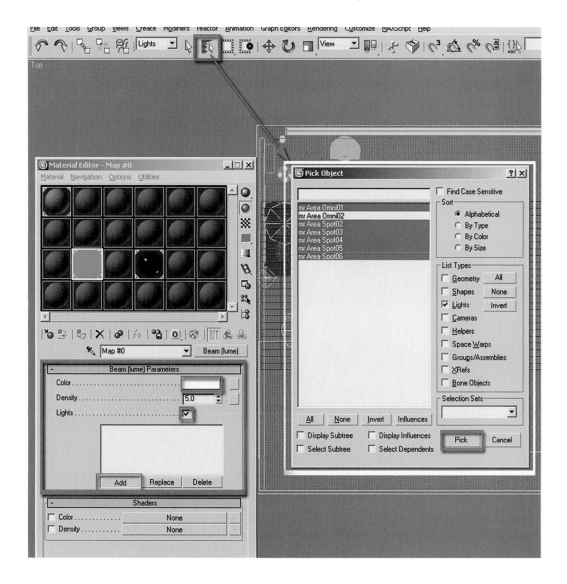

14. Click Render for a test. If you get the Missing/Map Coordinates dialog simply click Continue.

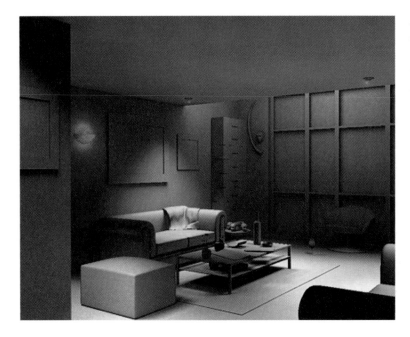

Although there is a slight difference in the previous render the beam's density is a bit too low to provide the more dramatic effect that is evident in the sample photos:

15. Increase the beam's density to about 50.0.
16. Click Render again for a quick test. If you get the Missing/Map Coordinates dialog simply click Continue.

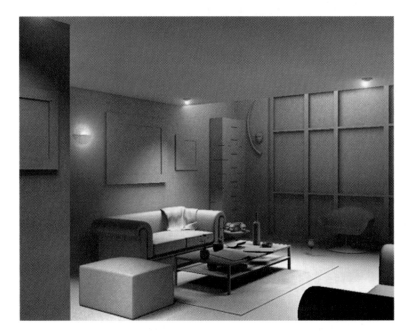

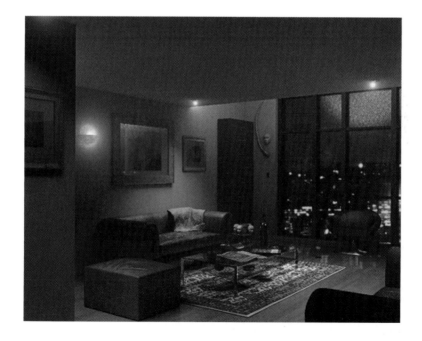

17. To quickly check how the lights are interacting with the materials, uncheck the Enable Material Override option in the Processing tab of the Render Scene dialog.
18. Click Render.

The light on the floor above seems to be generating some undesired highlights on the window glass. It is the light affecting the specular highlights of the window glass object:

19. To correct this problem, select the mr Area Omni light for the floor above.
20. Click on the Modify tab of the Command Panel.

21. In the Advance Effects rollout, uncheck the Specular option.
22. Render again.

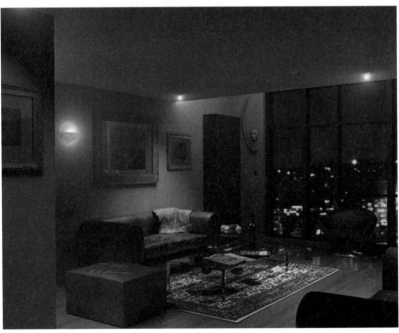

Note that the window glass is very transparent – this is due to the very low level of reflectivity in the glass. In real life you know that when you stand in an illuminated room and look outside into a dark exterior there will be a reflection in the glass of the interior space. Therefore you need to increase the amount of reflectivity to decrease the transparency of the glass:

23. To enhance the transparency open the Material Editor dialog box and select the Glass window (Physical) material. (Sixth column in the first row.)

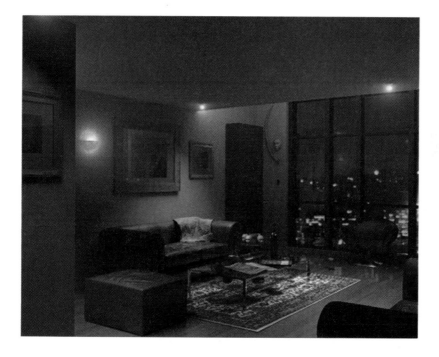

24. Go to the BRDF rollout. In the Custom Reflectivity Function area set the 0 deg. refl: to 0.2. This will increase the reflection to a more realistic level.

Note: Some material parameters may need to be changed depending on the scenes that the materials are used in.

The scene is looking good now; however, we can improve the image further by using exposure control tools.

3.7 Adding Exposure Controls to Improve the Image and Final Render

1. Open the file **LR_Exposure.jpg** or continue working on your current file.
2. Click the Rendering selection on the pull down menu, then choose Environment. The Environment and Effects dialog box will display.

3. Select the Logarithmic Exposure Control from the list under the Exposure Control rollout.

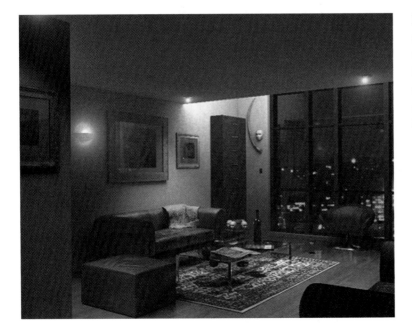

By default the Exposure Control settings are set to brighten the scene while the contrast remains constant. In this scene the best results are obtained by keeping the brightness constant and increasing the contrast. Start by changing the brightness:

4. In the Logarithmic Exposure Control area change the Brightness value to 50.0. This will reduce the overall brightness of the scene.
5. Click Render for a quick test.

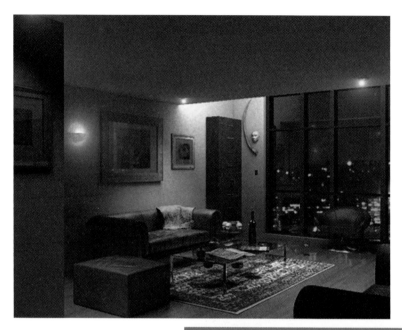

6. Increase the contrast to 70.0. Increasing the contrast will provide more depth to the image.

7. Click Render for a quick test.

8. Check the Desaturate Low Levels option.

These settings worked well for this scene and they most probably work for most scenes; however, you can always experiment and change the values below as a matter of personal preference:

9. Click Render.

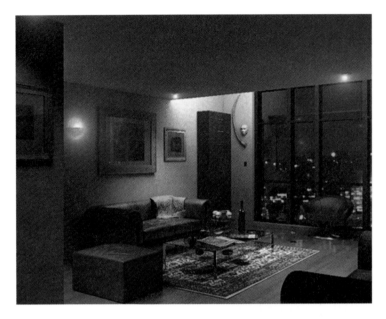

The image looks satisfactory now. It is now ready for a final render:

10. Open the Render Scene dialog box.

11. In the Indirect Illumination tab, Final Gather rollout, change the Preset from Draft to High. Note how some of the values in the Basic area underneath changed automatically.

12. Change the Rays per FG Point value to 300. Higher values will subsequently increase the rendering time.

13. Change the Diffuse Bounces value to 1. Higher values will result in excessive color bleeding.

14. In the Advanced area, change the Noise Filtering (Speckle Reduction) to High.

15. In the Indirect Illumination tab of the Render Scene dialog, pan up to the Caustics and Global Illumination (GI) rollout parameters and enable it.

16. Set the Maximum Num. Photons per Sample to 10000. This value works well in most common scenes without compromising the rendering time; however, you can always try different values.

17. In the Renderer tab of the Render Scene dialog choose the Mitchell filter type on the sampling quality rollout This filter is very useful for images of smaller resolution as it sharpens them.

18. Change the Width and Height values to 5.0. *Note*: These values will improve the quality of the image especially when the images are small.

19. On the Samples per Pixel section change the Minimum to 1 and the Maximum to 16.

20. Click Render for your final image.

Should you find the rendered image **slightly grainy**, simply increase the **Maximum** values to **64** or higher, on the **Sampling Quality** tab under the **Samples per Pixel** group. Note that this will slow down the render slightly.

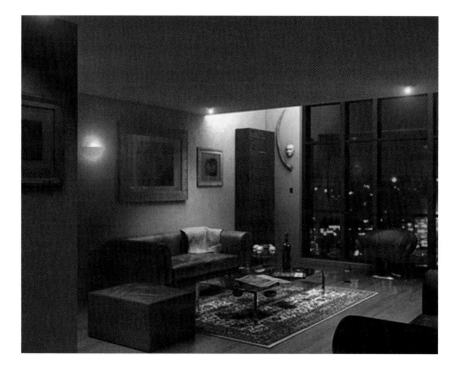

3.8 Conclusion

In a previous chapter, you saw how to use mental ray lighting to light the living room scene in the daytime. In this chapter, you have seen how to use many of the same techniques to illuminate the same space but this time at night. In addition, you used techniques like light decay and the application of a Beam (lume) shader to control the light and to make a light fixture look more realistic. Finally, you used exposure controls and set up the scene to be rendered to give you the best results for your final image.

The Harbor: Introduction

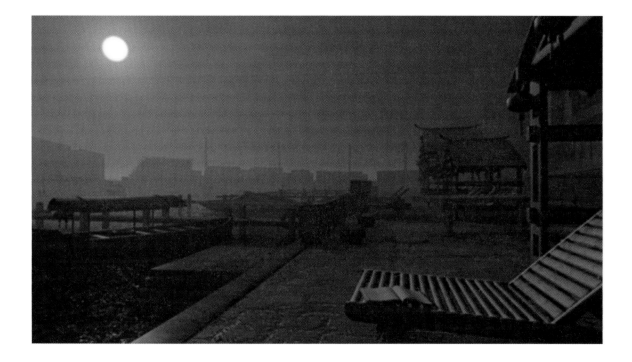

In this section you will create two daytime renderings of the same scene. The first rendering will depict a harbor scene during the day, the second in an early morning hazy light. The following section is composed of three chapters. In the first you work on the materials in the scene. In the second chapter you create the daylighting. Finally in the third chapter you work with the sky and create a hazy environment.

Chapter 4

Preparing Materials for an Exterior Scene

4.1 Introduction

In this chapter you will see how to prepare materials for an exterior scene. This chapter is composed entirely of material creation in a light-free environment. Working both lighting and materials simultaneously increases rendering time and therefore reduces efficiency. While either lighting or materials could be worked on first, the choice was made to work on materials first as it is easy to disable the materials when working on the lighting.

4.2 Starting the Scene

Before beginning on a new 3ds Max scene it is imperative that you ensure that the units are properly set up in your scene. Otherwise you will later encounter a number of undesirable results.

1. Start or Reset 3ds Max.
2. From the Customize pull down menu select Units Setup ...

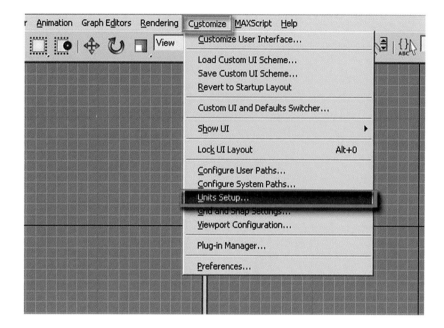

3. In the Units Setup dialog, in the Display Unit Scale, set the scale to Metric Millimetres.

4. In the Unit Setup dialog click on the System Unit Setup button.

5. In the System Unit Setup dialog set the System Unit Scale to Millimetres.
6. Click OK to exit both dialog boxes.

Note: It is important that the Units Setup and System Unit Setup are the same to prevent undesirable results when rendering.

To get started we are going to open the version of the harbor scene where only grayscale materials have been applied:

7. Open the file ***Harbour_Materials_Start.max*** from the files folder.

The units of the 3ds Max have been carefully set in advance to match the units of the incoming file; both are in metric millimetres. It is often the case that a file being opened does not match the system units of 3ds Max. In this case, the File Load: Units Mismatch dialog box will alert you to the discrepancy. You should always adopt the file unit's scale in order to avoid problems with units later in the development of the scene:

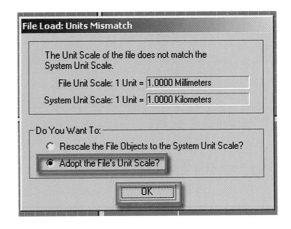

8. Once the scene is loaded, open the Render Scene dialog by clicking on the Render Scene dialog button on the Main toolbar.

9. In the Render Scene dialog, click on the Common tab.
10. Set the Output Size Width to 500 and the Height to 277.

Note: These values worked well for this scene, but you could enter different image sizes if desired:

11. Click on the Lock button next to the Image Aspect value to enable it.
12. Click on the Lock button next to the Viewport list at the bottom of the dialog. This will lock the Camera01 view to be rendered until it is unlocked.

Now you will load the mental ray renderer:

13. In the Render Scene dialog, click the Common tab and scroll down until you reach the Assign Renderer rollout.
14. Click on the button to the right of the Production renderer.

15. In the Choose Renderer dialog select mental ray Renderer and click OK.

16. Render the file by clicking the Quick Render button on the Main toolbar. The scene is rendered with its default grayscale materials.

4.3 Applying Materials to the Background Buildings

Often in a 3D scene there will be buildings which are not a prominent element of the scene but still need to look like proper buildings for the scene to be convincing. A good technique is to create a material which is composed of a photo of one or more real life buildings and apply that material to a simple geometry object:

1. Open the Material Editor by clicking on its icon on the Main toolbar.
2. In the Material Editor dialog box choose any unassigned sample material slot by clicking on it.

3. Click the Standard material type. The Material/Map Browser dialog box will pop up.
4. Choose the Arch & Design (mi) material from the list and click OK to close the dialog box.

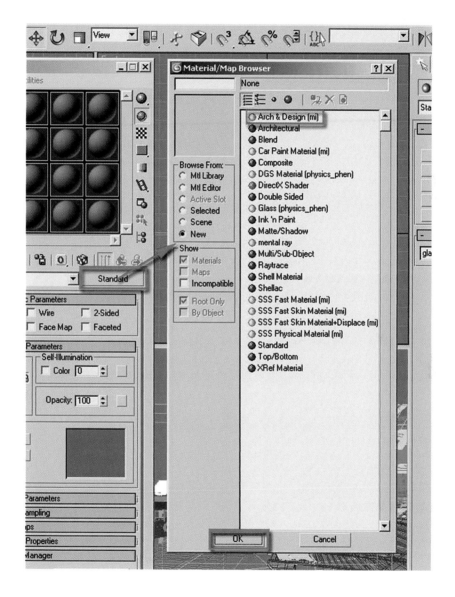

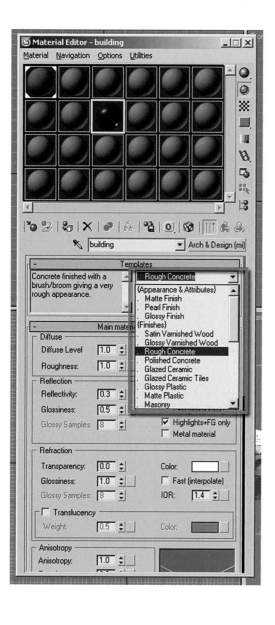

5. Choose the Rough Concrete template from the Templates dropdown list.

Note: The properties of each template will appear on the window alongside the templates as one scrolls past each one of them on the list.

6. Name the material, building rough concrete, by typing it in the edit box to the left of Arch & Design (mi) shader button.

The reason for naming the material after the template is to make it easier to remember which template was used to start the material. Once applied the template name will disappear on execution of any action such as click of a toolbar, etc.

This template is very good and it comes with its own custom color and bump maps; however, these and other settings are not the ideal for the building surface we are trying to achieve. Therefore you will have to make some adjustments before you apply this to your building surface. First start by changing the diffuse color map in the Main materials parameters rollout:

7. Click on the Map button to the right on the color swatch in the Diffuse area of the Main materials rollout.
8. Click on the Map button currently set to RGB Multiply. The Material/Map Browser dialog box will pop up.
9. In the Material/Map Browser dialog box choose Bitmap and click OK to close the dialog.
10. Choose the *lowres-ams-0109.jpg* bitmap from the files folder.

11. Click Open to select the bitmap image and close the Select Image Bitmap File dialog box.

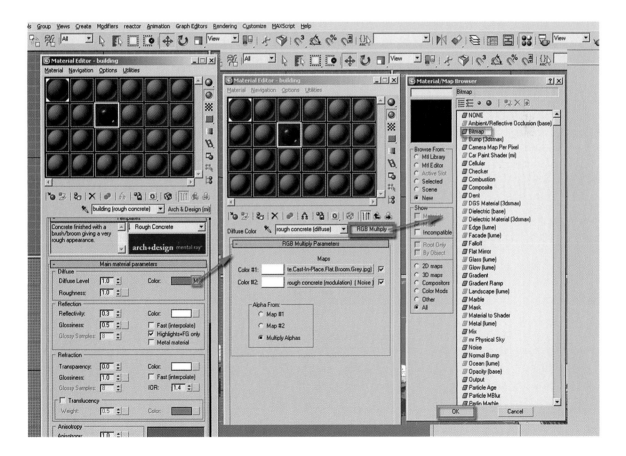

12. Click on the Go to Parent button.

13. In the Main material parameters rollout of the Arch & Design (mi) material change the Glossiness value in the Reflection area to 0.3. This will make the material much less shiny.

14. Go to the Special Purpose Maps rollout and remove the checkmark in the Bump map. This will remove the roughness to the surface.

15. Select the buildings mesh in the scene and assign the newly created material, building (rough concrete) to it.

16. Also assign the building (rough concrete) to the following objects:
 - Back buildings
 - Glass 01 to 09
 - Panel buildings

17. To insure that the bitmaps are accurately rendered, go to Fast Glossy Interpolation rollout parameters and change the Interpolation grid density to 1 (same as rendering).

18. Render to see the results.

You can now see that the buildings in the background and to the side of the image have some texture and are excellent representations for buildings at this scale. Next you will work on an element in the foreground of the image, the wooden chair.

4.4 Creating a Material for the Wooden Chair

Seeing that the wooden chair is in the foreground of the image you will need to produce a good accurate material for it, otherwise the image will breakdown and become unconvincing. Reference images are important at this stage to guide you in developing your material:

1. Open the file *Harbour_chair.max* or continue working on your current file.
2. In the File menu choose View Image File and open the file *Wood_Chair_01.jpg*.

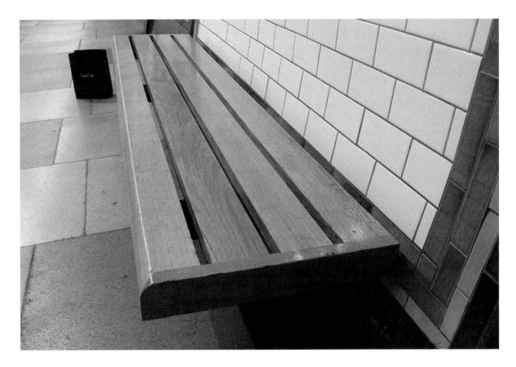

From the image you can see several characteristics of the wood material to strive for. There is an obvious grain to the wood but it is not overpowering. The grain of each element of the bench is in different direction and in some cases color. The wood is moderately shiny but does not have a perfect mirrored finish. The surface

has been weathered somewhat by the elements and usage. The wood surface does reflect its environment only slightly:

3. Dismiss the Image window.
4. View the file *Wood_Chair_02.jpg*.

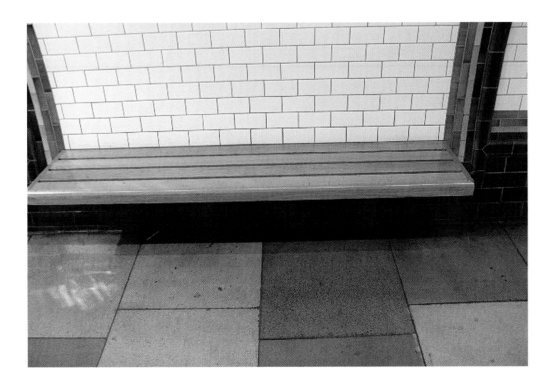

From this angle the wood surface is slightly more reflective:

5. Dismiss the Image window.
6. Open the Material Editor and choose any unassigned sample material slot by clicking on it.

7. Click the Standard material type. The Material/Map Browser dialog box will pop up.
8. Choose the Arch & Design (mi) material from the list and click OK to close the dialog box.

9. Choose Pearl Finish from the Templates dropdown list.

Note: The properties of each template will appear on the window alongside the templates as you scroll past each one of them on the list:

10. Name the material, wooden chair (Pearl Finish) by typing it in the edit box to the left of Arch & Design (mi) shader button.

The reason for naming the material after the template is so that one can remember the template applied, as its name will automatically disappear on the execution of any action such as click of a toolbar, etc.:

11. Pick the Material Map button to the right of the color swatch in the Diffuse area of the Main material parameters rollout.

12. In the Material/Map Browser dialog box choose Bitmap and click OK. The Select Bitmap Image file dialog will appear.

13. Choose the **basswd.bmp** bitmap from the file folder and click Open.

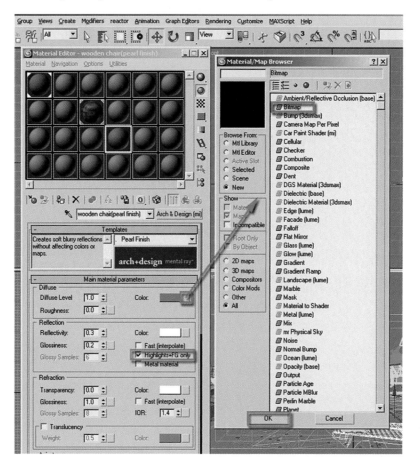

14. In the coordinates rollout settings set Blur to 0.2 to sharpen the material as it is quite small in pixels.

15. Click on the Go to Parent button to navigate to the top level of the material.

16. In the Reflection area enable the Highlights+FG only option and remove the check in the Fast (interpolate) checkbox.

Highlights+FG only is generally required whenever the Glossiness values are lower than 0.3. Highlights+FG is a faster way of rendering surfaces where there is a specular highlight but no reflection, i.e. a low glossiness value. It is a faster way of rendering these surfaces as the Highlights+FG function discards the reflection and only generates specular highlights of the lights affecting its surface, through final gather. An example would be a tarmac at night.

The tarmac will pick up the shine from a car or airplane's lights, but the surface does not reflect the surrounding environment of buildings, other cars and planes or the sky. Other examples could be plastics, stones and rubber:

17. Assign the wooden chair (Pearl Finish) material to the five chair objects in the foreground named chair to chair04.

18. Render to see the results.

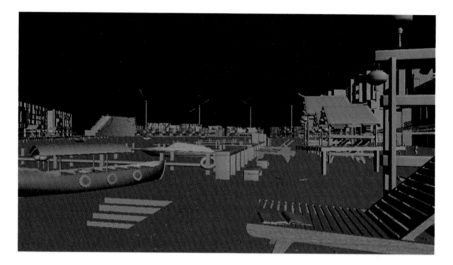

19. To insure that the bitmaps are accurately rendered go to the Fast Glossy Interpolation rollout and change the Interpolation grid density to 1 (same as rendering).

139

20. Go to the Special Effects rollout and enable Ambient Occlusion.

Note: This option will require that final gather/global illumination is enabled to bring out shadow details that otherwise would have been lost.

21. In the same Special Effects rollout enable the Round Corners option.

This option works on straight edges (regardless of its complexity), including round objects with straight edges, to produce a rounded corner where there would have been a hard edge. Most objects in a scene do not have hard edges; in the wooden bench example the reference photos show slightly rounded edges throughout the geometry:

22. In the Round Corners area check the Blend with other materials option. This option will allow the rounding of the corners against all materials possible.

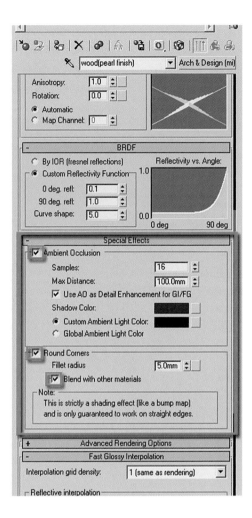

23. Click Render for a quick test.

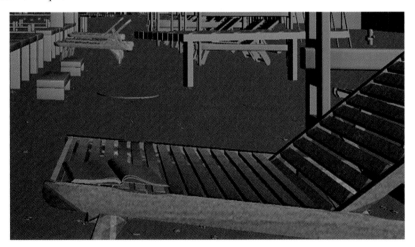

The Round Corner effect is not looking as good as anticipated. That is due to the scale of the object vs. the Fillet radius of 5.0 mm. This radius is too large for the size of the object:

24. In the Rounded Corners area of the wooden chair (Pearl Finish) material, change the Fillet radius to 0.12 mm.
25. Render to see the material on the chair again.

Note: The Fillet radius default value of 5.0 mm is based on the scene unit set up values and the scale of the object. If not satisfied with the default values try higher or lower values until a satisfactory appearance is achieved. The Rounded Corner effect is only visible when the scene is rendered and does not affect the geometry.

4.5 Creating a Material for the Pavement

The next item to work on is the pavement. Prior to starting, take a look at the reference photos of the material we are trying to achieve:

1. Open the file **Harbour_Pavement.max** or continue working on your current file.
2. In the File menu choose View Image File and open the file **Pavement_Image.jpg**.

Note the coarse nature of the surface such as the grain and grout, and its variation of shades are caused mainly by the environment and its inhabitants.

3. Dismiss the Image window.

4. In the Material Editor dialog box choose an unassigned sample material slot.

5. Click the Material type button, currently labeled Standard. The Material/Map Browser dialog box will display.

6. Choose the Arch & Design (mi) material type from the list and click OK.

7. Choose the Rough Concrete template from the Templates pull down list.

Note: The properties of each template will appear on the window alongside the templates as you scroll past each one of them on the list.

8. Name the material, pavement (rough concrete), by typing it in the edit box to the left of Arch & Design (mi) shader button.

The reason for naming the material after the template is so that one can remember the template applied as its name will automatically disappear on the execution of any action such as click of a toolbar, etc.:

9. Pick the Material Map button to the right of the color swatch in the Diffuse area of the Main material parameters rollout. This will bring you to the Diffuse map level which is currently set to an RGB Multiplier Map.

10. Click on the Material Map button currently labeled RGB Multiply.

11. In the Material/Map Browser dialog box choose Bitmap and click OK. The Select Bitmap Image file dialog will appear.

12. Choose the **pavement copy.jpg** bitmap from the file folder and click open.

13. Navigate to the upper level of the material by clicking Go to Parent.

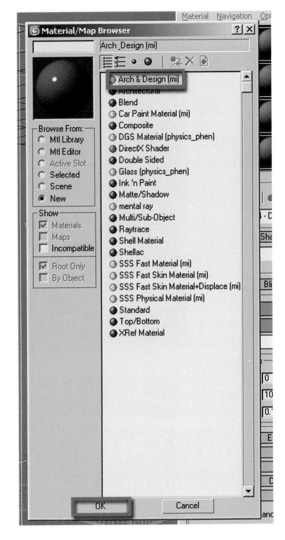

14. Go to the Special Purpose Maps rollout and replace the Bump map with the bitmap *pavement copy bump.jpg*.

15. Change the bump value to 0.2.

16. To insure that the bitmaps are accurately rendered go to Fast Glossy Interpolation rollout parameters and change the Interpolation grid density to 1 (same as rendering).

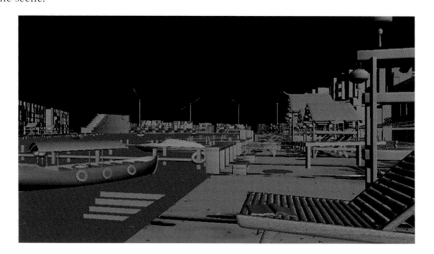

17. Assign the pavement (rough concrete) to the object pavement which is part of the export group in the scene.

18. Render the scene.

143

In the first rendering with this material applied you will note that the size of the material is vastly oversized vs. the size of the scene. Some adjustment of the bitmap is required:

19. Go back to the Material Editor and adjust the Tiling in the Coordinates rollout of both the Diffuse and the Bump Maps. Change the U value to 15.0 and the V value to 23.0.

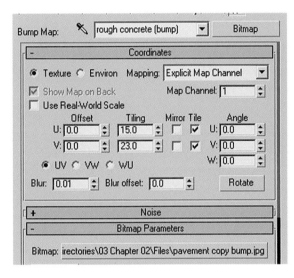

20. Render the scene again.

Although the color of the pavement looks very gray for the moment, it is better to wait for the application of lights to the scene as these will affect the scene's materials.

4.6 Using the Ocean (Lume) Shader for Water

In the next section you will use the water template in the Arch & Design material to create the surface of the water in the harbor. An important element of this template is the Ocean (lume) shader which is used in the Bump Map. Understanding this shader will help you get better control over the appearance of water surfaces in your model. Some of the more important parameters are as follows:

Largest: This determines the size of the largest waves on the ocean surface. Default = 20.0.
Smallest: This determines the size of the smallest waves on the ocean surface. Default = 1.0.

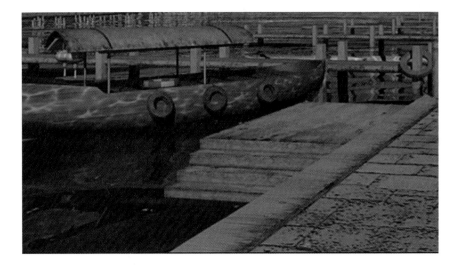

Largest = 20.0; smallest = 1.0.

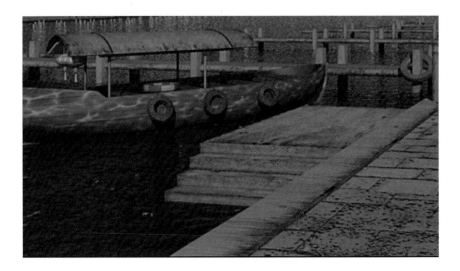

Largest = 0.2; smallest = 0.05.

Quantity: This determines the quantity of wave sizes between the largest and smallest values on the ocean surface. Increasing the number of sizes will make the surface of the water look rougher. Default = 5.0.

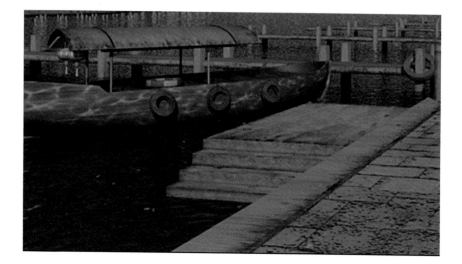

Quantity = 5.0.

Quantity = 20.0.

Steepness: This determines the appearance of the waves. High values give a rougher more disturbed sea appearance, while a lower value a smoother and calmer appearance. Default = 1.0.

Steepness = 0.05.

Steepness = 5.0.

Relative to world: This determines the alignment of the wave patterns. When an object with this material is moved across in the scene, the relative to world option will preserve the wave patterns as if nothing had been moved. Default = checked.

Relative to object: When an object with this material is moved across in the scene, the relative to object option will allow the wave patterns to move with it. Default = unchecked.

Plane normal: This determines the vertical axis direction only. Default = 0.0; 0.0; 1.0.

Plane distance: This determines the distance of the plane. Default = 0.0.

Directed: This enables the effect of rolling waves. Default = unchecked.

Direction angle: This determines the movement direction of the waves. Default = 0.0.

The below options are for animation purposes only:

Wave speed: This determines the movement rate of the waves. Default = 1.0.

Loop animation: This enables the wave animation to be looped automatically. Default = checked.

Loop frames: This determines the number of frames in the loop. Default = 100.

Flats: This enables the visibility of variations between rough and smooth areas of the water surface. Default = unchecked.

Size: This determines the flat area. Default = 10.0.

Variation: This determines how much these areas differ. Default = 1.0.

Bump: This determines the mode in which the effect will be displayed. Default = checked.

4.7 Creating the Water Material in the Harbor Scene

Now that you have had a look at the Ocean (lume) shader parameters, you will apply this knowledge to the water material in the harbor scene. Prior to starting, take a look at the reference photos of the material we are trying to achieve:

1. Open the file ***Harbour_water.max*** or continue working on your current file.
2. In the File menu choose View Image File and open the file ***Water_ref01.jpg***.

Note the undulating nature of the water surface and the change in the reflectivity of the surface as the viewing angle changes, thereby changing the apparent color of the water.

3. Dismiss the Image window.
4. View the file *Water_ref02.jpg*.

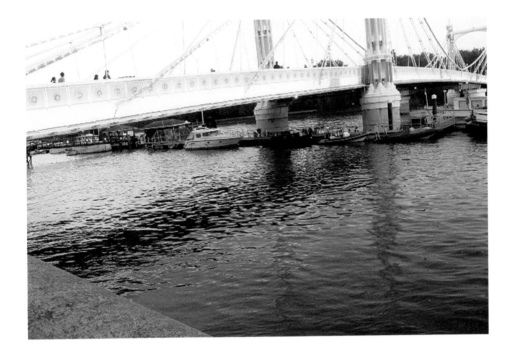

When the water surface is reflecting a prominent object in the scene note how the reflection is fragmented:

5. Dismiss the Image window.
6. In the Material Editor dialog box choose an unassigned sample material slot.
7. Click the Material type button, currently labeled Standard. The Material/Map Browser dialog box will display.
8. Choose the Arch & Design (mi) material type from the list and click OK.

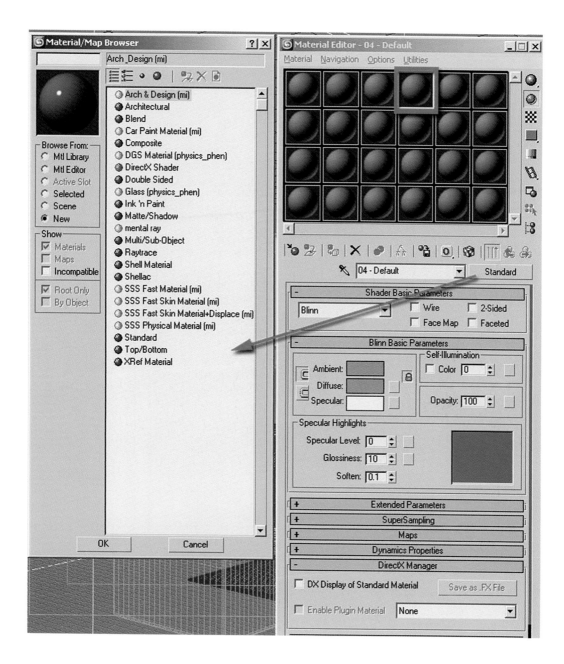

9. Choose the Water, Reflective surface (Thin Geometry) template from the Templates pull down list.

Note: The properties of each template will appear on the window alongside the templates as you scroll past each one of them on the list.

10. Name the material, water, by typing it in the edit box to the left of Arch & Design (mi) shader button.

The reason for naming the material after the template is so that one can remember the template applied, as its name will automatically disappear on the execution of any action such as click of a toolbar, etc.

Next we are going to assign the shader to the water object (mesh):

11. Click on the Select by name dialog from the Main toolbar.
12. In the Select by name dialog select the water object, and click the Select button to close the dialog.

13. Assign the water material to the currently selected water object.

14. Render the scene.

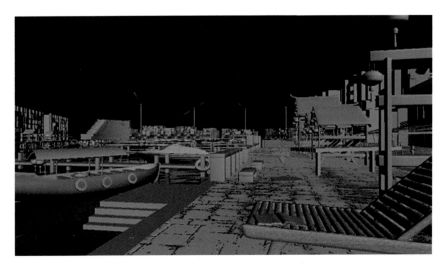

15. Go to the BRDF rollout parameters and open it.

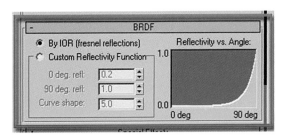

By default the BRDF is set to: By IOR (fresnel reflections); however, if this setting is not satisfactory you can change it to Custom Reflectivity Function and tweak the 0 deg refl: values. Lower values will produce less reflections and higher values will produce more reflections:

16. Click on the Custom Reflectivity Function button in the BRDF rollout.

17. Render to see the result.

18. Change the 0 degree refl: value to 0.4.
19. Render the scene again.

Note: The reflection of the boat in the foreground in the water is more pronounced, while the reflection of objects in the water in the distance is relatively unchanged. The Custom Reflectivity Function provides you with this flexibility. Next you will make some adjustments to the Ocean (lume) shader to adjust the surface of the water:

20. Go to the Special Purpose Maps rollout. Note the Ocean (lume) map in the Bump map slot.

21. Click on the Map slot to Display the parameters of the Ocean (lume) shader.

The current settings work well for most scenes; however, we are going to change them for better results in the harbor scene. Note that the values in the shader's parameters are relative to the scale of the objects as well as the current units set up:

22. Change the largest value to 0.2 mm and the smallest value to 0.05 mm.
23. Render the camera view to see the difference in the water.

24. Increase the steepness value to 2.0.
25. Render again.

Steepness determines the height of the waves, the right value will create realistic highlights on the water if the sun is directed to them. Your parameters should look like the following:

26. Go back to the Main parameters by clicking on the Go to Parent button.
27. Under the Special Purpose Maps rollout parameters set the Bump to 3.0.

28. Render the camera view.

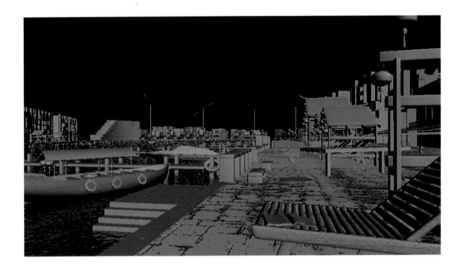

29. In the Main material parameters rollout, click on the Diffuse Color swatch to change its current color to pale green.

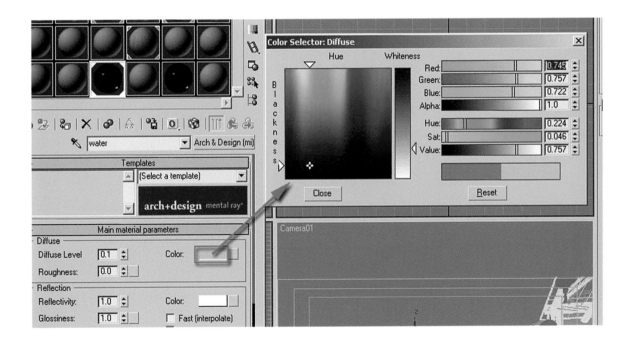

30. Click Render again.

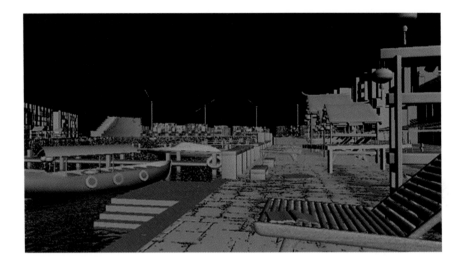

31. Save your file.

If you wish to experiment with other materials you can do so. Many of the objects in the scene will use the same techniques which have been introduced in this chapter.

4.8 Conclusion

In this chapter you worked on several materials in the exterior harbor scene. You used the Arch & Design material and learned about the Ocean (lume) shader used in the water surface.

Chapter 5

Lighting for an Exterior Scene

5.1 Introduction

In this chapter you will learn about lighting an exterior environment while you work on the lighting for the harbor scene. Specifically you will learn how to:

- Use mental ray for lighting an exterior environment.
- Adjust the parameters of the mr Sun object.
- Change the parameters of the mr Sky object.
- Apply this knowledge to a realistic scene.

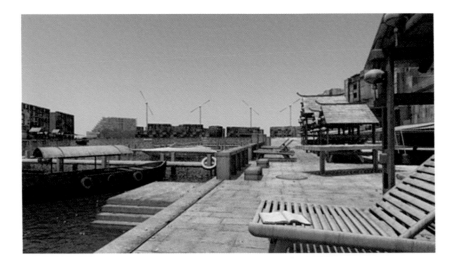

5.2 Exterior Lighting Concepts with mental ray

Exterior lighting with 3ds Max and mental ray has the potential to be a quick and easy process. Inserting a daylight system in an external scene can quickly establish three components for your exterior lighting: the sun, the sky and the sky environment.

While the daylight system provides this quick ease of use, it also provides an incredible amount of control over how the three components interact with one another to provide you with the lighting you want in your scene. The following section will describe many of the parameters of the daylight system.

When you have mental ray as the default renderer and create a daylight system in a scene, 3ds Max will create the daylight system with an mr Sun and an mr Sky and will also prompt you to use an mr Physical Sky environment map. While you may choose to not use all three of these components, the following chapter will use all three so that you can appreciate how they interact together.

You create a daylight system through the Create pull down menu on the Main toolbar.

When you expand the rollout of the daylight system you created you will see the amount of parameters which can be adjusted.

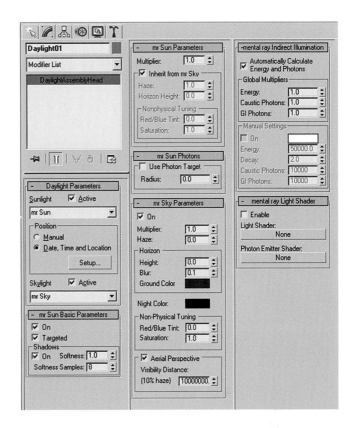

Quickly placing a daylight system in a scene like the harbor will show you what can be easily attained. The first image is only default lighting. The second image has the materials with a daylight system inserted. The third image has the materials overridden with a matte material. It is easier to see the effect of the lighting on the scene with the matte material.

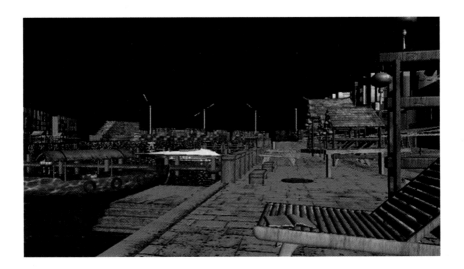

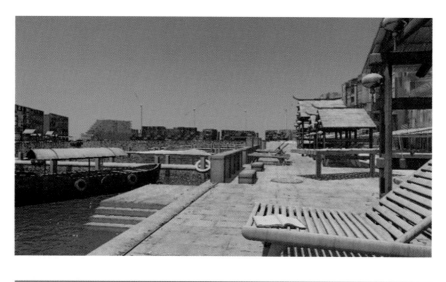

Although the scene lighting with a default daylight system is not bad, there is considerable room for improvement. Once you understand the parameters in mr Sun, mr Sky and mr Physical Sky you will be able to produce much more interesting lighting for your exterior scenes.

5.2.1 mr Sun Parameters

In the daylight system parameters you can adjust several parameters that will allow you to create different effects for the sun. The parameters discussed below are in the mr Sun Parameters rollout.

Multiplier: The multiplier affects the overall intensity of the light from a given source. In the two examples which follow the Sun and Sky Parameters were adjusted to give a different color. The multipliers are then adjusted to vary the effect of lighting in the scene.

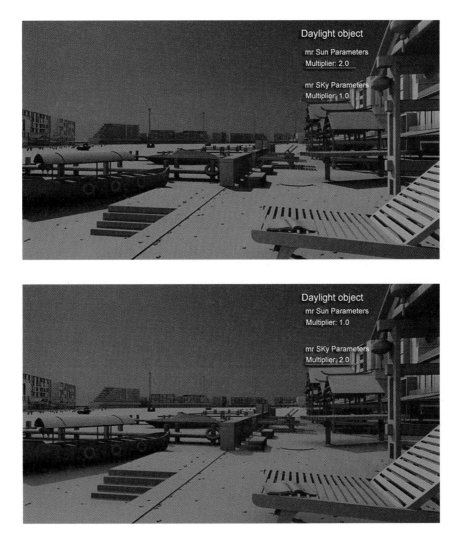

When you remove the check in the Inherit from mr Sky option, you will have access to a few additional options which allow further control over the lighting.

Haze: Essentially the amount of particles in the air which can lead to the sun's ability to penetrate to the earth.

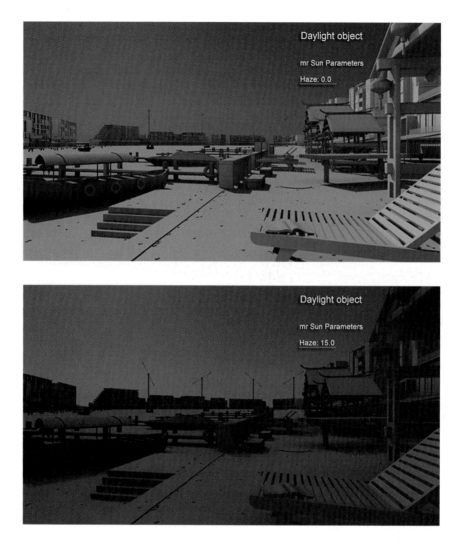

The second image would be mostly dark if it were not for light coming from the mr Sky component of the daylight system.

Red/blue tint: Sets the color (tint) of the sun, negative values start from −0.1 which is equivalent to light tones of blue down to darker tones of blue which is equivalent to −1.0. Positive values start from 0.1 which is equivalent to light tones of yellow down to darker tones of yellow which is equivalent to 1.0.

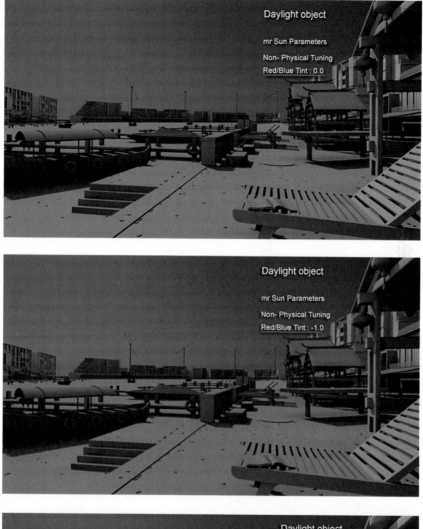

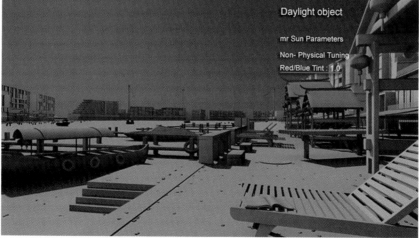

Saturation: Sets the saturation of the red/blue tint. This option is very useful to tone down strong colors like dark blue (−1.0) or dark yellow (1.0).

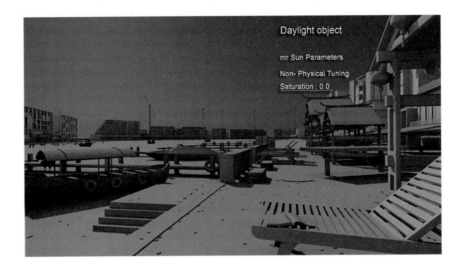

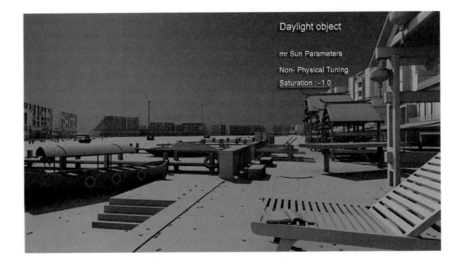

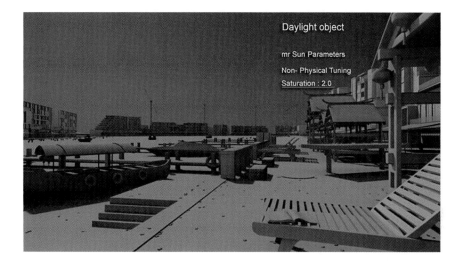

5.2.2 mr Sky Parameters

In the Daylight system parameters you can adjust several values that will allow you to create different effects for the sky. The parameters discussed below are in the mr Sky Parameters rollout.

Haze: Essentially the amount of particles in the air which can constrain the ability of light from the sky to penetrate to the earth.

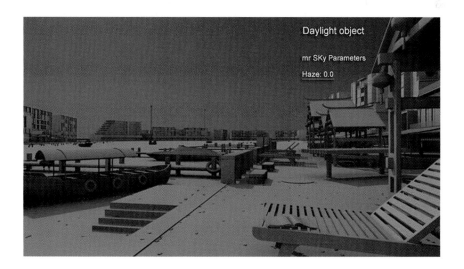

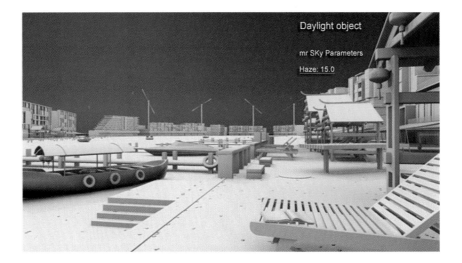

Red/blue tint: Sets the color (tint) of the sun, negative values start from −0.1 which is equivalent to light tones of blue down to darker tones of blue which is equivalent to −1.0. Positive values start from 0.1 which is equivalent to light tones of yellow down to darker tones of yellow which is equivalent to 1.0.

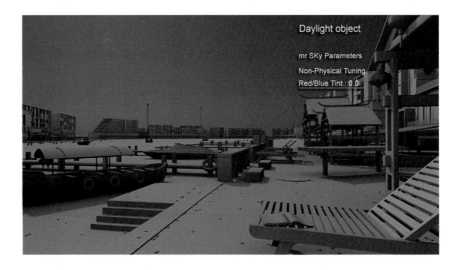

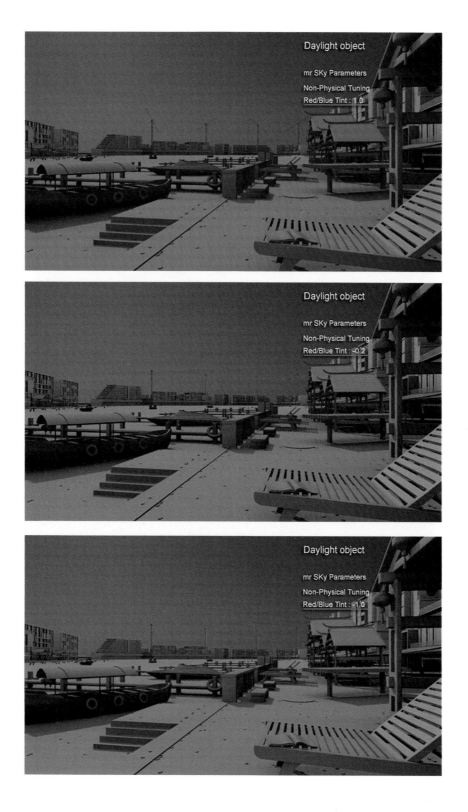

Saturation: Sets the saturation of the red/blue tint. This option is very useful to tone down strong colors like dark blue (−1.0) or dark yellow (1.0).

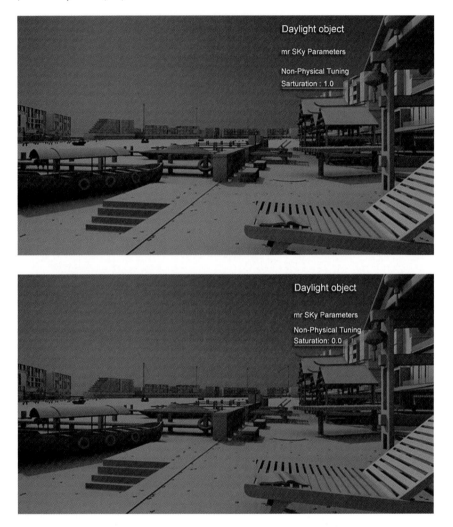

5.3 Starting the Scene

Before beginning work on this file you need to change the Default settings of 3ds Max to take advantage of the automatic creation of a mr Physical Sky environment map. This occurs automatically only when the Default Initial Settings are set to DesignVIZ.mentalray. To change this follow the steps below.

1. Go to the Customize pull down menu and select Custom UI and Defaults Switcher
2. In the dialog which appears select DesignVIZ.mentalray in the Initial Settings for tool options area in the upper left of the dialog.

You will be warned that these settings will only take effects once you restart 3ds Max

3. Restart 3ds Max

Next you will go through and establish the units setup, otherwise you will later encounter a number of undesirable results.

4. From the Customize pull down menu select Units Setup …

5. In the Units Setup dialog, in the Display Unit Scale, set the scale to Metric Millimetres.
6. In the Unit Setup dialog click on the System Unit Setup button.
7. In the System Unit Setup dialog set the System Unit Scale to Millimetres.
8. Click OK to exit both dialog boxes.

Note: It is important that the Units Setup and System Unit Setup are the same.

To get started you are going to open a version of the harbor scene where all the materials have been applied, but where only default lighting is being used:

9. Open the file **_Harbour daylighting.max_** from the files folder.

The units of 3ds Max have been carefully set in advance to match the units of the incoming file; both are in metric millimetres. It is often the case that a file being opened does not match the system units of 3ds Max. In this case, the File Load: Units Mismatch dialog box will alert you to the discrepancy. You should always adopt the file unit scale in order to avoid problems with units later in the development of the scene:

10. Once the scene is loaded, open the Render Scene dialog by clicking on the Render Scene dialog button on the Main toolbar.

11. In the Render Scene dialog, click on the Common tab.

Note: The output size values are currently set to a Width of 500 and a Height of 277. These values worked well for this scene, but you could enter different image sizes if desired.

12. Make sure the Camera01 view is selected, click on the Lock button next to the Viewport pull down list at the bottom of the dialog. This will lock the Camera01 view to be rendered until it is unlocked.

5.4 Establishing Basic Lighting Parameters

Before creating lights in the scene you will establish some parameters for how mental ray works with these lights:

1. If it is not already displayed, open the Render Scene dialog by clicking the icon on the Main toolbar.

2. Select the Indirect Illumination tab.

Note: The parameters for Final Gather are grayed out. This is simply due to the fact that it has not been enabled yet.

3. Click on the Enable Final Gather checkbox.

4. Make sure in the Advanced group that Draft Mode (No Precalculations) is not selected.

To reduce rendering time you are going to switch off all the materials in the scene. This will allow you to focus on the lights and their effect on the scene:

5. In the Render Scene dialog box, click on the Processing tab.
6. In Translator Options rollout check Enable in the Material Override area.

Next you are going to add a base material to the Material Override:

7. Open the Material Editor dialog box by clicking on its icon on the Main toolbar.

8. Click on the material called matte in the first column and the first row.
9. Drag and drop it onto the Material Override slot. The Instance (Copy) Material dialog box will pop up.
10. Choose the Instance Method and click OK to close the dialog box.

Note that the material assigned has ambient occlusion enabled. This option generates connecting shadows wherever this surface meets another.

11. Render the file by clicking the Render button on the Main toolbar.

Although quick to render, the rendering time could be decreased further for the purposes of these test renderings:

12. In the Final Gather rollout change the Preset from Custom to Draft. Note that the Basic parameters values have changed.

The next step is to add some depth to the image by creating lights in the scene. In this particular exercise we are going to emulate a harbor in the afternoon with a clear sunny sky.

The adjacent photo is a good photo reference for this exercise.

Note how the sun interacts with the environment as a whole. For instance the highlights created by its intensity; the strong shadows cast by it with a hint of blue generated from the sky's atmosphere. The scene's dark and bright areas create a very nice settled contrast that complements the calm waters.

In this example the entire lighting of the scene will be handled through the daylight system. The first step is to create the system itself:

13. Click Create on the main pull down menu, on the dropdown list choose Lights, followed by Daylight System.

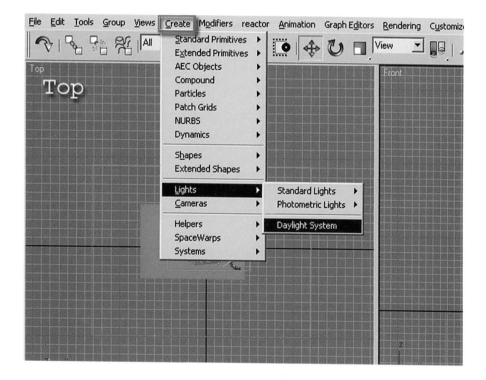

14. The Daylight Object Creation dialog box will pop up, prompting you to use the logarithmic exposure control. Click Yes to accept.

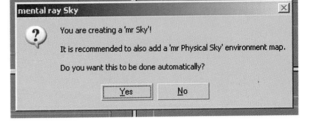

15. In the top viewport click and drag to create the compass rose so that the object is big enough to fit all the objects in the scene.

16. Release the mouse button to set the size of the compass rose. The mental ray Sky dialog will appear.

17. Click Yes to add a Physical Sky environment map automatically.

18. Drag the height of the Sun object and click to set the height. Make sure that the Daylight object is relatively far away from the scene objects, otherwise the scene will become too bleached due to excessive light.

19. Press Esc to come out of the creation process.

20. Render the Camera01 viewport to see immediate results.

Note the change in lighting from the initial rendering with default lighting. Note as well that a default sky (physically correct) has also been created. Next we are going to change the sky lighting color to a much darker blue to create some contrast in the scene:

21. In the mr Sky Parameters rollout under non-physical tuning section set the Red/Blue Tint value to −0.34.

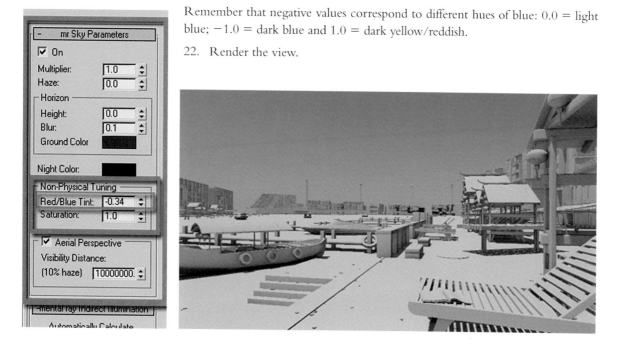

Remember that negative values correspond to different hues of blue: 0.0 = light blue; −1.0 = dark blue and 1.0 = dark yellow/reddish.

22. Render the view.

The scene seems overly blue now; that is due to the fact that the sun is inheriting the Sky's Parameters (tint, etc.):

23. To correct this go to the mr Sun Parameters rollout and uncheck the Inherit from mr Sky option.
24. Render again to see the changes.

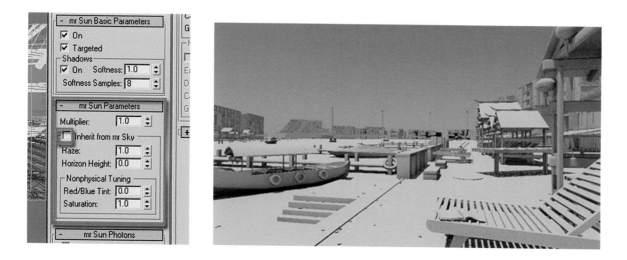

The tint in the scene is more balanced now; however, the dark shadows are not catching the tint from the atmosphere:

25. A simple way of changing that is to increase the Sky's Multiplier value to about 4.5 under the mr Sky parameters rollout.

26. Click Render.

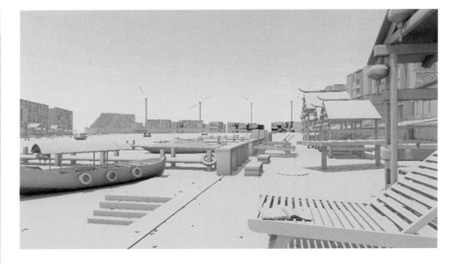

27. Next we are going to change the sun's color to a dark hue of yellow by changing its Red/Blue Tint value to 0.5 in the Nonphysical Tuning section under the mr Sun Parameters rollout.

28. Also change its Multiplier value to 2.0 so that sun's color will be more noticeable as the sky's color is currently too predominant.

29. Render to see the changes.

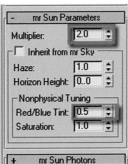

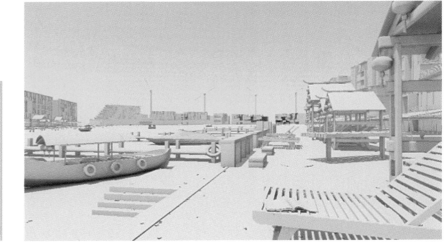

Note that haze values, as described in the above section, are available in both the Sun and Sky Parameter rollouts. You can make adjustments to the haze values, but you need to be careful. Increasing the sun's haze values too high and you may end up with no shadows from the sun. Increasing the sky's haze values and you may end up with no shadows from the sky.

5.5 Refining the Lighting and Creating a Rendered Image

More information on the mr Physical Sky shader will be presented in the next chapter. For the moment you will finalize your settings for the lighting and execute a rendering. In an exterior scene with a daylight system Global Illumination is not typically necessary. This is due to the combination of the mr Sun and mr Sky shaders producing both direct sunlight and ambient lighting. Occasionally, you may wish to enhance the exterior lighting with Global Illumination and the following procedure may be helpful:

1. Open the file **Harbour daylighting_01.max** or continue working on your previous file.
2. Open the Render Scene dialog and click on the Indirect Illumination tab.
3. Go to the Caustics and Global Illumination rollout and check the Enable option in the Global Illumination.
4. Make sure the Daylight01 object is selected.
5. In the Modify panel open the mr Sun Photons parameter rollout.
6. Check the Use Photon Target option.
7. Adjust the radius value to encompass the entire harbor area, a value of approximately 500.00 is good.

Adjusting the photon's **radius** to target a desired area only will avoid processing areas of no importance. Experiment with Global Illumination being on or off and notice the difference in rendering speed and the quality of the image. For the purpose of the remainder of this tutorial you should turn off Global Illumination:

8. Go to the Render Scene dialog.
9. Go to the Caustics and Global Illumination rollout and turn off Global Illumination.

Next you will enable the daylight object manual settings option under the Indirect Illumination rollout:

10. Go to the mental ray Indirect Illumination rollout and uncheck the Automatically Calculate Energy and Photons and check the On option in the Manual Settings area.
11. Go to the Render Scene dialog and select the Processing tab.
12. Remove the checkbox in the Enable option of the Material Override section.

13. Render to see the results of your lighting in the scene.

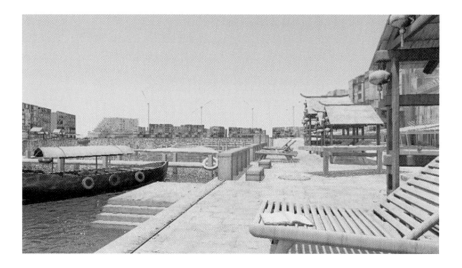

Next you are going to balance the overly bright scene by changing some logarithmic exposure settings:

14. In the Rendering menu on the main pull down menu choose Environment. The Environment and Effects dialog will display.
15. Change the Brightness to 50.0 in the Logarithmic Exposure Control Parameters rollout.
16. Increase the Contrast to 70.0.
17. Check the Desaturate Low Levels checkbox.
18. Render to see the results with the new Exposure control settings.

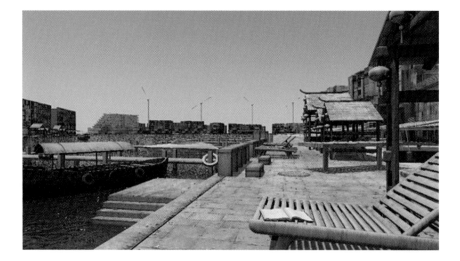

The image has been greatly improved by reducing its brightness and increasing contrast. You can make further adjustments to these settings to experiment and see if you can obtain settings which are more suitable to your personal preferences.

Note: The Exterior Daylight option in the logarithmic exposure settings is enabled. When you created the daylight object and the exposure controls were turned on, this option was automatically enabled. Exterior Daylight makes allowance for the bright sunlight contained in the daylight object. It should always be enabled for scenes with a daylight object. Removing the option would give you a scene completely washed out with light as illustrated:

19. If you had experimented with the Exterior Daylight option make sure the option is properly enabled. With the proper exposure controls the image looks satisfactory.
20. Open the Render Scene dialog box.

21. Go to the Indirect Illumination tab.
22. Under the Final Gather rollout change the draft settings to High. Note how some of the Basic settings change automatically.
23. Change the Rays per FG Point value to 150. Keeping this value to as low a value as possible will speed rendering time.
24. Change the Diffuse Bounces value to 1. Higher values will result in excessive color bleeding.

25. Click on the Renderer tab in the Render Scene dialog.
26. In the Sampling Quality rollout, Filter group, change the type to Mitchell.

This filter is particularly useful on images of a small resolution as it sharpens them:

27. Change the Width and Height values to 5.0.

Increasing the width and height values will improve the image especially images of smaller resolution:

28. In the Samples per Pixel group change the Minimum value to 1 and the Maximum to 16.

29. Render to obtain a final image.

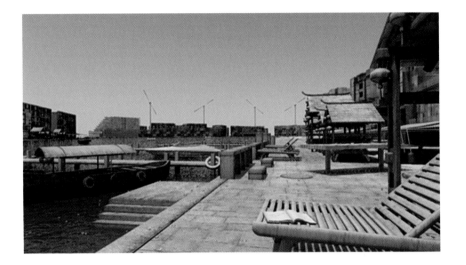

Once you are finished this lesson it is best to switch your defaults back to the standard 3ds Max defaults.

30. Go to the Customize pull down menu and select Custom UI and Defaults Switcher
31. In the dialog which appears select Max in the Initial Settings for tool options area in the upper left of the dialog.

You will be warned that these settings will only take effects once you restart 3ds Max

32. Restart 3ds Max at your convenience

5.6 Conclusion

In this chapter you learned about creating lighting in an exterior environment using a daylight system and mental ray. You learned about specific settings in the daylight object and their effect on the exterior lighting. You then went on to apply this knowledge to a realistic scene where you created a daylight system and used the mr Sun and mr Sky to adjust the appearance and quality of the lighting. The results show a much improved daylight scene.

Chapter 6
Working with the mr Physical Sky Shader

6.1 Introduction

In this chapter you will learn about enhancing the exterior environment through the use of the third component of the daylight system, mr Physical Sky. mr Physical Sky is an environment map that you find in the Environment and Effects dialog automatically inserted as the Environment Map when you choose to use mr Physical Sky when the daylight system was created. In this chapter you will learn how to:

- Render a disk of the sun or moon using mr Physical Sky.
- Adjust the parameters that affect the appearance of this disk element.
- Create camera haze.
- Apply a bitmap background which will interact with the mr Physical Sky shader.

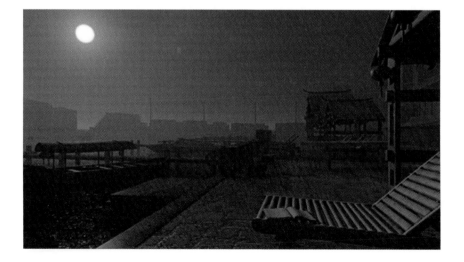

6.2 mr Physical Sky and the Sun Disk

The sun disk, or moon for that matter, is a rendition of the spherical shape of the sun. It is generated by the mr Physical Map Environment shader at the location of the of the Sun object in the daylight system. By default the Sun object is placed based on a set of automatic parameters based on the default location of San Francisco, California, with North pointing up in the top view. These parameters can be adjusted by select-ing the Setup button in the Daylight Parameters rollout of the daylight system.

What is of greater interest to us at the moment is the ability to place the Sun object at a specific location in our scene. Note in the same rollout above a Manual option, which will allow you to place the sun by using the Select and Move tool. While using this method is not necessarily correct based on the location of the scene on the earth and the time of day and year, it allows you to add some artistic license and improve the composition of the image.

6.3 Moving the Sun to a Desired Location

In the steps which follow you will relocate the sun so that it will fall into the field of view of the camera:

1. Open the file *Harbour Physical Sky.max*.
2. Render the Camera view.

3. Select the Daylight 01 system.
4. In the Daylight Parameters rollout select the Manual option in the Position area.
5. Click on the Select and Move button in the Main toolbar.

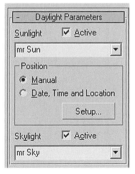

6. Move the top of the daylight object in the Front view so that the angle of the system is approximately 10–15 degrees off of the horizontal. You should be able to see the Sun object in the camera viewport.

7. Render the Camera view.

Further adjustments of the mr Physical Sky need to be done in the Environment and Effects dialog and the Material Editor.

6.4 The mr Physical Sky Shader

When you open the Environment and Effects dialog you will note the presence of the mr Physical Sky in the Environment Map slot.

Creating an instance of this map in the Material Editor will reveal the mr Physical Sky Parameters.

You will only be able to see the effect of these parameters when you render the scene. Numerical values are based on the scale of the objects as well as the units set up.

6.4.1 Sun Disk Appearance Group

Note that there is a slight offset between the position of the daylight object on the Viewport and the Sun Disk Appearance when rendered.

Disk intensity: Sets the intensity of the sun disk. The term disk is used to describe the "oval" shape of the sun. Default = 1.0.

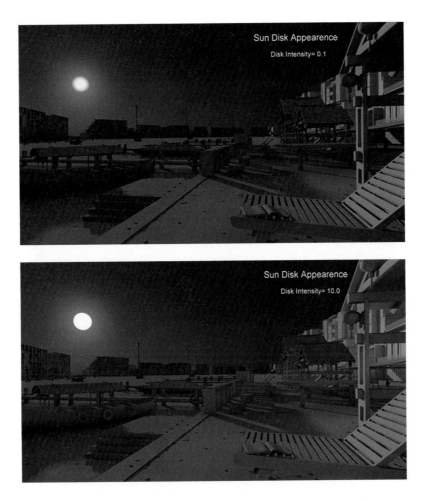

Glow intensity: Sets the amount of glow around the sun. Default = 1.0.

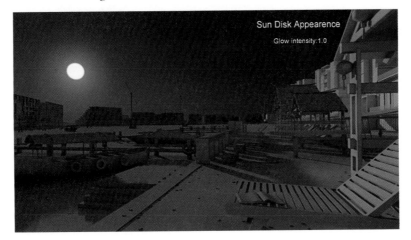

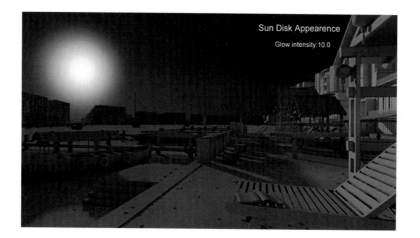

Scale: Sets the size of the Sun Disk Appearance when rendered. Default = 4.0.

Use custom background map: When enabled it allows a bitmap to be applied to the environment. Default = none.

6.4.2 Inherit from mr Sky Group

When unchecked it unlinks the mr Physical Sky Parameters from the mr Sky component of the daylight system object parameters (skylight).

Multiplier: Sets the brightness of the sky. When on, the default = 1.0.

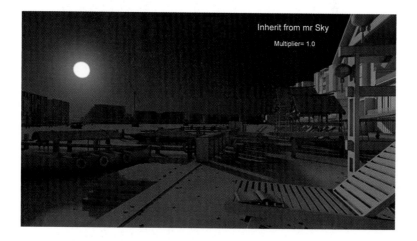

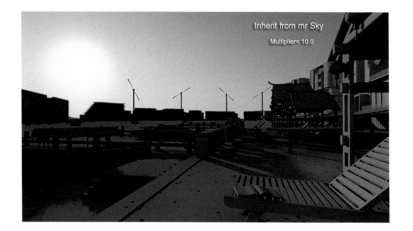

Haze: Sets the amount of haze (fog) in the sky. This section is mainly to blend a bitmap with the current sky. Note that when using a bitmap in this slot the RGB Level value under the Output rollout parameters has to be 6.0 or above for visible results. Default = 0.0.

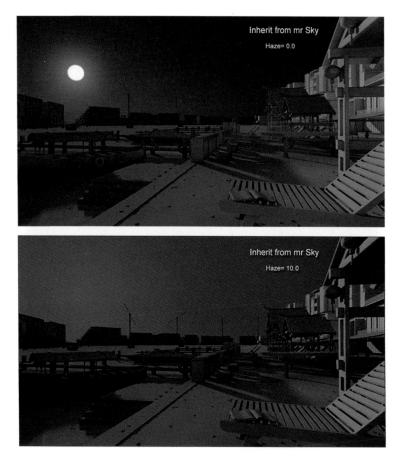

A map can be assigned to the Haze value to give a varied texture to the sky. See more about this in the tutorial which follows.

6.4.3 Horizon and Ground Group

Horizon height: Sets the position of the horizon line. In a typical 2 point perspective, where the camera and target are at the same Z height, the horizon is in the vertical center of the view (i.e. halfway up the *y*-axis). This value allows you to adjust where the horizon is positioned relative to this default location. The horizon will only be visible when the horizon is visible in the view. For example a view looking up or down where only sky or ground is visible will not see the horizon line. The default 3ds Max perspective view does not see the sky and therefore the horizon line is not visible. Default = 0.0.

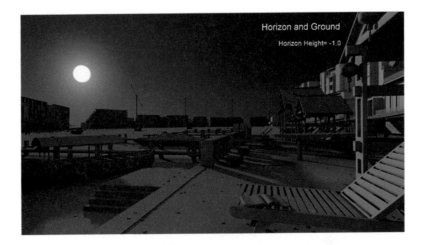

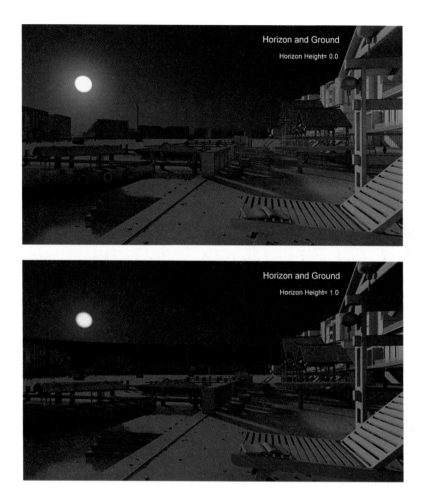

Blur. Determines the blurriness of the horizon line. Default = 0.1.

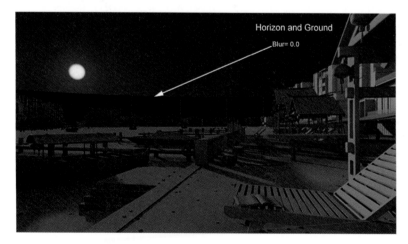

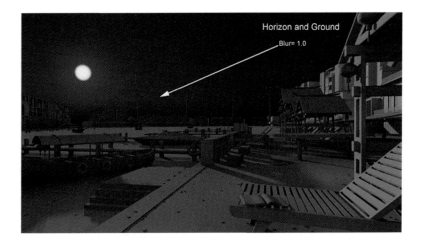

Ground color: Sets the color of the lower part of sky's horizon line. Its default color can be changed by clicking and holding its color slot. Or alternatively load a custom bitmap on the empty slot. Default = dark gray.

6.4.4 After Dark Group

Night color: Sets the color of the sky as the daylight system object comes closer to the horizon line; note that the night color transition happens automatically. Its default color can be changed by clicking and holding its color slot. Or alternatively load a custom bitmap on the empty map slot. Default = black.

6.4.5 Non-Physical Tuning Group

Red/blue tint: Sets the color or tint of the sky. Negative values start from −0.1 which is equivalent to light tones of blue, to darker tones of blue which is equivalent to −1.0. Positive values start from 0.1 which is equivalent

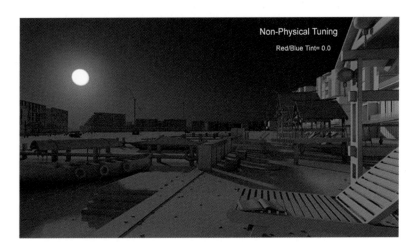

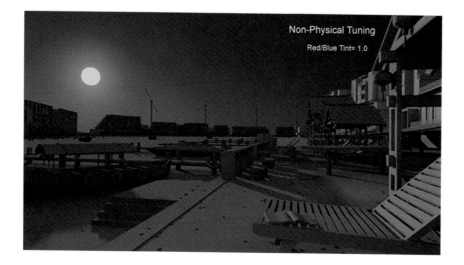

to light tones of yellow, to darker tones of yellow which is equivalent to 1.0. Alternatively a custom bitmap can be loaded into the empty map slot. Default = 0.0 (neutral).

Saturation: Sets the saturation of the red/blue tint. This option is very useful to tone down strong colors like dark blue (−1.0) or dark yellow (1.0).

Default = 1.0.

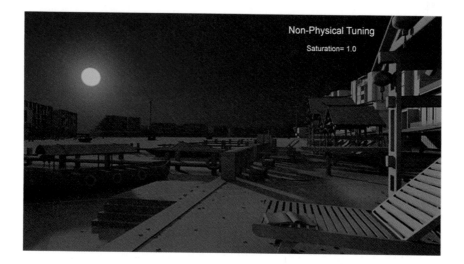

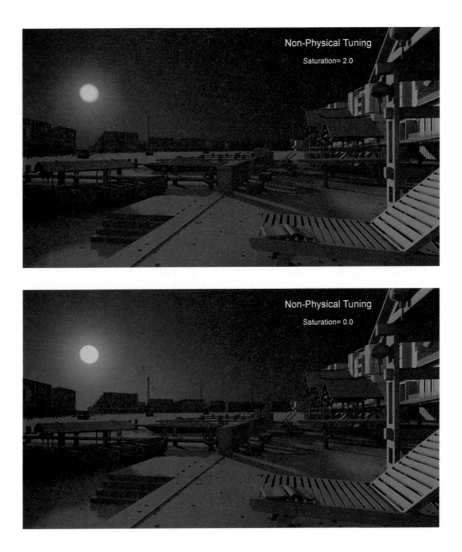

6.4.6 Aerial Perspective (When Used as Lens/Volume Shader Only) Group

Visibility distance (10% haze): Sets the visibility of the sun disk under the haze (10%). Note that this option is recommended only when using this shader as camera shader, as this will enable the haze's distance control.

6.5 Creating Camera Haze

In the following steps you will create a camera haze which will allow you to control the haze depth:

1. Open the file ***Harbour Camera Haze.max***.
2. Open the Render Scene dialog box.
3. Click on the Renderer tab.
4. Go to the Camera Effects rollout.

5. Click on the Map slot next to the Lens option in the Camera Shaders area.

6. Select mr Physical Sky from the Material/Map Browser. Click OK to close the dialog.
7. Drag and drop this map into the Volume Map Slot, select Instance when prompted by the Instance (Copy) Map dialog.
8. Open the Material Editor.
9. Drag and drop the map in either the Lens or Volume slot into a Material Editor sample slot.
10. Select Instance when prompted by the Instance (Copy) Map dialog.
11. Open the Environment and Effects dialog.
12. Drag and drop the map in either the Lens or Volume slot into the Environment Map slot.
13. Select Instance when prompted by the Instance (Copy) Map dialog.

Note: Even though there is already is an mr Physical Sky map in the Environment Map slot, it is not instanced to the one in the Camera Shaders slots. The above operation creates an instanced map.

14. Render the Camera viewport.

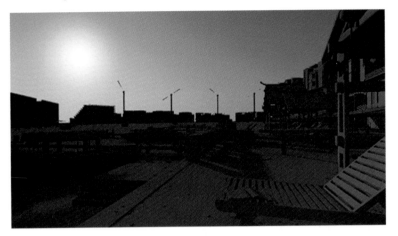

No haze appears in the view since the default Visibility Distance of 0.0 disables the haze.

15. Change the Visibility Distance to 200.0.
16. Render the Camera viewport.

A very obvious haze now appears in the image. You can adjust the distance to your liking so that the haze starts coming closer to the camera or goes further away.

Note: These parameters are similar to the daylight system object. The daylight system object parameters interact with the objects in the scene whereas the mr Physical Sky parameters only affect the sky. Its interactivity only goes as far as being visible on reflective surfaces.

6.6 Using a Bitmap Background in mr Physical Sky

In the next few steps you will insert a background in the mr Physical Sky shader so that the background will interact with the other settings in the mr Physical Sky:

1. Open the file *Harbour Sky Bitmap.max*.
2. Render the Camera01 viewport.

3. Open the Material Editor dialog box.
4. In the Render pull down menu, select Environment.
5. Drag and drop the map in the Environment Map slot (mr Physical Sky) shader from the slot to a material slot in the Material Editor dialog box.
6. The Instance (Copy) Map dialog box will pop up. Choose the Instance Method followed by OK to close the dialog box.

7. The mr Physical Sky Parameters rollout will appear.
8. Uncheck the Inherit from mr Sky option.
9. Click on the Haze Material slot and choose Bitmap from the Material/Map Browser dialog box list followed by OK to close the dialog box.

10. Locate and load the bitmap *Sky sunset copy.jpg*.
11. Once the bitmap is loaded, in the bitmap Coordinates rollout choose Screen.

12. Change the Blur values to 0.5. This will sharpen the bitmap.

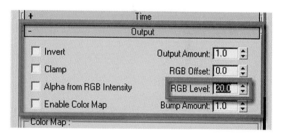

13. Go to the Bitmap Output rollout and set the RGB Level value to about 20.0. Higher values are recommended so that the bitmap will be more visible in the rendering.
14. Click Render.

6.7 Some Notes About mr Physical Sky

When a background map needs to be accurate when rendered it is necessary to tweak some of its settings. If you would like to try some of these suggestions you could repeat the previous exercise and after step 7 pick up with the following:

8. In the mr Physical Sky Parameters rollout Click on Use Custom Background Map.

9. Click on the Use Custom Background Map button.

10. Select Bitmap from the Material/Map browser and find *Sky Sunset copy.jpg*
11. In the Output parameters of the Bitmap rollout, change the RGB Level to 150.0
12. Click on the Enable Color Map option.
13. Select Mono as the Color Map Type.

14. Render the Camera view.

Note: You can further manipulate the background image by adjusting the color curve. You can move and add points in the curve. Even something as simple as the curve adjustment pictured above can produce dramatic results.

Even though this map is used as a background reflective objects will continue to reflect the sky generated by the daylight system. In order to get the reflective objects in the scene to reflect the correct shade of the sky you will have to adjust the color of the mr physical sky.

6.8 Conclusion

In this chapter you learned about using the mr Physical Sky shader. You used this shader to affect the background of the image including the color and placement of a disk object which can be used to simulate the sun or moon. Finally you used mr Physical Sky to create camera haze and you used a bitmap to create haze in the scene.

Conclusion and Further Study

Naturally it is not possible for us to cover every aspect of mental ray in a book of this size. Our approach is to give you a taste of what it is like to work on real life projects and how to develop materials and lighting for those projects. It is our hope that you can now apply the principles seen in these chapters to your own projects.

To continue to improve you will need to search out material in a variety of forms. Books, DVDs and courses are, as you should have found in this case, very useful when you want to substantially increase your knowledge in a particular subject.

E-learning and web sites offer a great source of material which can be more easily assimilated in smaller pieces. User forums can offer assistance from your peers.

In addition, you should keep your eye out for this book again in future releases. We hope to keep adding to the material contained here and make the book bigger and better all the time.

All the best!

Web sites
http://area.autodesk.com/
http://www.cgchannel.com/
http://rec-blog.blogspot.com/

Books
3ds max 9 Essentials, Focal Press & Autodesk

Appendix 1

CAD Transfer

A1.1 Introduction

In this Appendix you will learn about transferring CAD models to 3ds Max to be used in rendering with mental ray. Specifically you will learn:

- What exactly is CAD transfer.
- The reason you would want to link or transfer CAD files.
- An approach to modeling and rendering with linked files.
- A process to linking CAD files from AutoCAD and Revit Architecture.

A1.2 Overview

CAD transfer refers to the translation of geometry from one CAD program to another. This process can be in both 2D and in 3D, but the focus in this book will be primarily on the 3D translation of information. In its simplest form if you had a geometric primitive like a box, sphere or cylinder in one CAD program, you would like it to at the very least appear to be a box, sphere or cylinder in another CAD program. There are two approaches available to transfer 3D geometry from CAD programs in 3ds Max: importing and linking.

A1.2.1 Importing 3D Geometry

When you import 3D geometry from a CAD software package into 3ds Max you are instructing 3ds Max to read the contents of a non-native file, i.e. not a *.max* file, and read it into the current scene file.

There are a multitude of file types which are supported like the Autodesk *.dwg* or *.dxf* file format, the old 3D Studio *.3ds* file format as well as formats which are supported from Inventor, Lightscape and Wavefront.

When you combine this with the fact that many 3D modeling software have the ability to export directly to the *.dwg, .dxf, .3ds* or *.obj* file format you have the ability to import geometry from almost any source into 3ds Max.

When you import geometry from these CAD software into 3ds Max it is important to note that the geometry has been translated and recreated in 3ds Max. The original file in the home program still exists, but the translation of the geometry has not created any link between the file in the CAD software and 3ds Max. This becomes important if and when you update the geometry in the original CAD software. The updated geometry must be re-imported into 3ds Max.

A1.2.2 Linking AutoCAD Files

The difference in linking and importing files is the difference between having a live link between your CAD file and 3ds Max, and having no link between the files. When you import geometry you have no link, when you use file linking you have a live link between an AutoCAD *.dwg* file and the 3ds Max *.max* file. At this point in time the ability to link files to 3ds Max is limited to the AutoCAD *.dwg* file format only.

Although the step-by-step process in linking a file is different to importing, the overall idea is the same. You select a file, then establish a series of settings and the geometry from the chosen file is brought into 3ds Max.

When you link AutoCAD *.dwg* files you create a link which allows you to change the geometry in the *.dwg* file such that this information can be updated in 3ds Max. AutoCAD users who are familiar with the Xref feature in AutoCAD should expect a similar type of behavior with file linking in 3ds Max. One additional characteristic in 3ds Max is the ability to add modifiers and materials to objects which have been file linked. For the most part modifiers and materials will remain properly applied when linked files are updated.

A1.2.3 Why Transfer Files?

You might be asking yourself at this point why transfer files at all? Can't I just model in 3ds Max? The short answer would be that yes you can model in 3ds Max and avoid any of the problems associated with transferring files. It should be said that this approach is not without precedent. Some architectural animation artists will remodel a 3D model in their rendering application instead of transferring files. As the ability and fidelity to transfer files increase the need to recreate geometry diminishes.

Here are some of the situations or reasons which you might encounter when in work-related situations that might cause you to transfer data from a CAD program to 3ds Max.

- *Individual preferences*: Probably one of the strongest motivators for individuals using one software program or another is "I know how to use it". If an individual is skilled in modeling in AutoCAD is suddenly asked to create a model in 3ds Max, so that they render it in 3ds Max, they might find it easier to model in AutoCAD rather than relearn some of their tried-and-true modeling techniques in 3ds Max.
- *Precision tools*: 3ds Max has had some history as having some difficulty with precision tools. With more recent releases some of these issues have been resolved, whereas some have remained. AutoCAD continues to have the most accessible and accurate set of precision tools in the Autodesk suite of products. For this reason it is often favored by architectural modelers who require a high degree of precision.
- *Architectural modeling*: Autodesk Revit is the software application which is being favored by more and more architectural firms. The advantage in using an application like Revit is its ability to create and modify architectural geometry. Although 3ds Max contains Wall, Door and Window objects, they are not to the level of sophistication as in Revit. Revit will generate a 3D model while it creates final construction documents for the building project. This dual use for the Revit drawing set makes it an ideal choice for building projects.

A1.3 An Approach to CAD Transfer

Probably in each and every one of your projects you may need to change your approach to CAD transfer slightly. Even so, there are some guidelines that you will always need to keep in mind. Circumstances may make it impossible to implement these principles in whole or in part, but the more you can adhere to the guidelines the more your project should run smoothly.

In the sections which follow we will focus primarily on using File Linking of AutoCAD *.dwg* files to 3ds Max.

A1.3.1 A Generalized Approach to Modeling and Rendering with Linked Files

This section serves as a generalized overview of the processes and rules of creating a rendering using a linked 3D model. They are hard-and-fast rules which can be bent somewhat once you are more comfortable with the process.

- *Modeling*: Do all of your modeling in the modeling program. If you are using AutoCAD to model a building then do all of the modeling in AutoCAD.
- *Lights and materials*: Add lights and materials in 3ds Max. Although AutoCAD allows you to add lights to your scene and materials to your objects the lights will not be the mental ray light types nor will the materials be of the Arch & Design material type used extensively in this book.
- *Modeling and materials*: When you model your buildings you should try to keep in mind how you will be applying materials once you are in your rendering program. Different modeling programs will require different approaches, but remembering that something you are modeling is going to be rendered with two or three materials, might make you change your modeling approach. See the individual discussions in the AutoCAD and Revit sections.

A1.3.2 Exceptions to the Generalized Approach

As with most rules there are exceptions to the rules. As stated earlier you may need to alter your workflow as situations change. Perhaps it might be different team members on your project, or perhaps data may be available in another format that you are traditionally used to working with. Probably the most common exceptions to the Modeling > Lights, Materials workflow presented above are as follows:

- *Entourage*: Generally refers to the non-building elements which are placed in and around a building or space. Sometimes an entourage element can be a 2D poster or an entire 3D model. Entourage can be landscape elements like trees and plants or they can be people, vehicles, light posts, etc. The overriding commonality between all these elements is that they are placed in a scene to enhance the scene's realism, its believe ability and finally they are inserted in the scene quickly without much work involved. In 3ds Max a great amount of entourage elements are available all the way from individual *.max* files which you can merge into your scenes. To plugins that generate geometry based on user-specified parameters. In order to keep the entourage as quick and easy to use as possible, materials should already be applied. In the case of entourage these modeling elements will most likely come directly into 3ds Max and never be modeled or imported into AutoCAD.

- *Materials*: For the most part materials will be defined in 3ds Max. There are some situations in Revit where a complex wall can be defined with profiles and with multiple materials. For example you may wish to have an exterior profile with stone below and brick above. If you do not assign materials to this wall in Revit the wall will be imported into 3ds Max as one material, leaving you the task of assigning materials by faces. If you do assign the material in Revit you will be able to choose the material in 3ds Max and reassign it to whatever 3ds Max material you would like.

A1.4 Process of Linking Files

This section will discuss in some more detail how you go about importing models from two popular CAD packages from Autodesk: AutoCAD and Revit. AutoCAD is a general purpose CAD package which has a multitude of tools available to you to create 3D models of buildings. For the most part, the 3D tools in AutoCAD are generalized tools and have been adapted by end users to suit them in creating buildings. AutoCAD has an adaptation of AutoCAD for architects called AutoCAD Architecture or what used to be called Architectural Desktop.

Revit on the other hand is a software program designed for architecture. It works with 3D data and then displays that information when required in 2D. It is a completely standalone program from AutoCAD.

A1.5 Linking Files from AutoCAD

Consider a file like the one below.

This might be a typical file you may have to deal with from AutoCAD. The model is carefully layered and has been constructed mostly using solid modeling techniques in AutoCAD.

A1.5.1 Layers

This building has been modeled with an eye on the eventual materials which will be used in the rendering in 3ds Max. Probably the easiest way of keeping different materials separated is to place them on different layers. Look

215

carefully at the layers for the curtain wall glass. There are three layers due to the fact that the design calls for three colors and levels of transparency for the glass. Separating them on different layers will make it much easier to apply materials in 3ds Max later.

A1.5.2 File Link Manager Parameters

When you use the File Link Manager you can adjust some parameters to control how the 3D geometry will be imported in from AutoCAD. Once you locate the *.dwg* which you wish to link there are two basic areas of major concern:

- A Presets Tab in the File Link Manager allows you to modify the import parameters.
 - In the Basic Tab, adjust the Surface deviation for 3D solids to lower values to get smoother curved solids geometry.

- In the Advanced Tab, you might note the different type of methods that 3ds Max can generate objects from the imported AutoCAD information. It is worth to note, but only experiment with this value if there is truly a problem with the imported 3D geometry.

- In the Attach Tab, a Select Layers to include button allows you to select individual layers to include or exclude. By default layers frozen in AutoCAD are ignored.

A1.5.3 AutoCAD Layers, 3ds Max Layers and 3ds Max Objects

Once you import the file in 3ds Max you will get the following result. Note that there is a one-to-one ratio between the layers in AutoCAD and the layers in 3ds Max. Also you might notice that there is one layer in the 3ds Max illustration which is frozen, remember that a frozen layer in 3ds Max does not mean the same thing as a frozen layer in AutoCAD. That layer was originally locked in AutoCAD.

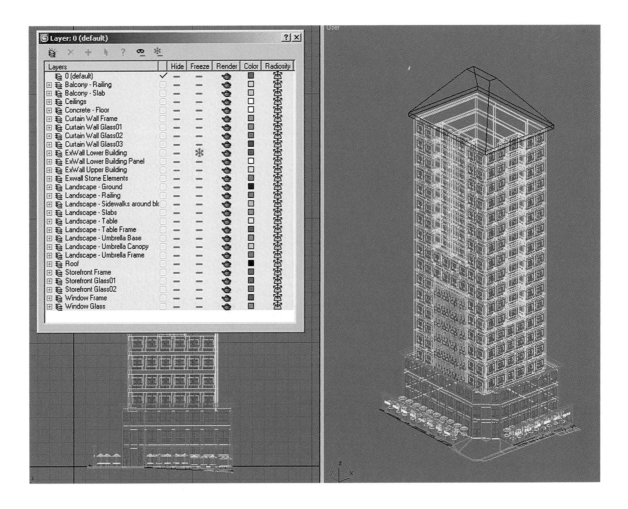

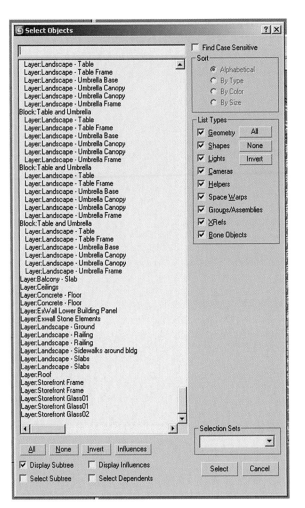

If you display the Select by Name dialog you will see some more similarities with the layer structure.

In some cases where objects are on a layer in AutoCAD and are not blocked with objects on other layers these objects will be attached into a single object. In the illustration these objects are listed at the bottom of the dialog. For example the object Layer:Roof.

In other cases there are 3ds Max objects listed in the Select by Name dialog as blocks and then a series of linked objects which are identified as layers: (layername). In the illustration you should note a series of blocks called Table and Umbrella. There will be an object like this for each occurrence of the AutoCAD Block, Table and Umbrella. The structure underneath the 3ds Max Block object is all the elements on a given layer attached to that occurrence of the block.

Although this may seem complicated, this structure allows a great amount of flexibility to select a single block occurrence, a single object within the block or all the objects on a layer.

Single Table and Umbrella block selected:
In the Select by Name dialog the Block: (Blockname) object entry is selected with the Select Subtree checkbox enabled.

Single Umbrellas selected in 1 block:
Selected in the viewport or by selecting by name in the Select by Name dialog.

Select all Umbrellas:
by switching the current layer to the Layer, Landscape – Umbrella Canopy and then selecting the Select Objects in the Current Layer in the Layer toolbar.

A1.5.4 Applying Materials

Once you have the ability to easily select objects that were created on the same layer in AutoCAD, it should be easy for you to apply a material to these objects. Simply select the objects you want the material to be applied to and use the Apply Material to Selection button in the Material Editor of 3ds Max. The objective is to make the layers in AutoCAD match with material assignments in 3ds Max.

A1.5.5 More Complex Material Assignments

In certain situations it will be difficult or practically impossible for you to create an object on different layers in AutoCAD so that the materials are easily distinguishable. Take the example of walls: each side of a wall may require a

different finish, whether it is as simple as two colors of paint for two sides of an interior wall, or a different material completely like the inside and outside of an exterior wall. In situations like this it may be more beneficial to use techniques in 3ds Max which allow you to assign materials directly to the face of an object.

In the following illustration the exterior walls of the base of the building have been isolated. The interior faces of the exterior walls have a neutral material applied to them while the exterior faces have a purple granite, somewhat exaggerated for the clarity of the illustration.

In order to apply different materials to separate faces of the same object, you must do two things:

1. Create a special material called a multi-subobject material where you will create a series of numbered materials.
2. Assign a material modifier to selected faces using the mesh select modifier. The material number in the multi-subobject material corresponds to the number assigned in the material modifier.

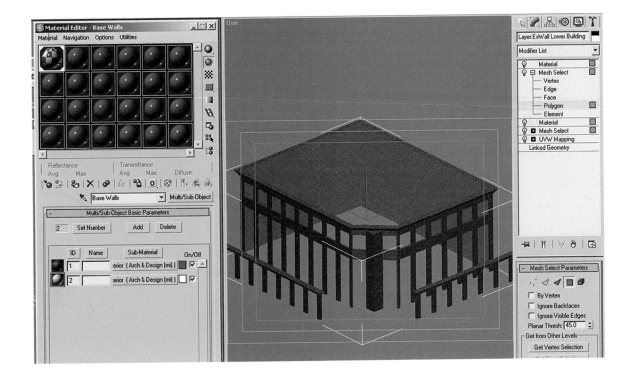

A1.5.6 Mapping

A similar approach to mapping textured materials will be necessary if you need to have a distinct patterned material, like the roof seams in the following illustration, applied to a single object. A simple roof form, like the one pictured, will require the application of Mesh Select modifiers and UVW maps in order that the direction of the texture changes on different surfaces of the same object.

A1.5.7 Reloading Linked Files

One of the great advantages to linked files is the ability to reload a linked *.dwg* file which has been changed or modified in some manner. With some

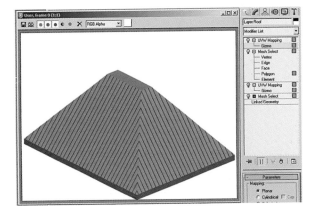

exceptions the lighting and materials which you have applied to the model in 3ds Max will be applied to the newly reloaded model. Reloading a linked file occurs in the File Link Manager Dialog in the Files tab.

When you change your AutoCAD model and save the file, an icon with a red flag will appear in the file list in the File Link Manager. This icon is a reminder that the file needs to be reloaded. Once reloaded the changes to your model will appear in 3ds Max. Generally the lighting you have created in 3ds Max will not be affected by any new geometry.

When materials and mapping are simple they will not be affected by any changes in the geometry of an object in AutoCAD. Here are some of the things to look out for in reloading your AutoCAD geometry.

- You must select the two checkboxes in the File Link Settings dialog box in the Advanced Tab related to Using Scene Material definitions and assignments. Otherwise the reloaded file will be reloaded without any materials assigned and you will have to reassign them.
- If you create a new layer and populate it with objects in AutoCAD this will create a new object in 3ds Max. Since this object has never been in 3ds Max before this object will not have any materials or mapping assigned to it.
- If you have assigned materials based on faces on a given object, if that object were to change in AutoCAD such

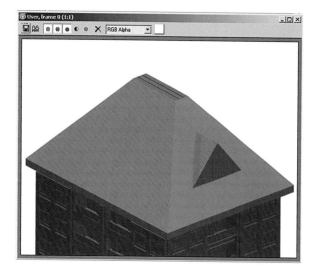

that the number and positioning of faces were changed (called a change in topology), this would disrupt the assignments of materials by faces in 3ds Max. You would need to go into the mesh select modifier of each material and reselect the faces.

- The same holds true for complex assignments of mapping, if a topology change occurs in AutoCAD, then you will need to reselect the faces in your modifier stack which is assigned to which UVW Map coordinates.

The illustration of the roof shows the result of a topology change in AutoCAD, reloading the file in 3ds Max, with the Use Scene Material Definition checkboxes on. As you can see the material is still applied, but the mapping is no longer properly applied due to the change in the number and distribution of faces in the roof object.

A1.6 Linking Files from Revit

Another software program which is becoming more and more popular amongst architectural and building professionals is Revit Architecture. Revit offers to these professionals an enhanced toolset to create a 3D model of a building. It is used to create both construction documentation and presentation graphics. Transferring a CAD model created in Revit to 3ds Max to be rendered gives the building professional and the 3D artist the best of both tools to create construction documents in Revit and superior presentation graphics in 3ds Max.

A1.6.1 Revit Object Database

Revit Architecture toolset is geared toward creating a building model in 3D. It does so by creating building elements using objects. Tools in the Revit software allow you to create building objects such as walls, doors, windows, stairs, etc.

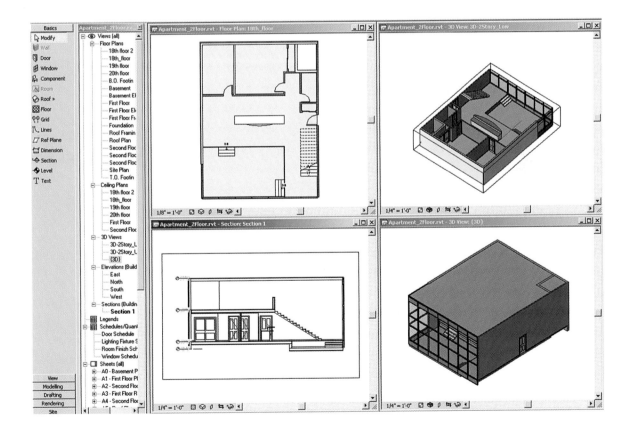

These objects can then be displayed in 2D and 3D simultaneously to generate practically any view you require.

A1.6.2 Exporting 3D Model to AutoCAD

When you are ready to take the 3D model from Revit to 3ds Max you must first export the model to AutoCAD. It is not even a requirement that you have AutoCAD on your computer, the only important thing is to create a **.dwg** file.

The File Export Process is initiated in the File pull down menu.

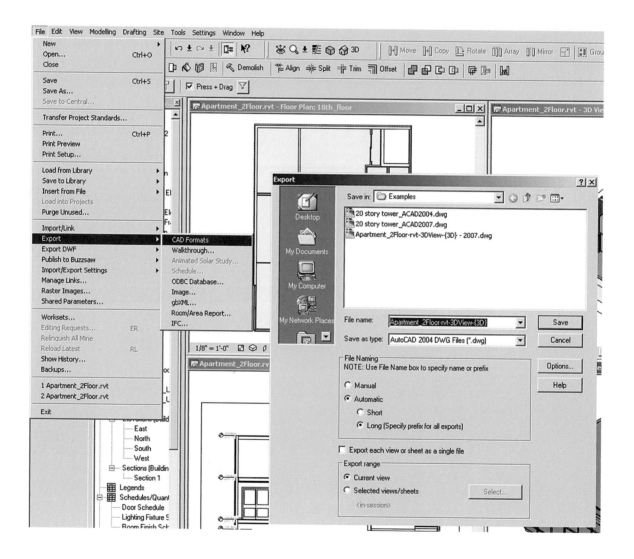

You must be careful when you export the Revit model as it will, by default, create a **.dwg** file based on the current view selected.

A1.6.3 Linking an AutoCAD File Exported by Revit

When you file link an AutoCAD file into 3ds Max that has been exported by Revit the process of file linking is not different from executing a file link from a native AutoCAD file. Where you will see a change is in the structure of objects in 3ds Max.

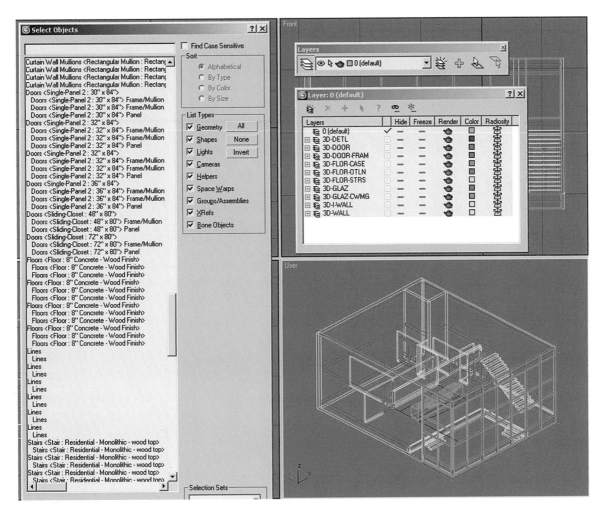

The layering inside of 3ds Max has been determined by the exporting process from Revit. Although Revit does not use any apparent layer system, whenever a file is exported from Revit a layering system is created in the target file. That layering system is apparent in the **.dwg** file which was created earlier and subsequently in the 3ds Max file. Each layer name makes sense and selecting the objects on each layer will display the objects you might expect.

The creation of objects in 3ds Max has some variation to the organization of these objects in Revit. Regardless how the objects are organized selecting the objects by layer will remain the easiest way of selecting them as a whole and applying a material to the selected objects. In the following example all the doors have been selected by making the 3D-Door layer current and then using the Select Objects in the current Layer tool on the Layer toolbar.

A1.6.4 Reloading a Revit Model Linked through a .dwg File

As with an AutoCAD file 3ds Max allows you to reload a Revit model, but this link from Revit was never done initially in a direct manner, and therefore reloading the Revit model will be done indirectly as well. The Revit model must be re-exported through the File Export tool in Revit, thereby recreating the existing exported **.dwg** file. Once the file is recreated the same rules apply for reloading the **.dwg** file into 3ds Max as if it were a native AutoCAD drawing.

A1.6.5 Materials in Revit

Revit allows you to create material definitions in its object styles. For example it is possible for you to create a wall style with multiple components and profiles. This could be a change in wall material from a stone to a brick on the exterior face of an exterior wall, and it can also be a different material used in a profile (either a sweep or

reveal). The example which follows is a simple example of a wall style created with the wood base of the wall added. The wall surface is created with gypsum board and the base with birch wood.

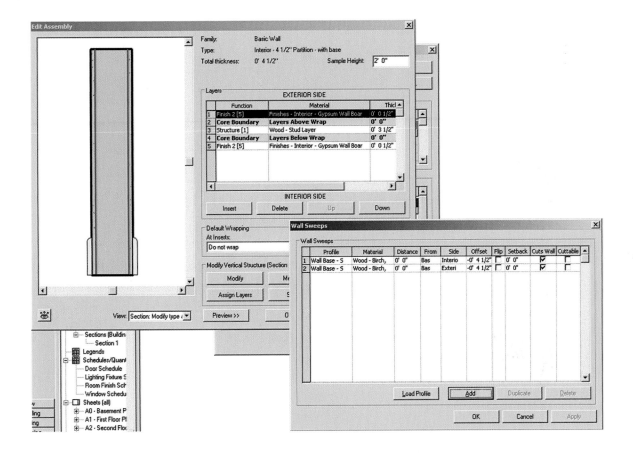

A1.6.6 Accessing Revit Materials in 3ds Max

Once a Revit file which contains materials assignments is DWG linked into 3ds Max, you will be able to access the material assignments in 3ds Max. The wall style displayed in the previous section in Revit is shown in 3ds Max. Note how the objects in 3ds Max automatically pick up the shading of the material which was defined in Revit.

By default the incoming material will be assigned a name like "RevitMaterialDefinition17799" and be defined as an architectural material. You can access the material in the Revit model by using the eyedropper icon in the material editor. Then you can change parameters in the material and even switch the material type. As long as you follow the same rules of reloading the file as you did with AutoCAD files you should not have any problems. In the material definition case the rule is:

- You must select the two checkboxes in the File Link Settings dialog box in the Advanced Tab related to Using Scene Material definitions and assignments. Otherwise the reloaded file will be reloaded without any materials assigned and you will have to reassign them.

This rule is slightly altered, if you do not enable the checkboxes, the original material definition from Revit will be loaded.

A1.6.7 Caution About Using Revit Materials

One of the issues of using Revit materials is not so much a problem in 3ds Max but is more of a problem in Revit. Revit is a Building Information Model design software. It builds a database of objects which can be displayed in drawings and also be counted for schedules and quantity takeoffs. If you develop too complex a system of wall styles the quantity takeoffs will also become complex.

You have to find a median where it makes sense to use materials in Revit. Back to the case of walls, it certainly makes sense to have different materials on an exterior wall to distinguish the interior from the exterior face of the wall. For interior gypsum walls it probably does not make too much sense to have each interior finish of each room defined in a wall style. That would create a multitude of wall styles for what is essentially one wall composition.

A1.7 Conclusion

In this Appendix you have learned about some principles in transferring CAD models to 3ds Max to be used in rendering with mental ray. You have learned what CAD transfer is, and the difference between importing a file and linking CAD files. You have been introduced to an approach to modeling and rendering with linked files, and finally some specifics in linking CAD files from AutoCAD and Revit Architecture to 3ds Max.

Appendix 2

Caustics

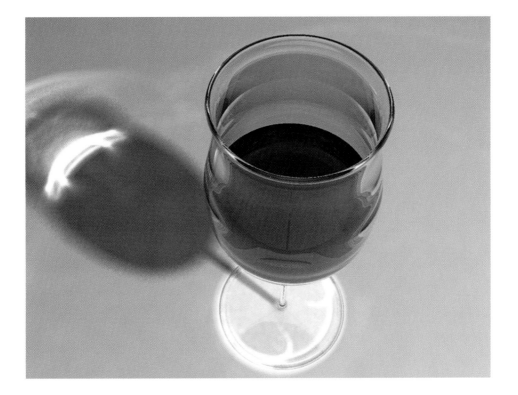

A2.1 Introduction

In this appendix you will learn about creating caustics effects. The procedures written here have been written for 3ds Max 9 but can apply equally to 3ds Max 8 and 3ds Max 7. Specifically you will learn:

- What is caustics.
- How to create caustics in a simple scene containing a wine glass.
- How to adjust lights, objects and materials to generate caustics effects.

A2.2 Caustics

Caustics is an effect of the scattering of light as it is either reflected off of, or is refracted as it passes through, a transparent or translucent material. Some common examples of caustics are:

- A wine glass which has light directed through the glass. As the light is refracted by the glass and liquid it creates distorted bright spots of light on the surface on which the wine glass is resting.
- Reflections from water in a pool. As the light from the sun or another source hits the undulating surface of a pool it will create a wavy light reflection on surfaces surrounding the pool.

A2.3 Creating Caustics in a Wine Glass

In this tutorial you will create caustics from light as it passes through a wine glass filled with wine.

As you have done throughout this book it is important for you to establish the units of measure to millimetres before you open your file. If you have forgotten to do this, 3ds Max will nonetheless give you the File Units Mismatch dialog where you can switch the system units to the incoming files units. The incoming file units are already in millimetres:

1. Open the file *glass caustics.max* from the files folder. If the File Units Mismatch dialog appears adopt the incoming files units.

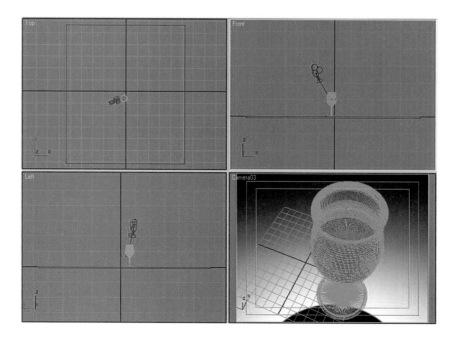

2. Open the Render Scene dialog box by clicking the icon on the Main toolbar. Make sure that the mental ray render is already loaded.

The next step is to quickly preset the lights while the materials are switched off. The reason for this approach is to increase productivity by getting quick and accurate results without the usual time-consuming rendering process:

3. In the Render Scene dialog box, go the Indirect Illumination rollout.
4. Check the Enable checkbox in Final Gather rollout in the Basic area.
5. Lock the Render Viewport to Camera03 to avoid rendering the wrong viewport.
6. Render the file by clicking the Render button on the Main toolbar.

Although quick to render the rendering time could be decreased further as you do test renderings:

7. Under the Final Gather rollout change the Preset pull down list from Custom to Draft. Note that the basic parameters values have also changed.
8. Render the file again and note the difference in rendering time.

The next step is to start applying the shaders to the respective objects:

9. Open the Material Editor dialog box by clicking on its icon.
10. Select the glass object in any of the viewports.

In the Material Editor one material slot should have highlighted corners:

11. Select the material slot. It should be named glass.

At the moment the glass material has a basic standard material shader applied to it. To apply a nice glass shader you will have to change the material type first:

12. Click on the Material/Map Browser button which is currently set to Standard.

13. In the Material/Map Browser dialog which pops up, choose the mental ray shader type and click OK.

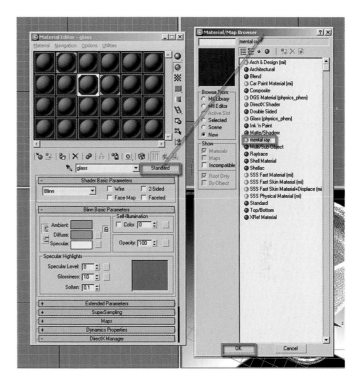

The mental ray Material Shader parameters will display:

14. Under the Basic Shaders group click on the Surface slot button.

The Material/Map Browser dialog box will pop up:

15. Select the Glass (lume) shader from the list followed by OK.

The Glass (lume) Parameters will load up:

16. Click Render for a quick test.

The glass in the image is looking good; however, the scene looks a bit plain, due to a lack of color. Next we are going to add some shade and color to the wine inside the glass:

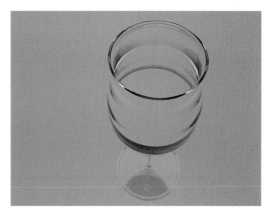

17. Select the wine object in the scene.
18. Open the Material Editor dialog box. Note that the respective material slot has its corners highlighted as the wine object is selected.
19. Select the material slot. It should be named wine.

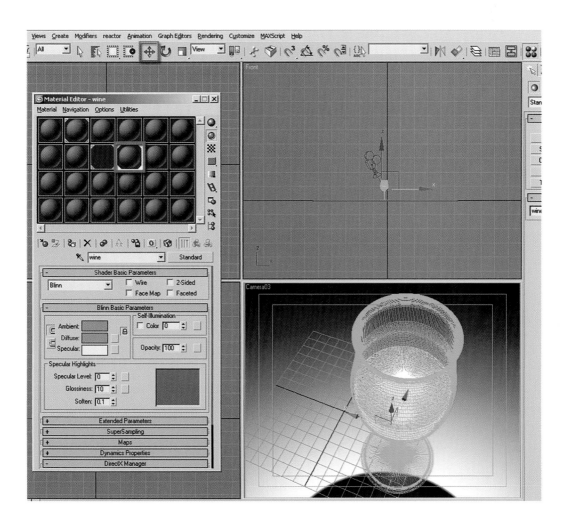

At the moment we have the basic standard shader applied to it. To apply a nice shader for the liquid you need to change the material type:

20. Click on the Material/Map Browser button which is currently set to Standard.
21. In the Material/Map Browser dialog which pops up, choose the mental ray shader type and click OK.

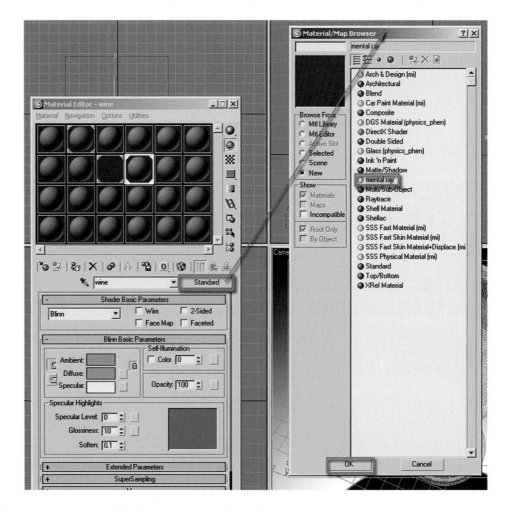

22. The mental ray Material Shader parameters will display.

Since liquids have similar parameters to glass, we are going to apply the Glass (lume) shader to it:

23. Under the Basic Shaders group click on the Surface slot button.
24. The Material/Map Browser dialog box should pop up.
25. Select the Glass (lume) shader from the list, followed by OK; the Glass (lume) Parameters will load up.

The next step is to emulate the wine liquid by simply changing some of the Glass (lume) Parameters. The first thing to change is the color as the natural color of wine is a mix of dark burgundy and pale red:

26. Click the Surface Material color swatch in order to display the Color Selector: Surface Material dialog box.
27. Change the color to dark burgundy by simply picking the hue and sliding the whiteness arrow, or alternatively type its values (R: 0.145; G: 0.035; B: 0.071).

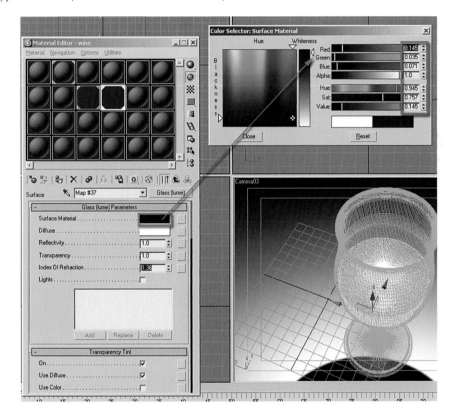

28. Change the Index Of Refraction (IOR) to about 1.36, this should be an accurate value for wine refraction.
29. Click Render for a quick test.

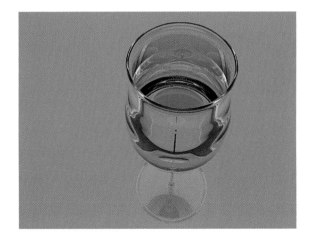

30. Next click in the Diffuse color swatch and change the color to pale red (R: 0.541; G: 0.22; B: 0.22).

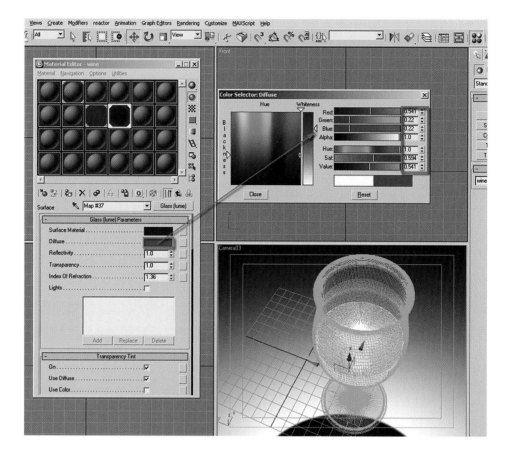

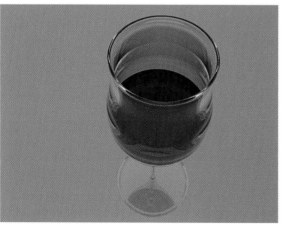

31. Click Render again for a quick test.

A2.4 Creating the Lights and the Caustics Effect

The next step is to begin creating lights in the scene. Since you will later emulate caustics in the scene, the mr Area Spot is the best choice. Caustics work best with direct lights which project light in one direction rather than with omni lights which disperse lights in all directions:

1. Open the file *glass caustics 02.max* or continue working on your file from the previous section.
2. In the Command panel, Create tab, select the Lights icon.
3. Click on the mr Area Spot button to create a light.
4. In the front viewport click and drag the Light roughly as shown in order to create it.

5. Click Render again for a quick test.

The image is looking good; however, the rendering time has increased significantly. You have already done a sufficient amount of work on the materials to be satisfied with them. Therefore, in order to decrease rendering times you will override the applied materials/shaders so that the test renders are more efficient:

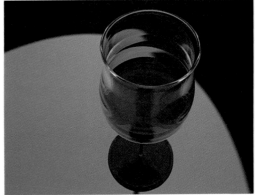

6. Open the Render Scene dialog box by clicking on its icon.
7. Go to the Processing tab.

8. Under the Translator Options rollout, on the Material Override group check the Enable option.

9. Click Render for a quick test.

The render time has decreased dramatically. The render is colorful because no material was applied to the Material Override slot button. Therefore, mental ray has used the object's default viewport color display to render the objects. In the next steps you will apply a base material to the Material Override by dragging a base material from the Material Editor:

10. Open the Material Editor and select a material which is not assigned to any object in the scene.

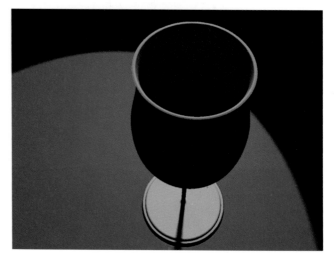

11. Click and drag the material onto the Material button in the Material Override area of the Render Scene dialog.

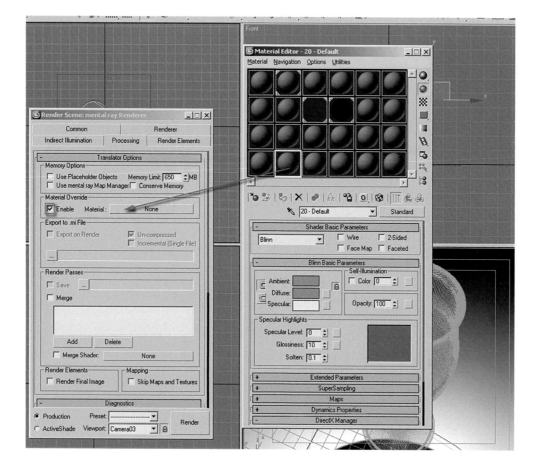

12. In the Instance (Copy) Material dialog select Instance.

Now you can focus on the lighting. Next you are going change the light's falloff values as the edge of the light changes too abruptly:

13. Select the mr Area Spot light.
14. Go to the Modify tab on the Command panel.
15. Under the Spotlight Parameters change its Falloff/Field value to about 73.5.
16. Click Render for quick test.

The spotlight's highlight is more feathered now. Next you will change the direction of the shadows:

17. In the top viewport, select the mr Area Spot and move it to a position where its head is below the glass (X= −125.0; Y= −442.0; Z= 500.0).

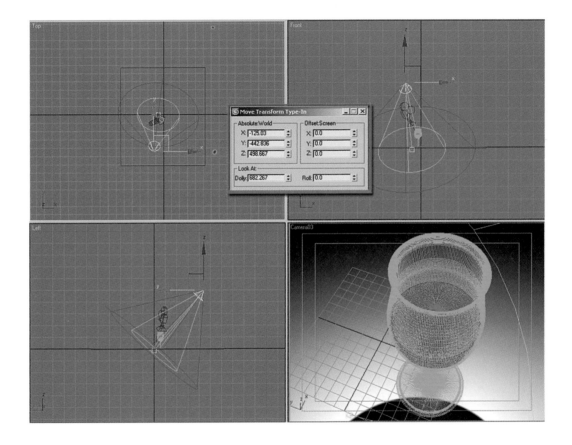

18. Click Render for a quick test.

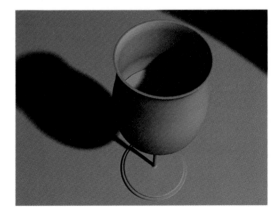

Next you will enable the caustics:

19. Open the Render Scene dialog box.
20. In the Indirect Illumination tab under the Caustics and Global Illumination (GI) rollout check the Enable option in the Caustics group.
21. Click Render for a quick test.

A mental ray warning dialog box will pop up, warning you that there are no caustics generators in the scene. An object must be set to generate caustics, by default no objects generate caustics:

22. Click Cancel to stop the rendering.

23. Select the wine object in the scene.
24. Right click on the object and choose the Object Properties from the list.

25. In the Object Properties dialog box, go to the mental ray tab.
26. In the Indirect Illumination group check the Generate Caustics option followed by OK to close the dialog box.
27. Repeat the same actions for the glass object.
28. Click Render for a quick test.

There are no caustics and the mental ray Messages dialog box appeared with some error regarding the photons.

This is due to the fact that in addition to the objects being set to emit photons, as you did above, you must establish photon emission in the wine and glass object material.

To do this you will start by adding some photon shaders to each one of the materials (glass and wine). Then you will need to turn off the Material Override option since that material has no photo shaders either:

29. In the Material Editor select the glass material slot.
30. In the Material Shaders under the Caustics and GI group, click the Photon button slot.
31. The Material/Map Browser dialog box will pop up.

32. Select the Dielectric Material (3dsmax) from the list.
33. Its parameters will display in the Material Editor.
34. Go back to the main parameters of the material, simply click on the Go to Parent button.

35. Repeat the same series of steps to add the Dielectric Material (3dsmax) shader for the wine material.
36. Go back to the Render Scene dialog and uncheck the Material Override option in the Processing tab.
37. Click Render again.

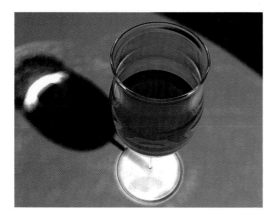

The caustics are now visible and there are no error messages. The next step is to optimize the caustics settings:

38. In the Render Scene dialog, under the Caustics and Global Illumination (GI) rollout, in the Caustics area, change the filter type to Gauss.

39. Click Render for a quick test.

The caustics appearance has improved somewhat; however, this could be improved even further by increasing the amount of photons which are generated by the light:

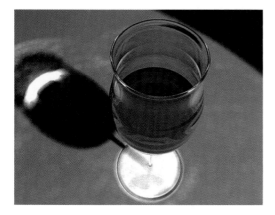

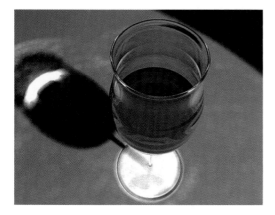

40. Make sure the light is still selected, otherwise select it.

Due to the fact the mr Area Spot has the Automatically Calculate Energy and Photons option checked, you can control its settings from the Render Scene dialog box:

41. In the Render Scene dialog, Indirect Illumination tab, under the Light Properties group, change the Caustic Photons per Light value to 80000.

42. Click Render.

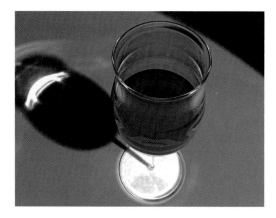

The caustics are accurately defined now.

A2.5 Final Adjustments to the Image

Next you are going to correct the overexposed lower part of the glass as well the color of the caustics:

1. Open the file *glass caustics 03.max* or continue working on your current file.
2. Select the material in the Material Editor labeled ground (first row, second column).
3. Lighten the value of the diffuse color so that the material is more white.

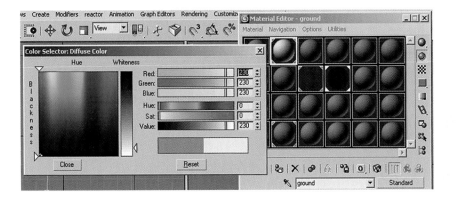

Next you will change the color of the caustics currently being generated from the glass object as it is generating the majority of the caustics due to the position of mr Area Spotlight:

4. In the Material Editor select the glass material slot.
5. In the Caustics and GI group, select the Dielectric Material (3dsmax) shader in the Photon slot.

6. Change its Light Persistence color swatch to a light burgundy color (R: 0.792; G: 0.651; B: 0.651). Lighter colors = lighter caustics; darker colors = dark caustics.

7. Change the Outside Light Persistence color swatch to white, this will allow more light to pass through.

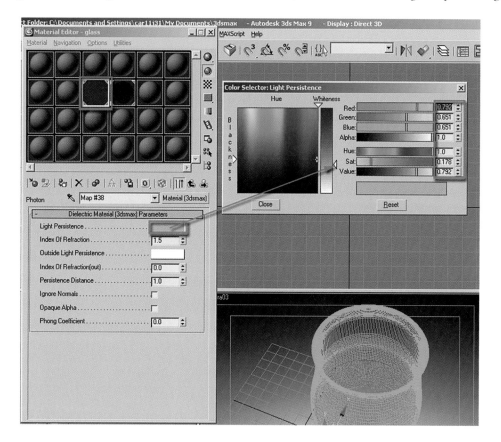

8. Click Render for a test.

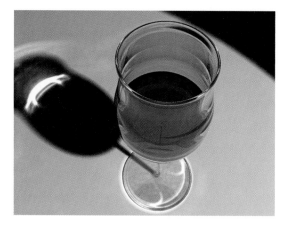

The image is looking much better now. Next you will make some adjustments to the light to eliminate the dark area on the upper right of the image, and make the shadows a bit more feathery and transparent:

9. Select the mr Area Spotlight.

10. In the Modify tab in the Command panel, in the Spotlight Parameters rollout change the Falloff/Field value to 150.

11. In the Shadow Parameters rollout, change the Object Shadows Density to 0.5.
12. Click Render.

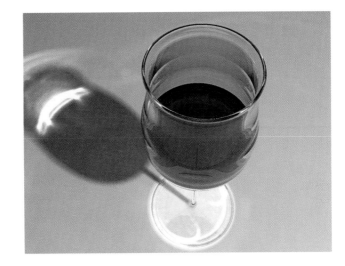

13. To adjust the softness of the shadows, change the Area Light Height and Width parameters to 40.0.
14. Render your image a final time.

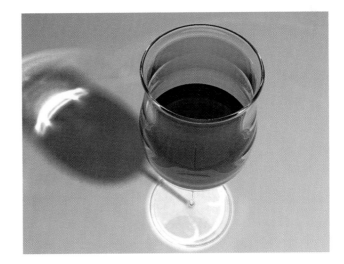

You can try experimenting with the mr Area Spotlight's position and settings to get different results.

A2.6 Conclusion

In this appendix you have seen how to create caustics. A simple scene of a wine glass was used to show you how to set up the lights, objects and materials to create the initial caustics effect. Then you worked on improving the image with the use of color and refining the shadow.

Appendix 3
Camera Effects

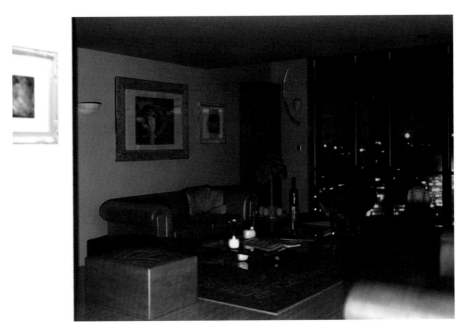

A3.1 Introduction

In this Appendix you will learn how to create two camera effects which are common in architectural visualization.

In this particular Appendix you'll learn how to:

- create a flash effect;
- control a camera's depth of field.

A3.2 Flash Effect and Depth of Field

The flash effect is a technique that a number of 3ds Max users have often associated with a rendering engine called Maxwell. The flash effect is the same as you would commonly find in interior photography, where a light source close to the camera will illuminate the scene by projecting an intense burst of light in the scene. This light will either add to, or completely dominate, the lighting in the scene. Although the results of this effect do not resemble your common visualization renders, it has become a huge trend among 3ds Max users and therefore is worth highlighting.

The depth of field effect is a common tool in photography to highlight a portion of a scene and throw out of focus either the foreground, background or both. The end result is an image which has a certain portion of the picture in sharp focus, which becomes the first thing an observer will be attracted to.

A3.3 Creating the Flash Effect

As you have done throughout this book it is important for you to establish the units of measure to millimetres before you open your file. If you have forgotten to do this 3ds Max will nonetheless give you the file units mismatch dialog where you can switch the system units to the incoming files units. The incoming file units are already in millimetres.

1. Open the file ***Flash Effect.max*** from the files folder. If the file units mismatch dialog appears, adopt the incoming files units.

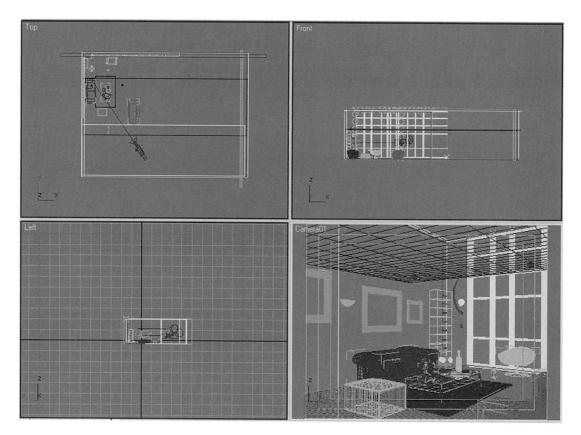

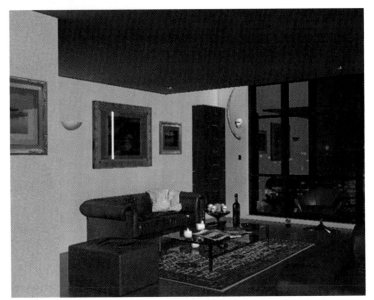

2. Open the Render Scene dialog box by clicking the icon on the main toolbar. At the bottom of the Common tab, make sure that the mental ray render is already loaded.

The next step is to quickly preset the lights while the materials are switched off. The reason for this approach is to increase productivity by getting quick and accurate results without the usual time-consuming rendering process.

3. In the Render Scene dialog box, go to the Indirect Illumination tab.

4. Check the Enable checkbox in Final Gather rollout in the Basic area.

5. Make sure the Draft Mode (No Precalculations) is not enabled.

6. Lock the render viewport to Camera01 to avoid rendering the wrong viewport.

7. Render the file by clicking the Render button on the Main toolbar.

Although quick to render the rendering time could be decreased further as you continue to do test renderings.

8. Under the Final Gather rollout change the Preset from Custom to Draft. Note that the Basic parameters values have also changed.

9. Render the camera view and note the reduction of rendering time.

The next step is to create the light that would emulate the "flash light effect" generated by the camera.

10. In the Create Command panel click on the Lights icon, followed by another click on the mr Area Omni button.

11. In the top viewport place the light in front of the 3D camera.

12. Move the light to the following position using the Move Transform Type-in dialog. (X = 1921.0 mm; Y = −2211.0 mm; Z = 0.0 mm).

The flash effect light has been placed at the ground level to add dramatic effect to the shadows. You can experiment with the light at different locations.

13. Render the camera view.

The image seems a bit overlit, and the addition of the light increased the rendering time. Therefore, in the next few steps you will reduce the rendering time to keep test renders within reasonable limits and balance the brightness of the scene by controlling the light's propagation.

14. Open the Render Scene dialog box by clicking on its icon.

15. On the Processing tab in the Material Override group check the Enable option.

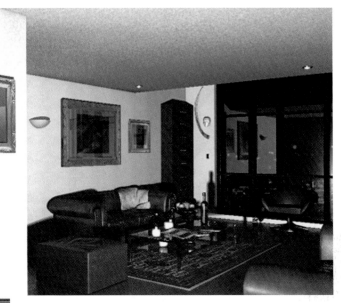

Next you are going to apply a material from the Material Editor to the override material.

16. Open the Material Editor dialog box by clicking on its icon.

17. In the Material Editor pick the material sample slot named ambient occlusion, in the third row, first column.

18. Drag and drop it on the Material Override map slot. The Instance (Copy) Material dialog box will display.

19. Choose Instance followed by OK to close it.

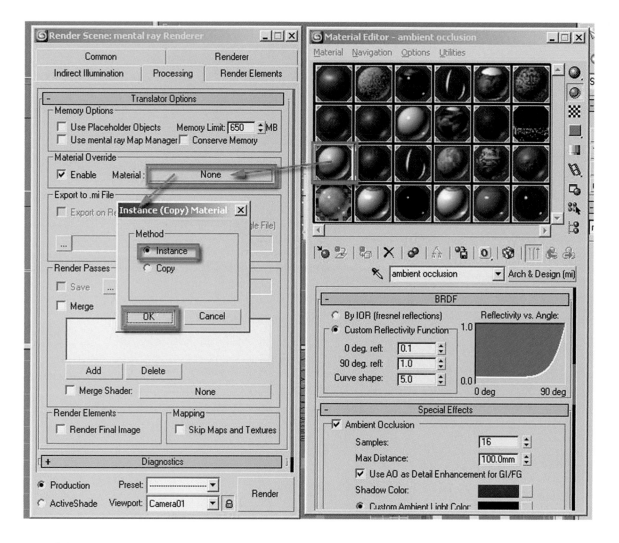

20. Click Render.

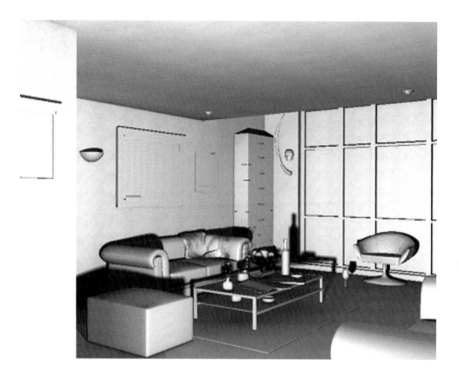

The image is rendering much faster now. Next you will adjust the decay of the light to emulate a photographic camera "flashing".

21. With the light selected, go to the Modify tab on Command panel.

22. Under the Intensity/Color/Attenuation parameter choose the Inverse Square Decay Type.

23. Check the Show option in order to view the light's distance gizmo on the viewport.

24. Render the camera view for a quick test.

The render is completely black. All the light decays before it strikes any of the objects in the scene.

25. Increase the Start value to extend beyond the sofa in the foreground nearly touching the table, approximately 1700.0 mm.

26. Click Render.

The image looks much better now; however, you may wish to move the light to another position in the scene to get different lighting and shadow effects.

27. Should you wish to feather the shadows simply increase the area light radius under the Area Light Parameters tab.

Since there is only one light in the scene there's no need to switch from Automatically Calculate Energy and Photons to Manual Settings under the mental ray Indirect Illumination tab.

A3.4 Depth of Field

To make the scene more realistic we are going to add a depth of field effect to the camera.

1. Open the file **Depth of Field.max** or continue working on your current scene.
2. Select the camera by right clicking on the top left of the camera viewport; a dropdown list will appear.
3. Choose the select camera option from the menu.

4. In the Modify panel under the Parameters rollout, find the Multi-Pass Effect group and check the Enable option.
5. In the Depth of Field type list, choose the Depth of Field (mental ray).

Note that as you choose the Depth of Field (mental ray) type, its Depth of Field Parameters appears in the rollout below.

- The f-stop value which appears in the rollout determines the amount of blurriness on the field (targeted area). The value is currently set to 2.0.
- The target distance determines the areas (field) in which the blurriness will take place.

The following images show some target distance and f-stop values.

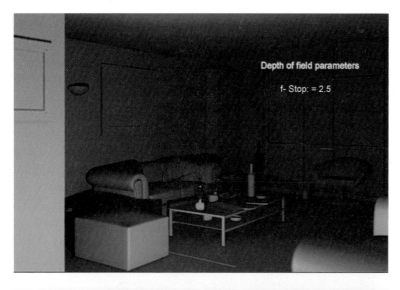

Depth of field parameters

f- Stop: = 2.5

Depth of field parameters

f- Stop: = 0.05

6. Before adjusting any parameters render the camera view.

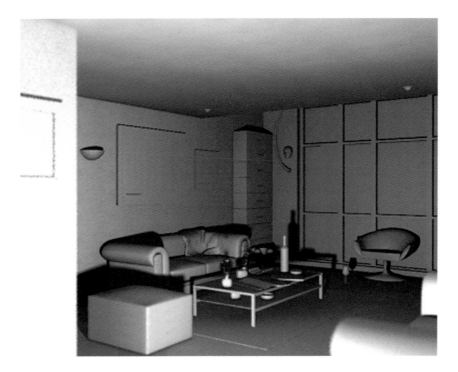

Note that there's a slight blur on the foreground, you can see this on the arm of the sofa. If you would like to reduce this effect increase the f-stop value to 2.5.

7. Once satisfied with your settings, open the Render Scene dialog box and go to the Processing tab.
8. Remove the check in Enable option for Material Override.

9. Click Render.

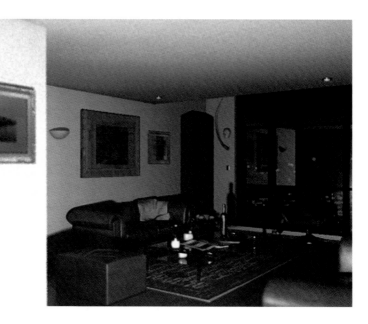

The image looks satisfactory now; however, the scene could use a bit more brightness in order to emulate a camera "flash effect".

10. Open the Render Scene dialog box.
11. Go to the Indirect Illumination tab and change the Final Gather Preset from Draft to High, note how some of the values changed automatically.
12. Change the Rays per FG Point option and set the value to 150, higher values will increase rendering times.
13. Adjust the Diffuse Bounces option and set it to 1, higher values will result in excessive "color bleeding."
14. In the Advanced group, change the Noise Filtering (Speckle Reduction) from Standard to High.

15. In the same tab of the Render Scene dialog, go to the Caustics and Global Illumination (GI) rollout parameters and enable Global Illumination.

16. Set the Maximum Num. Photons per Sample value to 10,000. This value works well in most common scenes without compromising the rendering time.

17. In the Render Scene dialog under the Renderer tab, choose the Mitchell filter type on the Sampling Quality rollout. This filter is very useful for images of smaller resolution as it sharpens them.

18. Change the Width and Height values to 5.0. Note that these values will improve the quality of the image, especially when the images are small.

19. In the Samples per Pixel area change the Minimum to 1 and the Maximum to 16.

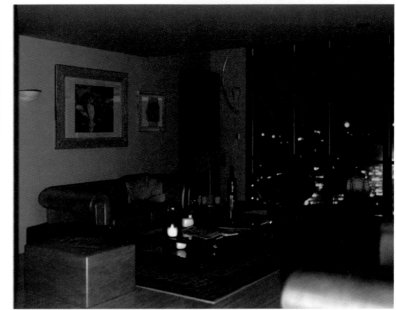

Appendix 4

HDRI

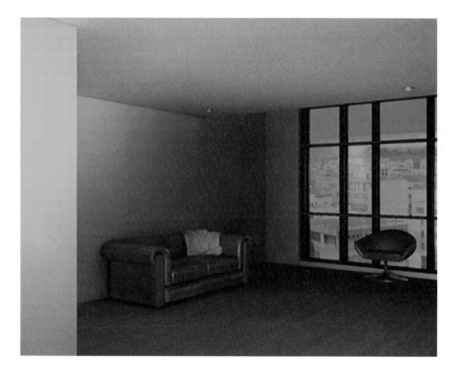

A4.1 Introduction

This Appendix will quickly show you how to use HDRI bitmaps with mental ray lights on interior scenes. HDRI bitmaps are also often used with the skylight object on exterior scenes.

In this particular appendix you'll learn how to:

- Set up a light source to accept an HDRI bitmap to control lighting.
- Adjust a HDRI image.

A4.2 Assigning a HDRI image to a light source

As you have done throughout this book it is important for you to establish the units of measure to millimetres before you open your file. If you have forgotten to do this 3ds Max will nonetheless give you the file units mismatch dialog where you can switch the system units to the incoming files units. The incoming file units are already in millimetres.

1. Open the file *LR_HDRI.max* from the files folder. If the file units mismatch dialog appears adopt the incoming files units.

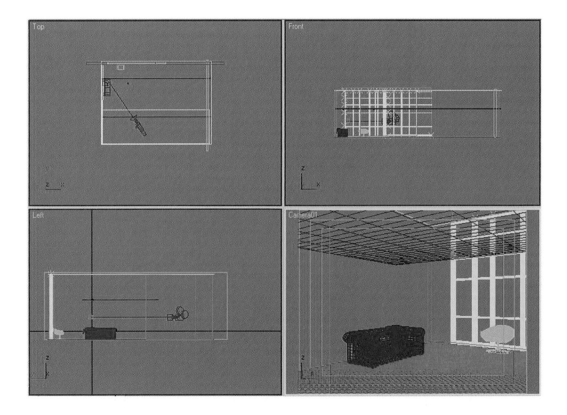

Many parameters and settings which you have been asked to set up in previous sections are already set up in this file. A list of these settings is below:

- The mental ray renderer is already loaded.
- The Camera01 viewport is set as the default rendered viewport and is locked.

- Final Gather has been enabled and is set to draft.
- A material override has been enabled with an ambient occlusion material assigned to the material override.

Feel free to verify any or all these settings.

2. Render the file by clicking the Render button on the main toolbar.

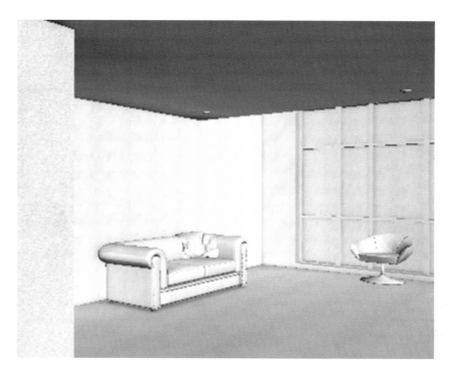

3. In the Create command panel select the Lights icon.
4. Select the mr Area Omni button.
5. In the top viewport place the light near the front of the camera.

6. Click Render for another test.

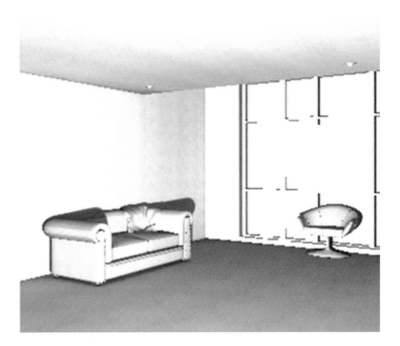

The image is too bright. That's due to the fact that the light is propagating to the infinite. The next step will be to control the decay of the light as the distance from the light source increases.

7. With the light selected click on the Modify tab of the command panel.

8. Go to the Intensity/Color/Attenuation rollout; Decay group and choose the Inverse Square type.

9. Check the Show option to display the decay gizmo in the viewport.

10. Click Render for a quick test.

The image is too dark now, in fact it is probably totally black. The start of the inverse square decay is very close to the light source, and the light decays too fast for any reasonable amount of light to reach a surface. Therefore, total darkness. If you change the start point of the decay you will give the light a better chance of illuminating a surface.

11. Increase the start value to about 1400 mm.

Note that as the start value is increased, you can clearly see the light's gizmo expanding in the viewport.

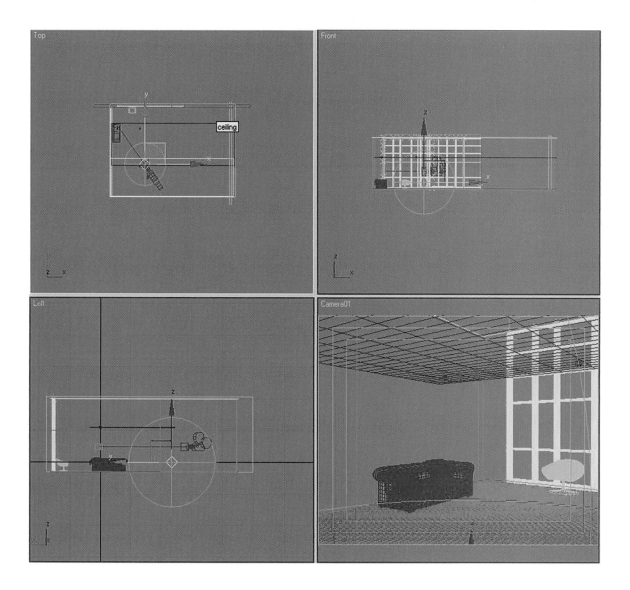

12. Click Render again for a quick test.

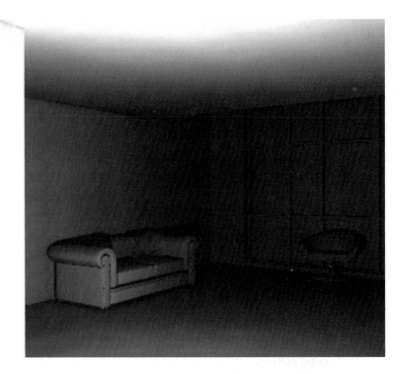

The image looks much better now. Next you will add a HDRI material to this light.

13. While the light is still selected, go to the mental ray Light Shader rollout and check the Enable option.

Note that once the Enable option is checked all the light parameters are disabled.

14. Click Render.

The image is completely dark. That's because the light shader function is enabled (checked).

15. To load the HDRI material first click on the Light Shader button slot. The material/map browser dialog box will pop up.

16. Choose the Light Point (base) shader type.

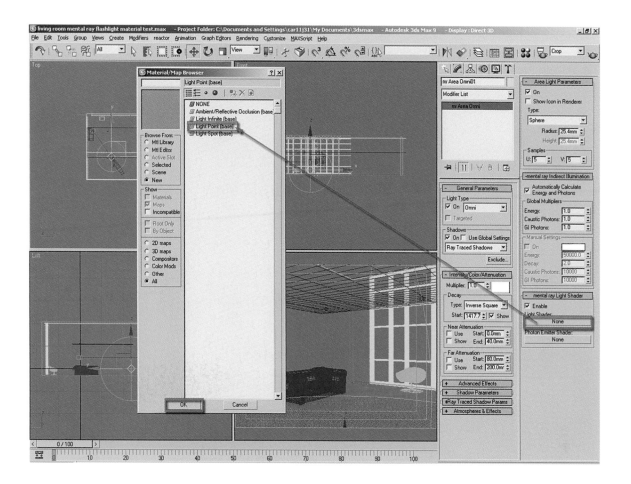

Note that Light Point (base) shader type is specifically designed for mr Area Omni lights and the Light Spot (base) shader type is specifically designed for mr Area Spot lights.

17. To view the parameters of the shader, open the Material Editor dialog box by clicking on its icon.

18. Drag and drop its parameters from the modify parameters onto a Material Editor sample slot. The Instance (Copy) Map dialog box will pop up.

19. Choose the instance method.

20. The Light Point (base) Parameters will appear in the Material Editor rollout.

A4.3 Light Point (base) Parameters

Color: This sets the light's color, default = white. The button slot to the right lets you load a bitmap/shader to it.

Shadows: When checked it enables shadows, default = unchecked. The button slot to the right lets you load a bitmap/shader to it.

Shadow transparency: This sets the shadows's transparency. Default = 0.0 (fully visible), 1.0 (fully transparent). Note that this function only has an effect when the Shadows option is checked. The button slot to the right lets you load a bitmap/shader to it.

Attenuation: When checked it enables the attenuation distances set by the Start and End values. Default = unchecked. The button slot to the right lets you load a bitmap/shader to it.

Start: It sets the starting attenuation distance from the light source. It only has an effect once the attenuation function is enabled, default = 0.0. The button slot to the right lets you load a bitmap/shader to it.

End: It determines the maximum distance of the light's attenuation, where the bright areas will stop. It only has an effect once the attenuation function is enabled. Default = 40.0. In some cases you need higher values in order to see any effect in the scene. The button slot to the right lets you load a bitmap/shader to it.

A4.4 Adding the HDRI image to the light

The sole reason for using the light shader is so that you can load a HDRI bitmap to the light.

1. Open the file *LR_HDRI_01.max* or continue working on your current file.

2. Click Render for a quick test.

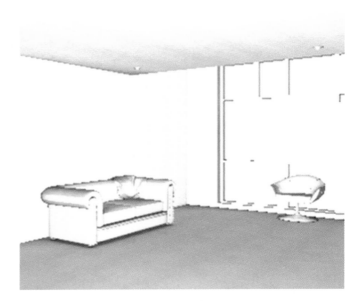

The image is too bright and without any shadows.

3. On the Light Point (base) Parameters check the shadows function and quick render again.

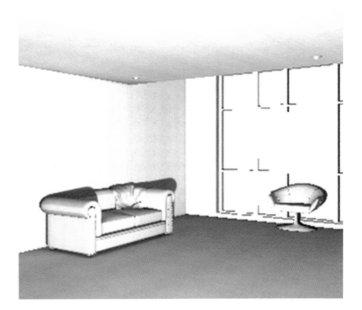

The shadows are now visible; however, the image is still too bright.

4. Check the attenuation function and click Render again.

The image is dark now. The attenuation function works similar to the inverse square decay-type function that you saw earlier in Appendix 4. The next step is to increase the end attenuation values to make the scene brighter.

5. Increase the end value to about 3000 and click Render again.

There is more brightness now; however, it's a bit dark further in the distance. In the next few steps you will use an HDRI image to illuminate the scene. You will use a HDRI image provided by Autodesk in the \maps\HDRs folder of 3ds Max 9. The file is also supplied on the DVD for convenience.

6. Click the Color Function button to load a bitmap.
7. The material/map browser dialog box will pop up.
8. Choose the bitmap type from the list.
9. The bitmap image file dialog box will pop up requesting the file.

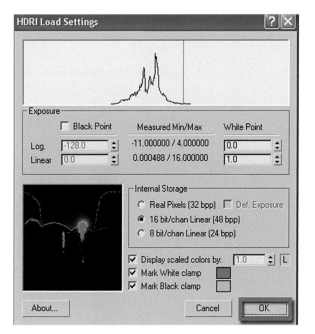

10. Open the HDRI image file ***Room_Lrg.hdr*** from the files folder.
11. The HDRI load settings dialog box will appear.
12. Note the exposure settings used in this image. They worked well for this scene and bitmap; however, you can use different settings to suit your requirements. Should you need more information on how to use HDRI images please check the 3ds Max help file. Note that this image is being used mainly for the purpose of color as opposed to reflection.

13. Once happy with your settings, click OK to load the bitmap. The HDRI bitmap coordinates will load up.
14. Change the bitmap from texture to Environ. type and also the mapping type to spherical environment.

15. Click Render for a quick test.

The rendering is very dark, but you can see traces of the HDRI image. Next you will increase the brightness in the scene by changing the HDRI bitmap parameters.

16. In the Material Editor, in the output rollout, of the HDRI Color Shader Bitmap change the RGB level value to 30.0.

17. Render to see the results.

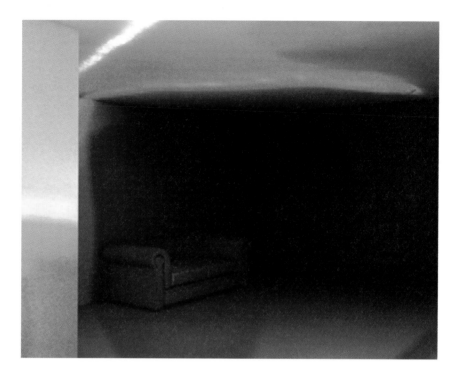

The HDRI image is too visible; in order to make the image less visible you will increase the radius of the light.

18. Select the mr Area Omni light, and under the Area Light parameters change its Radius value to 400.0.

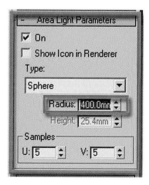

19. Click Render.

20. To correct the speckles and tiny dots caused by the hypersharp HDR image, you will need to increase the blur values of the bitmap to about 100.0.

21. Render your camera view.

The illumination from the HDRI image is looking less defined now. But there are some artifacts in the rendering. When using high radius values (e.g. 400 mm), you may encounter some artifacts when rendering. To correct that, simply increase the samples of the light.

22. Select the mr Area Omni light in the scene.
23. Change the U and V samples value to 10.0.

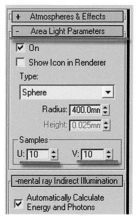

Note that this may increase the rendering time slightly; therefore, one should increase its values only when necessary. This last step should completely eliminate all the artifacts.

24. Render again.

The left wall and part of the ceiling are overlit. You will correct this with the logarithmic exposure control tool.

25. Render the scene a final time.

The settings used in the Logarithmic Exposure Control Parameters of the image below worked well for this scene; however, you can try different values to see what works best for you. In addition, for more information about using logarithmic exposure control parameters check the previous chapters or/and some 3ds Max help files. The image is a bit dark, so before executing a final render increase the end attenuation values to make the scene brighter.

26. In the Material Editor, in the Main Panel of the Light Point (base) Parameters, increase the end value to about 5000.

27. Finally, removing the material override and rendering with higher final gather settings should produce results similar to the following.

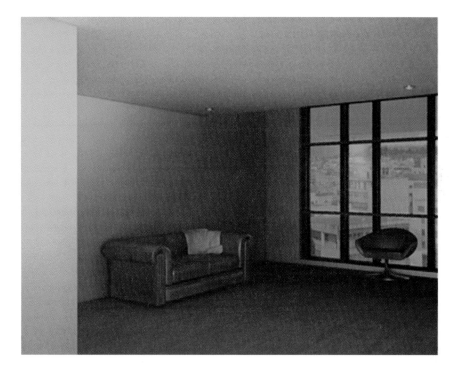

Appendix 5

Rendering Large Complex Scenes

A5.1 Introduction

In this appendix you will learn about a few techniques for decreasing rendering times in scenes which have demanding rendering situations requiring a large amount of time to render.

In this particular appendix you'll learn how to:

- Use render passes with a complex scene.
- Set up a scene to use bucket rendering.
- Use network rendering.

A5.2 Render Passes

When rendering scenes which contain objects with high mesh density or whose properties are taking too much of 3ds Max's resources to compute, one should resort to a mental ray function called render passes. When you have such a scene and you are rendering with mental ray, you can gain access to render passes in the Render Dialog, under the Processing tab, in the Render Passes group.

In this particular example, assume that the hospital bed is the main cause of the excessive rendering time (00.08.58 min on a selected system at 400 × 192 pixels).

The first thing to do in order to use render passes would be to make the bed invisible to the camera. You would do this in the Object Properties of the bed. Select the hospital bed, right click and select Object Properties from the menu.

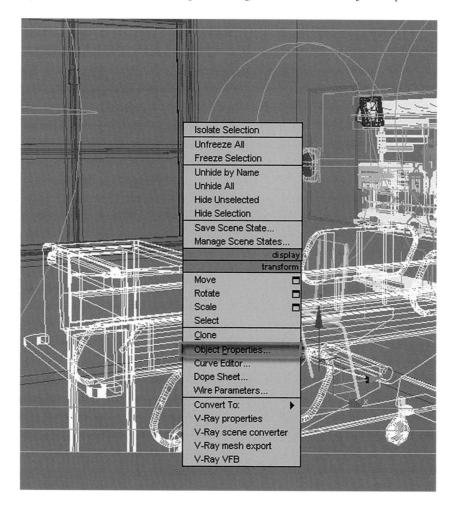

In the Object Properties dialog that appears you would uncheck the Visible to Camera option in the General tab. Note, by removing the check in Visible to Camera, the object will still be reflective, and will project and receive shadows. Dismiss the dialog.

Once you have gone this far you will next need to save the current state of the scene in the Render Scene dialog. In the Render Passes group click on the browse button. The Save As dialog box will pop up. In this example the file was saved as *pass1*. Note that the file will only be written or rewritten while the scene is being rendered.

Once you have completed setting up the file you can render the scene. When the file has finished rendering, go back to the Render Passes group. Uncheck the Save function to avoid rewriting the file, and check the Merge function. Once the Merge function is checked click on the Add button to load the presaved file, *pass1*. The Load Existing dialog box will pop up where you can select the file.

Now that the *pass1* file is loaded, the next phase is to reverse the process by making the remaining objects in the scene invisible to the camera except the bed ward.

On the main toolbar, you can use the selection filter to restrict the selection type to Geometry only.

Select the hospital bed in the scene, and access the object's properties. Check the Visible to Camera checkbox.

Dismiss the dialog box. A good technique here is to select the bed and freeze it to avoid selecting it by mistake.

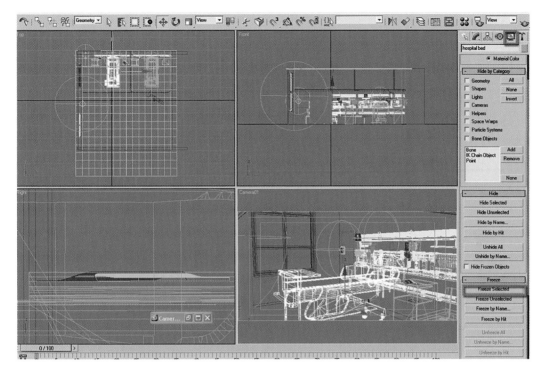

Next you need to select all the geometry in the scene by dragging across a rectangular selection window in the top viewport from left to right.

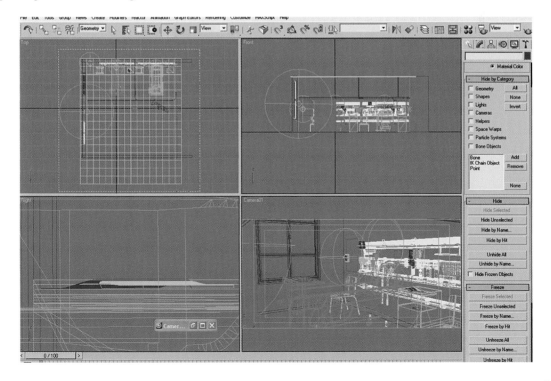

Once all the objects except the bed ward are selected, right click on them. Select Object Properties to display the Object Properties dialog. You would then uncheck the Visible to Camera checkbox.

If you render the scene again you would note how fast the image has rendered while the shadows and all the other details of the scene are still apparent.

Also, note that although the bed cupboard with the magazine on it is not visible to the camera, it's still appearing in the foreground (in front of the hospital bed) and blending with the environment seamlessly.

If you return to the Render Passes group uncheck the Merge option.

Taking a file which you have worked on and applying the principles demonstrated in this section clearly illustrate the unique functionalities of render passes.

A5.2.1 Render Passes Parameters

The following is a list of Render Passes Parameters as they appear in the Processing tab of the Render Scene dialog:

Save: By default it is grayed out, and it becomes available once the Render Passes file has been specified in the browse button. This function allows you to save the pass file by enabling it.

(…)Browse: This button allows you to specify the name and location of the pass file to be saved.

Merge: When enabled this button allows you to merge file(s) onto the Render Passes name field space in conjunction with the Add button.

Add: This button enables you to add pass file(s) by locating and loading them onto the Render Passes name field space. The files only become valid once the Merge option is checked.

Delete: This button allows you to delete any existing files in the Render Passes rectangle space, by simply selecting the file in name field space and clicking Delete.

Merge Shader: When checked, this option allows you to locate and load any custom shader.

Render Final Image: When checked, it enables the rendering of multiple pass files from the name field space as one final image.

Skip Maps and Textures: When checked, it allows you to skip any map or texture from the pass files.

A5.3 Distributed Bucket Rendering

Distributed bucket rendering is often useful when rendering large still images, as it allows you to use up to eight processors to render any given image. It can also be used for animations, but the network render is more appropriate for that type of situation.

The user's machine is automatically assigned to the render by default, so it is not necessary to specify the user's machine on the name field space. When using this technique (distributed render) it is often wise to assign computers with similar spec, otherwise slower machines may slow down the renders. If you have four machines with dual processors, you will need to purchase extra licenses as four dual processors are equivalent to eight processors in total.

A5.3.1 Distributed Bucket Rendering Parameters

Distributed Render: When checked, it enables you to add up to eight processors for free on the name field space.

Distributed Maps: When checked, it automatically specifies that all the texture maps can be found in the assigned machines. This will prevent the mental ray renderer from distributing the texture maps to the assigned machines by default. This saves time by eliminating this process.

All: This button enables you to select all machines specified on name field space.

None: This button enables you to unselect all machine(s) currently selected on name field space.

Add: This button enables you to add a machine to the render by simply supplying the IP address of the given machine on the Add/Edit DBR Host dialog box.

The name and IP address can also be found on the 3ds Max Backburner Queue Monitor. While in the Queue Monitor dialog box, select any given machine name; right click on it; and in the dropdown list choose properties, the machine's specifications should be displayed in the server properties dialog box.

Edit: This button enables you to edit the name and IP addresses of a selected computer. This button is grayed out by default, it only becomes active when a machine name is selected in the name field space.

Remove: This button enables you to remove any selected computers from the name field space. This button is grayed out by default; it only becomes active when a machine name is selected in the name field space.

Once all your settings are properly set up you are ready to render.

A5.4 Network Rendering

As mentioned in the previous section, rendering an animation is usually done with network rendering. When network rendering, you may encounter some errors related to texture maps. The most practical workflow to avoid this problem is as follows.

Simply copy and paste all the texture maps of the scene into one location. Then on the main toolbar click Customize and choose the Configure User Paths… option.

In the Configure User Paths dialog box under the External Files tab, click Add and locate the destination of your textures in the Choose New External Files Path dialog box. Click the Use Path button to close the dialog box.

You now have the path where 3ds Max will find the textures for your scene.

You can save your External File Path in the Configure User Paths dialog box. While the path address is selected you select the Save as button. The Save Paths To File dialog box will pop up. Choose a location, name and save the file as an *.mxp file.

Back in the Render Scene dialog, Common tab, you will set up a Net Render by enabling the Net Render checkbox.

Once the work is sent to render in the network, the Network Job Assignment dialog will pop up. In the path file group check the Use Alternate Path File option and use the Browse button to locate the file (*.mxp) you saved earlier and open it.

All your textures will now be found by computers participating in the network render.

Appendix 6

Common Errors

A6.1 Introduction

In this appendix you will be introduced to a variety of common errors that occur while using the mental ray renderer. The following sections will quickly show you how to overcome some of these hurdles.

In this particular appendix you'll learn how to:

- Display the mental ray Message Window.
- Correct photon errors that occur with Global Illumination.
- Fix Final Gather errors that occur on large renderings.

A6.2 The mental ray Message Window

To have access to the mental ray Message Window simply go to Rendering on the main pull down menu and select the mental ray Message Window option....

It is important to have this dialog box displayed at all times in order to view the rendering progress.

Once the mental ray message window is displayed, it also enables all the options available at bottom of the dialog box, so you can see all the important details of the render.

The Clear button allows you to clear any written messages in the dialog box, and the Close button enables you to close the dialog box.

A6.3 Photon Errors

One of the commonly encountered error messages when rendering is the one regarding photon emissions. Error messages like the following can appear: "no photons stored after emitting.... Photons from light …". When these errors appear, the GI computation will take longer.

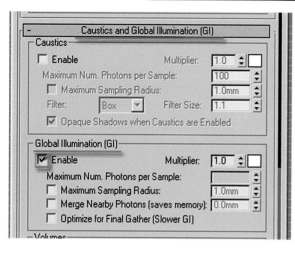

These messages only appear when the Global illumination (GI) group is enabled.

There are a number of reasons why this happens. In interior scenes it has mainly to do with the position of lights. If a light is flush against a surface or sunk into a surface, this error message will be produced. To solve this problem identify the problem light and simply move it away from the surface.

Another reason for a similar error message is when using mental ray material shaders and the surface and photon components are not being used.

The photon component should always have an instanced material shader as the surface component. You can easily accomplish this by dragging and dropping the shader from the Surface shader into the Photon shader and choosing the Instance option.

For exterior scenes, although it is not a common practice to use Global Illumination (GI) on exterior scenes (especially now, with the newly introduced Daylight system object for mental ray in 3ds Max 9), it may need to be used occasionally.

When using an mr Area Spot, the light should never be too far away from the objects in the scene. Also, the light's target shouldn't be far away from objects either. The adjacent image shows you a common mistake when using mr Area Spot lights on exteriors.

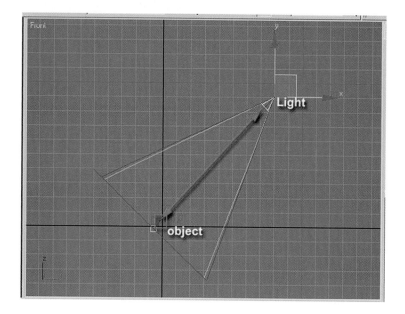

To correct this problem simply bring the mr Area Spot light closer to the objects in the scene and ensure that its target is touching an object in the scene.

When using an mr Area Omni on an exterior scene, things become a bit more complicated as rays of light are scattered everywhere to infinity. There are no surfaces for its photons to bounce from, and the mr Area Omni has no target.

To correct the photon errors in this scene simply create a sphere big enough to cover the whole scene and its lights.

Access the Object Properties of the sphere.

In the Object Properties dialog box under General tab:

- Uncheck the Visible to Camera option.
- Uncheck the Visible to Reflection/ Refraction option.
- Uncheck the Receive Shadows option.
- Uncheck the Cast Shadows option.

Due to the fact that the photons emitted by the light will be bouncing from the spherical surface, it is imperative to have a base shader applied to it. A basic Arch & Design (mi) or mental ray material shader would suffice. The surface doesn't need to be glossy or reflective, but its base color has to be fairly bright to produce a good bounce of light.

A6.4 Final Gather Errors

When using Final Gather you may at times run out of memory when rendering a large file. The error message will look similar to the one in the adjacent image.

The best way to solve this problem is to save a Final Gather Map into a smaller output size. For example, even if your final image is 4000 × 3000 you can save your Final Gather Map at 200 × 150. This smaller Final Gather Map file, executed at the same aspect ratio as the larger image, will save time and memory in the final render.

To save a Final Gather Map file, in the Indirect Illumination tab of the Render Scene dialog, you would check the box labeled Read/Write File in the Final Gather Map group. The Browse button below the checkbox allows you to pick the name and the location of your Final Gather Map file.

Click Render to start saving the file. You do not need to wait until the entire image has completed rendering. Simply wait until the entire Final Gather processing is done, and the first bucket or two is rendered, then press Cancel. Your low resolution .fgm file will be saved. Once the file is saved, simply check the freeze option under the Final Gather Map group.

This option is to skip any Final Gather computation on the final big size render. On the Common parameters change the Output Size to the higher resolution and click Render.

Appendix 7

The Cover Image

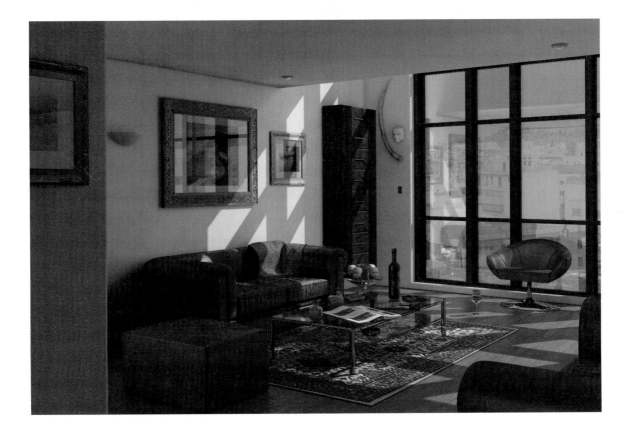

A7.1 Introduction

Throughout this book you have used many techniques to provide quick rendering results. Eventually, the ultimate quality of your image will take priority over the speed of renderings. This would be the point of creating a final rendering, like the one used on the cover of this book.

In this appendix you will learn:

- Some of the fine tuning required for final gather for high resolution images.
- Setting up the final render using bucket rendering.
- Final Adjustments to lights, materials and exposure control.

A7.2 Adjusting Final Gather Settings

If you wish to make the same adjustments as suggested here you could work with the file **LR_Final.max** found in Chapter 2.

The following are parameters to be adjusted in the Indirect Illumination tab, Final Gather rollout:

- Change the Multiplier to 2.0.
- Change the Interpolate Over Num. FG Points value to 60.
- The Final Gather Map was saved by first rendering the file at 200 × 156 pixel resolution and checking the Read/Write File option followed by specifying the (*. fgm) location and name.
- Once the Final Gather file was saved it was then frozen (the *. fgm file) by checking the Read Only (FG Freeze) option.

A7.3 Image Size

Based on information which you are normally provided by individuals creating graphic layouts with your image, you will get an output size of your image in pixels, or a resolution and a dimensional size. For 3ds Max what will be important is the final output size. For the front cover image the output size was set to 3000 × 2340 pixels.

A7.4 Sampling Quality

The sampling quality was kept as the original image in Chapter 2; as a reminder here are the parameters:

- Samples per pixel: Minimum – 1; maximum – 64.
- Filter type: Mitchell.
- Width: 5.0.
- Height: 5.0.

A7.5 Rendering

This rendering would take a considerable amount of time to render if a single computer was used to render it. Four dual processor machines were used through the distributed bucket rendering method. The adjacent image shows three machines since the user machine is automatically assigned and therefore does not appear on the list of machines to be added to the Distributed Render list.

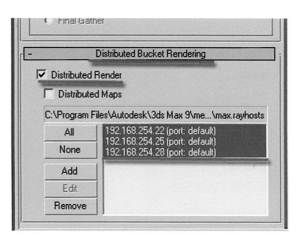

Of course if you don't have a network to render on you can render on a single machine; it will just take longer.

A7.6 Lights and Materials

In order to make the scene a bit more dramatic you can intensify the effect of the sunlight coming in from the exterior. Changing the Multiplier of the mr Area Spot light to 5.0 will provide more contrast between the direct sunlight and the ambient light.

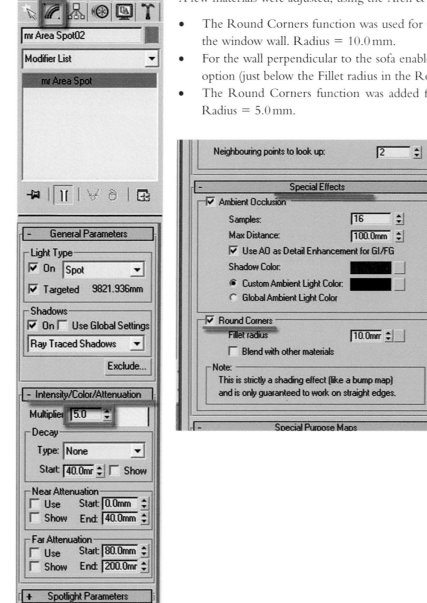

A few materials were adjusted, using the Arch & Design (mi) material:

- The Round Corners function was used for the wall close to the camera and the window wall. Radius = 10.0 mm.
- For the wall perpendicular to the sofa enable the blend with other materials option (just below the Fillet radius in the Rounded Corners group).
- The Round Corners function was added for the window frame material. Radius = 5.0 mm.

A7.7 Exposure Control

A few of the Logarithmic Exposure Control Settings were changed to enhance the final image.

- Contrast: 100.0.
- Desaturate Low Levels: Disabled.

Index